Texas
RANCH WOMEN

THREE CENTURIES OF METTLE AND MOXIE

CARMEN GOLDTHWAITE

D1402238

THE
History
PRESS

Published by The History Press
Charleston, SC 29403
www.historypress.net

Front cover, top, third from left: Dora Roberts, donor to three colleges—SMU, TWU and Southwestern University—all Methodist schools in Texas. *Courtesy of the Heritage Museum of Big Spring.*

Front cover, bottom: Carmen Goldthwaite on a research trip for this book to the Stovall Ranch on Matagorda Bay. *Photo by Linda Joy Stovall of Stovall Ranch, Matagorda Bay, Texas.*

All photos by the author unless otherwise noted.

First published 2014

Manufactured in the United States

ISBN 978.1.62619.598.1

Library of Congress CIP data applied for.

Those Who Made This Book Possible

First of all, to the ranch women of Texas past and present who have preserved a tradition and way of life, conserved the land and fed the world—thank you.

Personally, three women who helped bring this book to fruition:

To Ginnie Bivona, a woman in publishing who suggested I tackle a book focused on Texas ranch women; to SJ Mackenzie, a dear friend, first reader and cheerleader who, when research trails dried up and clouds of writing angst hovered, urged me to press on; and to my late mother, Kathryn Fitch Goldthwaite, a Floydada farm girl who inspired with her stories and her life, providing a firsthand glimpse at the humor that helps strong women skip through life's rough patches.

CONTENTS

PREFACE

E nchanted by the farm and ranch women with whom I've grown up or come to know, I've written these stories because they need to be told and retold. These women, whether members of our family or not, are our heritage. No, I've not been a farm girl, a ranch girl or a cowgirl, although I did grow up dreaming about them and idolizing those I knew of, even if their stories had been overshadowed by adventures of the fellows on the screen and in novels. Somehow, many of us—myself included as a youth—thought the woman's role of cooking and cleaning did not resonate; it was not exciting or adventuresome, or so it seemed.

Limited exposure to the ranch woman's role on Texas ranches, large and small, left us ignorant of the strength, integrity, love, humor and courage that powered these women through every adventure often attributed to men. I hope to help correct that gap, not only in my perception but also hopefully in yours, the reader. The women throughout these three centuries shared good times and hard times. They pitched in and partnered with parents, husbands and children. They "saddled their own horse," as one cowgirl often said, and took the reins over ranching kingdoms as well as "shortgrass" spreads, the latter often derided as "nesters."

May you ponder their tales and linger over their bravery.

CARMEN GOLDTHWAITE
September 23, 2014

ACKNOWLEDGEMENTS

No writer works alone, although countless hours might be spent in solitude, facing a screen. But to help us have something to type on that screen, we depend on countless people. For me, it began with people like the late Evelyn Koger, a Lamesa-area rancher's wife who pointed out some women I should learn about. Fellow (or sister) western writer the late Lou Rodenberger helped with her books and her wisdom. And then there are the librarians. They are unbelievable, whether it's the staffs at Fort Worth and Dallas public libraries, at SMU and UTA archives, at the Panhandle Plains Museum or at the Southwest Collection at Texas Tech. Two women—one at the beginning of my research, Kathy Jackson, and one at the end, Bethany Dodson with the National Cowgirl Museum and Hall of Fame—provided tons of information for women who were their honorees. My thanks for that…years apart.

And then there are some special ones, who went far beyond the call for information and photographs: Tom Shelton at UTSA Special Collections, Mandy Roane at Marfa Public Library, Brenda McClurkin at the University of Texas–Arlington archives, Cindy Wallace at Amarillo's Public Library and John Miller, manager at the Stillwell Ranch & RV Resort in Big Bend. A particular delight came about with an e-mail from Tracie Thomas, the great-great-granddaughter of a woman I'd sought a picture of. Tracie handed me over to her mother, Cheryle Campbell Stark, for more stories. Fort Worth writers David and Karen Ekstrom found a book whose information enabled me to include one story I'd given up on. Thanks to you all.

Throughout the production of this book, from conception to finish, I appreciate the steady hand and guidance of Christen Thompson, my editor at The History Press. Locally, I tip my hat in gratitude to longtime friend, writing companion and "indexer" Lourdes Raupe, who has indexed two books for me. I'd never have made it without you, gal. Next in order of huge thanks for making my first book a success are those who assemble "a mess" of photographs into an attractive picture story with the narrative. Before the book leaves Charleston, the publisher's outstanding publicity and marketing folks—Katie, Bob, Sara and another Katie— have paved the way to bring the book to you, dear readers. Many of you have welcomed me into your homes, churches and organizations to tell the women's stories these last dozen years. Now, as you have encouraged, they are in print: first, *Texas Dames: Sassy and Savvy Women Throughout Lone Star History*, and now *Texas Ranch Women: Three Centuries of Mettle and Moxie*.

To all of you and countless more, thank you and thank you again.

INTRODUCTION

Long have people marveled at Texans' spirit, spunk, true grit and overarching friendliness. Often, though, a part of the story goes untold—that of Texas women. These are women for whom Tejas and, later, Texas was home, women who presided over balls and palaces in the highest fashion of Spain yet grabbed the reins of sprawling ranchos and presidios with skilled wits and tensile strength.

Legends abound of Texas's story of friendliness that stems from an early Tejas Indian woman. Emigrants came later, seeking a better life. While some women came alone, most arrived with immediate family and settled here, far from home and other loved ones. For them, Texas was a foreign land. But they set down roots in the East Texas pine forests or the Coastal Plains and then, when opportunity or loved ones beckoned, pulled up stakes, donned sunbonnets and wrangled cattle up the trail, pushing Texas's borders west and north.

When ranching changed, many women led the change—moving from southern-style cotton and cattle plantations to sod busting on the sparse plains of the West. During droughts and low cattle prices, some turned their flair in the kitchen into a respite for city-dwellers escaping the muggy heat of the coast, beginning dude ranches in the Davis and Guadalupe Mountains regions.

Some ranch women emerged as astute businesswomen who made tough decisions with white gloves and feathered fedoras and cornered oil speculators into offering impressive royalties. Those riches kept alive the

Texas Hereford ranch of the West. In most pockets of the state, women created dynasties, clustering their families on sprawling ranchlands. Dedicated to keeping these empires intact, they dared any in-law to challenge the authority of the family spread or its matriarch. Some donned pants and slouch hats and roughed it up with the fellows. Whatever method or maneuver it took to hold on to the land, these women seized it. Today's generation of Texas women still hold high the grail of Texas land and cattle, preserving these roots for yet another century of Texans.

Women of the pines, desert, the South Plains, mountains and Coastal Plains adopted one another's ways and brought new ones, creating first a nation and then a state with an international flair. Whether it was a gracious but steel-fisted Spanish doña of the early nineteenth century like Patricia de León or the illiterate, tough-minded Irish immigrant Peggy McCormick or savvy Mexican Comanchero backer Juana Pedrasa, they shaped and changed the land and a way of life and were changed by it. Southern belles like Dora Nunn Griffin Roberts married cowboys with dreams and wound up with the reins when they fell. They created fortunes on the plains.

This book portends to tell the story of these women who, in their times, bred and nurtured the Texas we know, rife with heroic legend and fact. Be it early or late history, these are only a few of the women, though, who insisted that their children and families have more out of life than a Wild West adventure. Some of their stories are well known; others are not. Woven together, they provide a fresh look at the nature of Texas and the lives of Texas women. Undaunted by tragedy and undeterred by the scurrilous, they built communities and nurtured dynasties for a love of the land and its people.

Through the chapters in this book, our lantern peers into nooks and crannies around the state, illuminating tales of Indian, French and Spanish mythology that have been handed down to us and now mingle with love stories, legal twists, mysteries, hard times and galas. Whether this Texas woman is Indian, Canary Islander, Spaniard, Mexican, French or Anglo, we view the myth and fact of Texas through her eyes.

In Texas, the state's history is so steeped in ranching that many illustrious women will be left out of a book of this sort. I have, however, attempted to provide the reader with a flavor of the times through a sampling of the women and their lives, their contributions and where and when they lived from the late eighteenth century to the mid-twentieth century.

FABLE AND FACT THAT LED TO TEXAS'S CHANGING WAYS

From the Spanish expeditions to the New World in the sixteenth century until the breakup of New Spain's empire, women played lasting roles in the life and culture of Tejas, or Texas. Two of these women are legendary. One is a Spanish woman who never set foot on Texas soil, Sister Maria de Jesus de Agreda, the Lady in Blue, who succeeded in converting Jumanos and Caddos to Catholicism when many priests and friars had failed. The other, Angelina, a woman of the Caddo confederacy, held a gift for languages, bridging together the Indian, Spanish and French languages. Without these two, Texas's story, its culture and its way of life would not be the same.

The Spanish came with armies of soldiers and ranks of friars, the men of God. They came to conquer and convert. With armor of mace, riding horses and wielding metal-tipped spears, they dominated the Indians, especially agrarian ones like the Jumanos and Caddos.

The Lady in Blue

Not so, conversion. For nearly a century, the friars built missions, struggled and cajoled to win converts, but the Indians did not come. They resisted the new religion and clung to their own beliefs until a mysterious

occurrence. A woman began appearing to the Jumanos in visions; they called her the "woman in blue." She said that God allowed her and the Indians to understand one another. She taught about Mother Mary, Jesus and of becoming baptized. After each of her supernatural visits, those with whom she spoke walked several hundred miles to plead for baptism in the missions in New Mexico, which the friars had established in the sixteenth century. Confounded by the sudden appeal for baptism but rewarded by the conversion numbers, the friars could at last send positive reports to Mexico City church officials.

One day, an inquiring padre asked a Jumano about his sudden acceptance of the church and its teachings. The native pointed to a painting of an elderly nun hanging on the wall and said, "The Lady in Blue came to us and told us to seek baptism." The Jumano said that the woman who visited them dressed like the nun in the picture but was "young and very pretty."

At this time, however, no nuns had arrived in Texas. Of this, the friar was sure. He also knew that only the Poor Clare Order of Nuns in Agreda, Castille, Spain, wore that habit—a gray and white robe draped with a blue sackcloth cloak. After probing church records of Mexico City for a possible explanation and finding none, the friar sailed for Spain. In Madrid, Catholic officials, aware of the stories, awaited confirmation by someone from New Spain. Hearing Friar Alonzo Benevides's stories of the Jumano's report, they directed him to Agreda and Sister Maria de Jesus de Agreda, mother superior of the convent. He wrote of her: "Her face was beautiful, white except for a faint rosy tinge. She had large black eyes under heavy, high-arched eyebrows. Her cloak was of heavy blue sackcloth. If her eyes were darkly calm, her mouth had a little smile of sweetness and humor. She talked freely."

His report quoted Sister Agreda:

> I have made some 500 visits to the Indians of New Spain, and spoken to them in their own tongue. I do not know their language. I simply spoke, and God let us understand one another. I sent the Indians to fetch Fray Juan de Salas and Fray Diego Lopez to the Jumano Nation so they could be baptized. The nature of the Indians is gentle. It grieves me to see them continue in darkness and blindness and deprived of the immaculate, tender and delightful law.

Sister Maria, the Lady in Blue, through mystical powers, accomplished in a decade what missionaries had been unable to

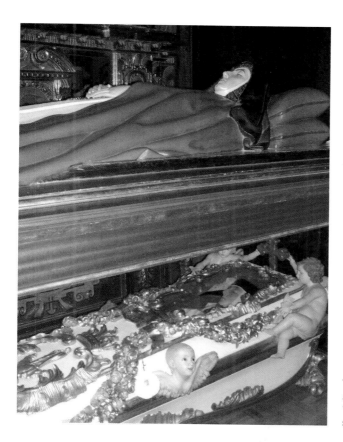

The Lady in Blue, a Spanish nun who "visited" out west, spiritually. *Public domain.*

do in one hundred years. Between 1620 and 1631, the years of her "bilocation" visits and teachings, thousands of Tejas Indians converted to Christianity and Catholicism. During this time of mass conversions out in the desert Trans Pecos region, word drifted to other Indians, the Caddos.

Some five hundred miles east, in the verdant piney woods, the Caddos also reported visits from a "Lady in Blue." The Tejas, or Hasinai, in the upper regions of the Trinity and Angelina River valleys saw her and heard her speak about Mother Mary and Jesus and were fascinated by her teachings of tears for the sick and dying, a Caddoan tradition. Tribeswomen cried when someone was about to die, a practice that struck fear in the heart of a hunter or warrior if in their presence.

To the Hasinai branch of the Caddos, Sister Maria's "gentle Indians," the Jumanos, toted news about Christianity and gossip about the

Spaniards and their priests. They gathered at the annual summer trade fair on the western edge of Caddo territory. Jumanos being middlemen, they swapped turquoise and cotton rugs from the Pueblo cliff dwellers to the Caddos for *bois d'arc* bow wood and salt, and Spanish horses became prized acquisitions of the Hasinai. They told stories about the "Lady in Blue."

Sister Maria's unique gift of bilocation seemed to be an outgrowth of an unusually spiritually tuned child. In 1610, at age eight, she took the vow of chastity and urged her family to give their home for a convent, which they did. At twenty-nine, she was made mother superior of the Poor Clare convent when Father Benevides called.

Through him and her letters, Sister Maria cautioned priests and governors about her beloved Jumanos: "All must exercise the greatest possible charity with these creatures of the Lord, made in his image and likeness with a rational soul to enable them to know him. God created these Indians as apt and competent beings to serve and worship him."

She sent Friar Benevides back to New Spain to organize a massive missionary effort to the Jumanos and Caddos, and then her bilocation visits ended. From then on, she no longer came to them in visions, though she continued to write of her convictions, experiences and cautions.

Had governors and military men of New Spain followed her counsel, later periodic rebellions of the Jumanos and the Caddos might not have occurred. But through her instructions to the Indians and to Father Benevides, the native population of Tejas, New Spain, became Catholic and remained so until the Revolutionary War of the Republic of Texas nearly two hundred years later.

Also inspired by Sister Maria Agreda, Father Damian Massanet wanted to spread Christianity to the Caddos. Because they already believed in one God, perhaps conversion would be easier. Father Massanet took twenty other missionaries to the Caddos in 1689. Two years later, Tejas governor Domingo Teran de los Rios took another twenty. Because his mother had been visited by Sister Maria years before, Governor Teran escorted missionaries to the Caddos as a believer in the Lady in Blue. In order to carry out his dying mother's wishes, he had to acquire the blue sackcloth of the Lady in Blue for her burial.

Across the centuries, scholars have studied and pondered Sister Maria's writings, which are housed alongside other official reports from missionaries in church archives. The great mystery of how she could

visit, understand, communicate with and convert a primitive people on the other side of the ocean confounded theologians and historians then and now.

Angelina

Far from the desert-farming Jumanos, a young Indian, Angelina, had grown up on stories about the Lady in Blue, passed down by the old people of her tribe, the Hasinai branch of the Caddo Confederacy. They lived along the Trinity River, where the long-leaf pines grow tall, the grapevines twist and turn and the bogs bloom in swamp grasses, flowers and cypress knees.

When the missionaries wound their way through the tangled forest and approached the Indians, Angelina was curious. The priest who met her wrote that she was "an Indian maiden with a bright intellect and possessing striking personal appearance...expressing a desire to learn the father's language."

Inspired by Sister Maria, and authorized by the Catholic Church, Father Massanet had arrived to establish Mission San Francisco de los Tejas, the first in East Texas. Angelina and her riverbank people welcomed the expedition with shouts of *tayshas*, meaning "friend" or "ally," and, as customary, they wept at the sight of strangers

Although puzzled by the tears, the Spaniards enjoyed the welcome and adopted the greeting, pronouncing it "tehas." Soon they applied this term to other friendly natives, and this signal became the province's name.

The friendliness represented by the *tayshas* greeting later became Tejas and then Texas—survived incursions of other peoples. Despite disagreements, this attitude toward strangers remained as persistent as the Caddos' ancient, towering, flat-topped, earthen temple mounds near present-day Palestine.

However, for the missionaries over the next few years, both language and cultural differences proved to be stalwart barriers to conversion of the Indians and adaptation of the Europeans ways. Angelina was gifted in picking up the Spanish language, but the priests struggled to learn the tongue-clicking dialect of her kin, the Hasinai. And in their zeal to convert, the friars showed no respect for the Indians' religion.

Governor Tejan's soldiers strained their woodland hosts' hospitality, allowing herds of cattle and horses to roam unchecked through Hasinai farmers' hand-seeded fields. Soldiers mistreated women, who enjoyed equal status as Caddoans. Compounding these problems, the troops acted like conquerors. Next, a smallpox epidemic (the first one) broke out, killing three thousand Tejas Indians. Angered by all this, Angelina's chief ordered the Spanish, carriers of the disease, to leave before he returned from the Red River villages of his countrymen. While these events challenged and interrupted the Caddoans' friendship with the Spanish, commerce, not religion, eventually bridged the chasm.

By 1715, trade increased between the Spanish, the Indians and the French, whom the Indians called "other Spaniards." The Royal Spanish spurned the French and chaffed at any movement of them into Texas. So, spurred on by a growing French presence in East Texas, the Spanish once again journeyed to the Caddos, this time to set up several missions and presidios, including Misión Nuestra Señora de la Purísima de la Concepción, which became the first capital of the Province of Tejas. Awaiting them, as they described, was a "sagacious woman, baptized and learned of the Spanish and Tejas languages," an interpreter, Angelina.

When the Spanish were forced out of her land because of their actions, Angelina's people welcomed the other Europeans drifting in from the coast and across the Sabine River. Her people favored the French, believing them to be friends and allies, or *tayshas*, since they came to trade, not conquer. When adventurer Robert La Salle came through, so hospitable were the Hasinai that several men deserted, remaining with the Indians on the banks of the river. With Frenchmen living in her village, Angelina picked up their language.

Once again, she interpreted for the priests. Described as having a strong personality and being gifted with language and sensitive to the needs of others, Angelina's legend follows as many twists and turns as the East Texas river that bears her name, a fitting tribute to the woman who interpreted for the French and Spanish, enabling the spread of trade and Catholicism. In every story about her, she is said to welcome strangers rather than fear them. Her river, the Angelina, would become known on maps of 1769 and later, further aiding communications and trade between the Indians, the Spanish and the French.

A common story is that a wounded and abandoned French officer stumbled into Angelina's village, where she took care of him. When he recovered, she sent her children to guide him through the Big Thicket

to join his countrymen at Natchitoches, Louisiana. There, the young Frenchman, St. Denis, and his Tejas-born, Spanish wife, Manuela Sánchez Ramón, would establish a large-scale trading fort.

By the end of the eighteenth century, Tejas had a name other than New Spain. A new religion had been offered and accepted by many natives, Catholicism. Between the Lady in Blue's visits that brought about large-scale conversions to Christianity and the welcoming nature and interpretive skills of Angelina, the land of Tejas was made ready—in language and religion—for emigration and settlement. Texas became, and for two hundred years remained, a Spanish-speaking, Catholic province until later emigrants from the United States challenged papal dictates and Mexican dictators in the War for Independence in 1836. First, though, the Royal Spanish in Mexico and New Mexico, and the Canary Islanders, brought their families to tame the unsettled province.

CHAPTER 2
SPANISH LAND GRANTS AWARDED TO OR INHERITED BY WOMEN, 1750–1821

Canary Islanders, Spanish and Mexican women ventured to Texas first, entering a society made more hospitable by a common language and a shared faith and bringing with them the embellishments of culture. Being from the wealthy and privileged class of Mexico, these women were educated and refined. They were not trained for taming a new country, but they recognized the needs and were willing to wrest civilization from the wilds. Women such as Manuela Ramón, Estefana Cortina Rosa Maria Hinojosa de Balli, Juana Pedrasa, Maria Gertrudis de la Garza Falcón and Salomé Balli saw Texas flourish under four flags—those of France, Spain, Mexico and Texas. Fanned out across the southern part of Tejas, they brought political ideals, culture and education to the northern province from the Rio Grande on the south, to the Sabine River on the east and the Chihuahuan Desert on the west. Embracing the church and accepting responsibilities for their families and a new country, they notched a deep foothold into the province's politics, wealth, real estate, fashion, folklore and family traditions.

Manuela Ramón

Among the earliest were dark-haired, dark-eyed, winsome young women like Manuela Ramón, wooed to the East Texas piney woods along the Texas-Louisiana border by French trader Louis Juchereau de St. Denis, whom Angelina had befriended. Born to the Spanish rancho, Manuela grew up on the South Texas border. Her grandfather was commandant of Fort John the Baptist on the Rio Grande, a major port of entry, and the family lived on a sprawling rancho. Sixteen-year-old Manuela fell for the Frenchman's handsome looks and charm while he was under house arrest at their place. Hers was a powerful family in Mexico, several generations deep, which no doubt eased St. Denis's efforts to trade with Mexico but could not undo the Spanish angst over possible French invasion. Word of French incursions spawned seesaw rulings, such as one governor urging St. Denis to trade and provision the Spanish Army while another banished him to the Louisiana side of the Sabine River.

During these political wind shifts, Manuela remained on the Ramón Ranch and gave birth to her first two children, while her father, grandfather and uncle joined St. Denis in smuggling contraband from Louisiana through Texas to Mexico. Their ranch, typical of Spanish custom and preference in that the family lived off to itself, stretched unchecked, separated from neighbors by tens of thousands of acres. Only the terrain of tanned sand, bunch grass and cactus lapped at the large, one-story, rambling hacienda that surrounded a courtyard. Each room faced inward, opening onto the courtyard, from which trees sprouted up, through and over the roof. Three-foot solid adobe exterior walls protected the Ramóns' extended family from hostile Indian raids, especially those of the roaming and warlike Lipan Apache.

But after the birth of Manuela's second child and during a temporary lull in the government's harassment of her husband, she joined him. From the open-space, open-air, near-desert environment, surrounded by generations of family, she moved to a French fort walled in by long, tall pines, far from loved ones. Her new home rose on the east bank of the Sabine River, in French territory, where her husband's language, not hers, was spoken. Nearby lived the Caddo Indians, Angelina's people, who had welcomed St. Denis's visits for years. He was *tayshas* to them. He had promised these Caddos that he would bring his young wife and live among them. However, a truce between governments,

declaring the west bank of the Sabine River for Spain and the east for France, prevented him and Manuela from settling in the Tejas province with the peaceful Caddos of the Big Thicket. Having known only more war-like Lipan Apaches, it's safe to say that Manuela was relieved not to live among this band.

She arrived with two children at the border town of Natchitoches, a stockaded fort, sometime after 1719—after Tejas had separated from Coahuila, Mexico, and achieved the status of an independent Spanish province. Here, Manuela reared two sons and five daughters, only two of whom were born in her native Tejas. In these woods, she cultivated among her children, and the area, her tastes, those common to a Spanish grandee's granddaughter—a yen for culture and education in Spain and Mexico, fine clothes and appointments—all helped along by St. Denis's trading prowess. Across this border from Tejas's first capital, Misión de la Purísima Concepción, established in 1715, and nearby the second and long-lasting one, Los Adaes, built in 1717, traffic piled up around Manuela's home, a fine one St. Denis built for her. In this post, she welcomed and entertained military leaders, traders and politicians from France, Mexico, Spain and the United States. Her graciousness created a hospitable port of entry into Tejas. In this cross-cultural setting, where Manuela insisted on education, fashion and refinement and where political contacts were nourished, it is no wonder that the Ramón–St. Denis children would become leaders in both Texas and Louisiana.

More than twenty years later, growing older and perhaps yearning for the land and family of Manuela's birth, and thinking that political problems had melted away, she and St. Denis sought to return to Tejas. He petitioned but once again was denied. Not long afterward, in 1744, he died. Manuela, widowed and with young children, apparently had grown comfortable in this timber region she had made home. By this time, in her late thirties, she traveled not only to New Orleans but also to the growing new city of San Antonio. She journeyed there to shop and to partake of the city's emerging reputation for culture and entertainment. Yet her roots must have sunk deep in the soil of Natchitoches and its active trail of commerce, social activity and family, for as a widow, Doña Manuela Sanchez Navarro Ramón de St. Denis could have returned to Tejas. Instead, this daughter of Texas elected to remain in Natchitoches, Louisiana, in the house St. Denis built, reveling in her young dynasty's flowering under both flags until her death in 1758. The town of Natchitoches offered safe harbor for early Texans, a port of entry to

"the foreign land of Texas" and throughout 2014 has celebrated its third century on the Eastern bank of the Sabine River, a neighbor in the Big Thicket land.

Doña Estefana Cortina

One who managed to swing with adversity and a changing political and business climate was Doña Estefana Cortina. A daughter of the Rio Grande, the river she knew in her childhood as Rio Bravo, Estefana grew up on her grandfather's original Spanish land grant, Potrero del Espiritu Santo, the Pasture of the Holy Ghost. She lived to adapt to the changes brought about first by the Mexican Revolution, which severed ties to Spain, and then the Texas Revolution, which embraced her land for Texas, not Mexico. Then, when Texas sought and received statehood in 1848, the U.S. Army arrived to enforce the boundary. All of Espiritu Santo lay within the United States' state of Texas. Still later, her region would be the only one prospering during the American Civil War, a time in which Confederate and Union forces alternated the military command. The last battle of the Civil War echoed near her El Carmen Ranch, her sons split politically and economically along Rio Bravo.

Jose Salvador de la Garza received this land grant of nearly 300,000 acres, fifty-nine and a half leagues, on the north bank of the river. Water and the need for more grazing rights on his vast spread prompted him to petition for more land near present-day Brownsville. He petitioned in 1772 but did not receive title until 1781, when he established Rancho Viejo, the Old Ranch. With sparse settlement and little buffer from Lipan Apache raids, he sought natural protection and built his ranch house in the inner part of a horseshoe-shaped *resaca*, former channels of the Rio Grande where floodwaters pooled. However, these waters had no streambed to flow back into the river, the Arroyo Colorado, a deep channel bounded by Espiritu Santo on the north. A *bracero*, an impenetrable thicket, guarded the west with the river on the south and lagoons on the east.

Soon after receiving the last grant, Jose Garza died, leaving his widow, Maria Gertrudis Blas, to guide the Rancho Viejo's interests—sheep,

cattle, mules, horses and nearly 300,000 acres. Under Spanish law, she was the heir. And under that law, land could not be sold. Her three children would establish ranches occupying various sectors within the boundaries of the vast Espiritu Santo Grant. One daughter, Maria Xaviera, claimed the upper or western third for her ranch. She married a Spanish municipal official, Jose de Goseascochea, who was killed in a rebellion against the Spanish government, the Delgado Massacre, in 1813, but not before their daughter, Estefana, had been born.

Maria Xaviera's ranch land sprawled up the riverbed from sea level. On the eastern edge, the lagoon-dotted landscape grew marsh grasses. Small trees, brush, weeds and tall grass blanketed areas not adjacent to the river. Sandy and salty soil and clay melded into red loam on the westward land on which Estefana, as a young woman, would establish her ranch. Earlier Spanish explorers had deemed the region "unfit for settlement because of the inadequate fresh water supply." Yet mission priests and Indians had begun irrigation, bringing farming into the economic picture on plots near the river.

Doña Estefana married Francisco Cavazos, and the couple had one son, Sabas, and a daughter, Refugio. When Cavazos died, Estefana married Trinidad Cortina, alcalde of Camargo, in 1824. Known as a hardworking and shrewd attorney in this city ruled by Mexico, he and Estefana had three more children: two sons and a daughter. The eldest son, Juan N. Cortina, grew up along both sides of the river. A brawler and a rebel, he was expelled from school so many times that he never learned to read and write. Their next son, Jose Maria, like Sabas, took advantage of the privileged education that only the sons and daughters of the aristocracy enjoyed. Jose Maria and Sabas would continue their mother's ways of flexing and growing with changing governments, weaving their roles into the changing political fabric.

Refugio died young, so Carmen Cavazos was Estefana's only daughter to live to adulthood, the one for whom Estefana named her ranch, El Carmen. Estefana's political grace, her aristocratic bearing and her "keen business acumen" would stand her in good stead when she returned to her "informal allotted portion" of the Espiritu Santo Grant, north of the Rio Grande. "Strong" and "fearless" were descriptions that attached themselves to Estefana's growing reputation in the valley. Her ranch house lay near the river about seven miles upstream from her grandparents' Rancho Viejo. Probably, the house was built with posts set vertically, about six inches apart. A matching row of posts outlining the walls would

be placed every two feet. The workmen, peasants on her land, laid sticks between posts and tied them on with strings made from the leaves of the Spanish dagger plant. This framework would be swathed with clay and dirt, mixed with horsehair or wool fibers and then whitewashed. Bundles of plentiful tall grass along the border country, tied with pita, a string made from the Spanish dagger, shingled the roof. Rooms could be added on to this basic structure as needed. As with Manuela Ramón's rancho, all of the rooms opened onto a patio.

As with many grantees of land between the Rio Grande and the Nueces River, Estefana shuttled her family back to Camargo for the duration of the war. When the war was over, Mexico claimed the Nueces River as the southern boundary of the Texians. Estefana and others on Espiritu Santo and other land grants moved back onto their lands. Their titles from the king of Spain and honored by Mexico stretched back over fifty years.

Texians, however, hankering for lots of land and granted headrights by the new republic's government, plus a growing conglomeration of merchants squatting on grantee land, disputed the old claims. Anglo laws changed forever the custom and law of Spain; now the heirs of grantees were free to sell their land, and some did. Vast stretches of fairly unpopulated territory were being sold outside the families. As a result, the valley's Anglo population grew and pressed for the Rio Grande to be the border, which was what the republic had claimed since its victory. A dozen years later, Texas itched to join the United States and needed protection along this border region. Citizens and outlaws called the span between the Nueces and the Rio Grande "no man's land."

Into this political conflict rode General Zachary Taylor, leader of the U.S. forces now that Texas approached statehood. He stopped at Corpus Christi and agreed with principals there that the southern border of Texas should be the Nueces River. However, a letter from President David G. Burnet ordered General Taylor to the Rio Grande to defend that river as the border.

The fledgling Texas government honored Estefana's title. While others who had settled on their portion of Espiritu Santo sold, neither Estefana, a widow again, nor her sons did. Her sons, including Juan Cortina, established ranches on her portion of the original grant. They ran livestock on lands away from the river, which were ideal for grazing with thick brush in places and open grassland in others. Acreage along the river was irrigated for farming. Her people grew corn, cotton, beans

and sugar cane, which they would cut in the winter months. They would extract the juice in a still, boil it in iron kettles until sugary and then pour it into clay, cone-shaped molds. When the clay was broken away, a cone-shaped sugar, *piloncillo*, remained. The agrarian community that grew up on Espiritu Santo and on El Carmen produced its food. Doña Estefana traded her horses and mules, cowhides and cotton for firearms, hardware and luxury items in Brownsville, a growing mercantile settlement and steamship port.

After the border war of 1848, Estefana and those in her family still on the Espiritu Santo grant became American citizens. The United States granted citizenship unless individuals repudiated it within a year, according to the Treaty of Guadalupe. No one in her family did so. A result of embracing her new country, there should not have been a dispute over the title to her land.

But there was. Courts ruled. Deals on disputed land were made. Estefana sued squatters. She hired lawyers, who sought payment in land. In the end, Doña Estefana, a Latino respected by both Anglo and Mexican powers, won the legal battle, proving the legitimacy of her title from the Espiritu Santo grant. She did, however, agree to sell the land on which the city of Brownsville rests for one dollar rather than experience more siphoning off of acreage for legal fees. Her daughter Carmen witnessed the transaction. Texas Rangers described Estefana as petite, "not a hundred pounds," and said she drew herself erect, her black eyes popping, and signed the papers creating Brownsville on the U.S. side of the river across from the Mexican town of Matamoros.

Other members of the family sold land for one-sixth the value. The military post later to be named Fort Brown and the city of Brownsville grew up on a portion of her Spanish grant. Steamboats tied up along the banks, disgorging goods from the United States now that a federal presence and stability reigned. Shopkeepers proliferated. An established currency and a growth of population, upward of eight thousand, eliminated the need for trading with New Orleans.

Doña Estefana's sons Sabas Cavazos and Jose Maria Cortina, with their education, wealth and aristocratic bearing, fit into the growing society, in both financial and political circles. However, son Juan N. Cortina did not. He resented the cheap land sales. A renegade, he roamed across the country, dancing at fandangos, brawling and gathering cattle for his ranch, on his mother's portion of Espiritu Santo. He crossed and re-crossed the border. While his brother and half brother gained acceptance

in the business community of Brownsville, he did not. While he had the manners of a gentleman, he preferred to ride with the rowdy and lowly vaqueros. A leader, his followers came from the peasants, the ones now bearing the brunt of prejudice from Texans. Racial slurs flew their way. And one day in 1859, when Juan rode to the defense of one of his mother's hands, the sheriff, whom Juan called "squinty-eyed," flung "greaser" slurs at Juan.

That spark lit the ten-year Cortina War, which found Juan raiding, igniting his long-smoldering rage against Anglo businessmen over his country's loss of territory. He and his band, the Cortinistas, threatened to lay waste to Brownsville. He killed. A skilled horseman of average size, he had brown hair, a reddish beard and gray-green eyes, giving vent to the name Red Robber of the Rio Grande. The Texas Rangers were dispatched. When Sam Maverick, another old Texas pioneer, heard about the shootouts, he wrote to his wife about the Texas Militia's and Rangers' handling of the situation: "The Cortina humbug is disgraceful to the intelligence of the age: how ridiculous it became. From what I hear it would have been a good thing if he had killed twice as many as he did."

Neighbors in the region did not hold Estefana responsible for Juan. One said, "She was a lady of culture, and indicated as much in her actions, and had all the politeness of a well-bred Mexican."

Juan and his Cortinistas' actions, however, brought in the Texas Rangers, determined to put a stop to the raging battles. Another son took Captain Rip Ford of the Rangers to see Estefana. Captain Ford described her as "a small woman, not weighing more than 100 pounds, being at the time over 70 years of age…very good looking…a pretty face…bright, black eyes and very white skin." While being assured of protection, her tears fell, fearing for her son's life. The U.S. Army chased him back across the Rio Grande yet respected his and his mother's ranch property. A rift between mother and son grew when Juan abandoned his wife and children and ranged into Mexico with a series of mistresses. Estefana no longer viewed him as her son and did not welcome him into her home when he passed through Rancho del Carmen.

Three years into the American Civil War, Juan's men approached Estefana and arranged a meeting. She met him across the Rio Grande from her ranch, where he handed her his riding crop and knelt before her. She whipped him across the shoulders, and then he rose and embraced her, ending the silence.

When Doña Estefana Cortina died in 1867, she was at peace with her son. She is buried near the brick chapel on her Rancho del Carmen. The daughter Juan had abandoned inherited Estefana's ranch, land that remains in the family today.

MEXICAN LAND GRANTS OWNED BY WOMEN, 1821–36

Patricia de la Garza de León

On the republican side of the political fence in San Antonio, a family of Tejanos emigrated from Mexico in 1799 and later moved to nearby San Antonio. These were the wealthy de Leóns.

Patricia de la Garza was born in Sota la Marian, Mexico, about 1777 to an aristocratic family headed by her father, the Spanish commandant. In 1796, she married Martín de León. A natural rebel with a yen for adventure, he told her of the Tejas country to the north. He drew verbal pictures of the land, where grass sprouted four to six feet high, where buffalo and antelope roamed and where handsome wild mustangs, descendants of the Spanish conquistadors' Andalusia horses, galloped across the great expanse of plains, stallions collecting their herds. Thousands of cattle roamed free, descendants of early, now abandoned missions. Doña Patricia, said to have enjoyed the outdoors, riding handsome horses across her father's range, caught his enthusiasm. Together they dreamed of founding a colony, of being empresarios.

After ranching in their native country, near Cruillas, Mexico, until 1799, the new parents loaded up carts and took their year-old son across the Rio Grande into Tejas, settling near the Aransas River to raise mules,

mustangs and cattle. Their first house was a *jacal*, an adobe shelter with a dirt floor. Getting started in this wild country meant rounding up cattle and mustangs, hunting for food and making clothing. The silks and embroidery of Mexico signaled the past. These pioneering de Leóns wore buckskins. Yet they began to profit from their livestock, selling in New Orleans and trucking back wagonloads of supplies by mule train.

With their ranch thriving, Patricia and Martín basked in the plenty of their new homeland yet remained vigilant to threats. They were among three thousand settlers set down in the midst of 250,000 Indians who didn't want them, protected or guarded by one thousand troops scattered over hundreds of miles. The de Leóns wanted to preside over a colony, to re-create the civilization in Tejas that they left behind in Mexico. Yet despite their family's powerful connections, they could not obtain a colonization grant from the Spanish government—not in 1807 or 1809. Perhaps their rebel nature and itch for new experiences or success troubled officials.

When the republican movement began in Mexico, Spanish troops were withdrawn from the province, opening frontier borders to Indian attack. Around 1810, after numerous incidents in which Doña de León stood in the doorway ready to fire a cannon, the family moved closer to San Antonio. Their children now numbered seven, the youngest not yet two years old. Again, they established a ranch on the outskirts, raising over five thousand head of cattle, mustangs laced with Spanish Andalusia bloodlines and droves of mules. Their stock carried the family's "EJ" brand, standing for *Espiritus Jesus* ("Spirit of Jesus"), one they ran in Spain.

Out of buckskins in San Antonio, dressing in the finest silks now that they were close to a city of trade, the de Leóns became the wealthiest ranching family in the territory. However, Patricia de la Garza de León and her husband, Don Martín de León—grandson of the 1689 expedition commander who first recorded the advantages of a fort at San Antonio—still could not get a colonization grant from the Spanish government. Moses Austin, an Anglo, could, but not the de Leóns.

Frustrated after repeated rejections, it should be no surprise that they became Mexican republican supporters, if they were not already. In turn, after Mexico defeated the Spanish, the de Leóns petitioned again. This time, with a friend well placed in the new government, they received an empresario grant to settle forty-one families at a place of their choice. Each family would get a league and a labor of land—like Austin's Colony—and, when established, the empresario, Don de León, would receive five leagues.

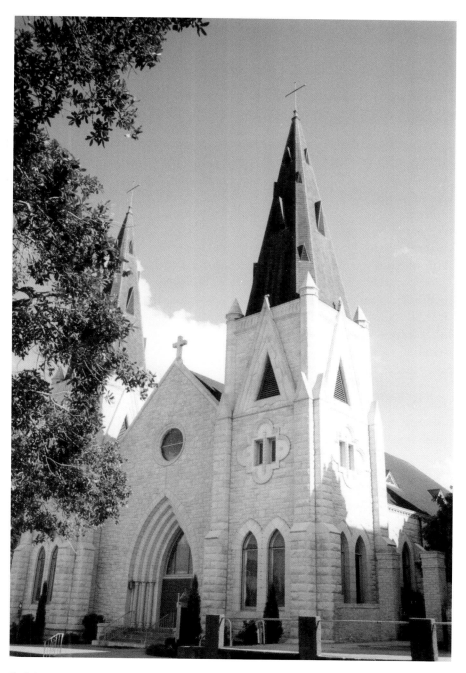

St. Mary's Cathedral in Victoria, Texas, founded by early colonist Patricia de León.

The land was rich and available. They could select from choicest locations, but Don de León was short on cash. However, Patricia de León's father had recently died, leaving her $9,800 and some $300 worth of cows and horses. She plowed this inheritance into the expenses of organizing and moving forty-one families to Tejas in a year of severe drought (1824–25) and establishing the colony that became Victoria Guadalupe, which Doña de León named, the only Mexican colony in Tejas. Later, Anglos shortened the name to Victoria.

To this outpost, bounded by the Coleto River on the west, Mission Valley on the north, the Lavaca River on the east and Matagorda Bay on the south, the de Leóns moved large herds of branded mustangs, mules and cattle. Traveling in magnificent coaches pulled by fine teams of horses harnessed with gold appointments, Doña Patricia and her children arrived to plant her exquisite European furniture on the dirt floor of another *jacal* on the town site lot. In addition to rural land, each colonist received a town lot on which to build. Placing the buildings close together in clusters would give them protection from Indian attacks.

While her husband surveyed and plotted the town site, Doña Patricia, now forty-seven, ran the sprawling ranch. Well schooled and a meticulous manager of accounts, she had long overseen the books. An early pioneer and excellent horsewoman, she rode roundup and was familiar with stock-raising chores—birthing, branding, treating and culling—all operations she directed. Some of her eleven children—the eldest near adulthood and the youngest two years old—helped. The eldest, the only one not Tejas-born, soon acquired his own league and labor of land.

Later, the de Leóns built a hand-hewn log house near the Guadalupe River, nine miles from Victoria on their new ranch. It had one big room with a large chimney, a ten-foot-long hall and a small room across the back. Two other rooms came later. Servants attended the family, and food was plentiful—fish from the rivers and bays, tender nettles and poke weeds for greens during the warm months, molasses and candy made from homegrown sugar cane, tortillas from ground meal, frijoles and their favorite: chili con carne. They sipped black coffee. When they butchered beef, venison or buffalo, they cut the meat into strings, let it dry and packed it in sacks, especially for long trips. It would be broiled on the coals and then cooked into hash.

Town building for Doña Patricia meant a church and a school. She established the first church, Nuestra Señora de Guadalupe, later renamed St. Mary's Catholic Church, Texas's second-oldest Catholic parish. For

a while, no priests were available, but the church was built, furnished and appointed with gold and silver altar vessels by Doña Patricia. This church shared a priest with another village until one came to reside in Victoria. The de Leóns eldest daughter was the first Tejana (a Mexican living in Texas) married in the church. Doña Patricia's older children were homeschooled during their first years in Texas, but as civilization blossomed around them and other families settled nearby, she brought in a teacher to instruct in the fundamentals.

Doña Patricia also would provide the extras, which, for her, meant the finest in clothes and furniture, music, art and dancing. When the mule trains returned from New Orleans laden with goods, bolts of the finest silk were carried for the mistress of the colony. Doña Patricia and her daughters were excellent seamstresses, making dresses that fell full-skirted over many ruffled petticoats, each ruffle embroidered by hand.

In the de León Colony of thirty-three Mexicans and eight Anglos, Doña Patricia imbued the settlement with a sense of community devoid of cultural rivalries. They hosted dances, dinners and receptions in their home, the grandest in the region. Colonists also brought instruments into Tejas such as the fiddle, accordion and guitar to play Mexican polkas and two-steps.

Doña Patricia and her husband's success passed on to the children and grandchildren. She sent this next generation to Europe and Mexico for education. Well endowed and prominent in Mexican Texas, these youngest de Leóns—and their parents, when they visited—were entertained by royalty in numerous European countries. They collected autographs of heads of state, which became family heirlooms.

For nine years, the family brimmed with success and created a prosperous colony, sustaining its easy mingling of Anglo and Mexican. The de León Colony was valued at $1 million; half was the de Leóns'. Their older children were established. Patricia and Martín had accomplished their dream. With hard work, they had overcome adversities of politics, Indian hostilities and nature. These were heady times—until a cholera epidemic swept through the colony in 1833 and claimed Martín, an early victim.

Doña Patricia grieved but rose to the challenge of managing the ranch and colony, continuing to support the community. For her at this time, it meant supporting the notion of a free and independent Texas. Winds of war blew, consultations (an early version of a town hall meeting) met and her sons and grandsons captained Texas Army units. Doña Patricia bought arms and ammunition from New Orleans

and smuggled the caches across her ranch to the Texas Army. This war, and her embrace of it, severed her ties to Mexico, despite the fact that a granddaughter's husband served as an officer in the Mexican Army.

On the heels of the Texas victory at San Jacinto, change was as sweeping and devastating as the cholera epidemic three years before that struck Victoria, Doña Patricia and her family. Anglo Texas soldiers straggled into town. They had fought Santa Anna and won but still fumed over his atrocities at the Alamo and Goliad. Despite Tejanos who had fought alongside them, they hated all with Mexican names. The town became Victoria, not Victoria Guadalupe. The church became St. Mary's Catholic Church, not Nuestra Señora de Guadalupe.

More significantly, Tejanos like the de Leóns faced new hostilities, this time from these fellow Texans. Cattle were stolen or shot, horses raided, homes looted and, finally, one of her sons killed. Dona Patricia, the sixty-year-old matriarch, decided that in order to save her large family, they must flee. Because of her Texas sympathies, she could not go home to Mexico. Instead, aided by her granddaughter's Mexican Army husband, they escaped on a ship to New Orleans, abandoning all but necessities one year after the Texans' San Jacinto victory.

Their riches sloughed off in the escape, the family had to eke out a living. Doña Patricia's sons labored on the docks and in the fields, while she and her daughters and daughters-in-law sewed. They lived in poverty. When they could not earn enough there, and tempers had cooled in Mexico, they sailed again, this time for Doña Patricia's native town, Sota La Marina, to live with family. Then, in 1844, after one of her daughters died, leaving orphaned grandchildren, Doña Patricia yearned for home. After six years in exile, she crossed the Rio Grande heading north one last time.

She returned to a wasteland of her former riches. Livestock were scattered. Newcomers had scavenged her furnishings and jewels. For the next five years, Doña Patricia reared her orphaned grandchildren and petitioned the Republic (and later state) of Texas government for reparations, debts of the fledgling republic long unpaid. Her meticulous control of the family's finances documented debts owed her by neighbors, too. She reaped little, if any, success in collecting these but despite these losses found solace in worshipping in her beloved church, the one she founded in 1824.

Shortly before her death in 1849, Doña Patricia wrote her will, documenting debts still owed her and bequeathing them, if collected, to

her children and grandchildren in like amounts, minus what each had borrowed from her over the years. She donated her home to the parish, the present St. Mary's Catholic Church.

Juana Pedrasa

Other Spanish and Mexican women, perhaps not so gentile as Estefana and Patricia, also rode into Tejas. Their goals were riches and opportunity, not community and prestige. One of these women, Juana Pedrasa, crossed the Rio Grande farther west, near present-day Presidio. A twenty-one-year-old widow, she purchased a vast spread in 1833. She probably chose her tanned, unbroken land for one of several reasons: (1) she had family in Paseo del Norte (now El Paso), (2) silver deposits were present or (3) the Chihuahua Trail wound through her ranch, and she cast eyes on it to increase her fortune. A shortcut between San Antonio and Chihuahua, Mexico, the route burgeoned with commerce. Along it rumbled mule trains of supplies from San Antonio and silver from Mexico's mines. Out here, Juana celebrated arrivals with fiestas and barbecues, whether it was traders with imported finery or young men from the States with armies of Mexican mule team drivers.

If Juana was not an opportunist, at least she attracted and married one, Ben Leaton. As a Comanchero, Leaton traded guns, liquor and ammunition to Apaches for mules they stole in Mexico. Later Indian raids on settlers and soldiers surging west swelled the supply of goods for trade. At this juncture of the trail, Juana fixed up crumbling ruins of an old mission to become her lavish, sprawling castle. This high-walled, armed fortress was the first private fort in the region. She named it Fort Leaton for her husband. From here, he could rule the only settlement between El Paso and Eagle Pass.

After moving into the forty-room adobe fort, Doña Juana could rock on the porch that faced the Rio Grande and gaze across the border river to El Cerrito de la Santa Cruz. This mission's rustic stone chapel held three crosses said to possess a spell that "kept the devil in his cave." From her rocking chair, she could survey her domain, forecast the arrival of visitors and welcome travelers and traders with sizzling barbecued

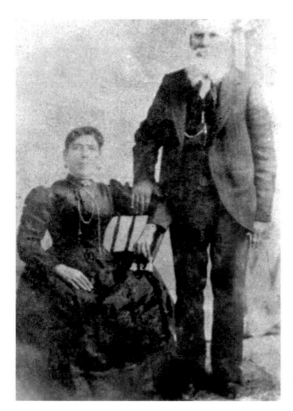

Juana Pedrasa and her husband, Ben Leaton. *Courtesy of Marfa Public Library, Marfa, Texas.*

goat and bubbling pots of beans, creating a festival air whether it was Indians, Anglos or Mexicans. Juana Pedrasa and Ben Leaton prospered in those years. Growing up on the premises were three little Leatons, two sons and a daughter.

Although Juana could not foresee it, her stance in support of Texas's independence from Mexico was one that would come to haunt her. The new Texans' government laws, modeled after those of the United States and England, created a sea change in women's rights and land laws not discovered until after Leaton was shot on a trip to San Antonio. In a state under Anglo law, and because she had married Leaton, Juana's ranch and fort were no longer hers; it belonged to him and his heirs, their sons. Although she could no longer own the ranch or Fort Leaton, she could manage it for their sons and did so until she married another Comanchero. They continued to operate the fort and provide hospitality for the caravans crossing the ranch.

Trade declined. At first, army trains came west, bringing brisk business but placing a damper on bartering with the Comancheros for stolen goods. Bank notes were made. When they could not be met, people stood by, eager to snag Juana's choice real estate, which was known to harbor silver deposits. In this time and place, bullets, not paper, collected debts, and guns made foreclosures. Juana was widowed again, this time dispossessed. She moved into Mexico, where her children matured. Her sons and grandsons reached manhood with a long-standing hatred of those who had moved them out, and they nurtured a vendetta to reclaim the Pedrasa Purchase. For nearly a century along the border, feuds broke out between Leaton young men and the families they loathed. The land title was never cleared, nor was it ever returned to Juana's sons. But a family who later owned and lived in the hacienda at historic Fort Leaton reported seeing an empty rocking chair creaking back and forth, unoccupied. Family members claimed that Doña Juana comes back in death to claim her adobe castle on the Rio Grande.

Inhabiting a land waiting for them with their language and religion, these women—Patricia de la Garza de León and Juana Pedrasa—continued the tradition of welcoming newcomers and making the wild country ready for later women and their families. Establishing churches, schools, villages and towns; extending hospitality to all manner of strangers; exercising nuances of politics and business; and embracing the arts and festivities, these women marked their place in Texas lore.

However, history's lamp dimmed on their contributions after they turned away from their native Mexico toward an independent Republic of Texas. For generations, the Spanish Texas woman was not hailed, her stories silenced in the vituperative backlash of Anglos after the war with Mexico. Anglo women, however, beginning to populate Texas, would build a republic and a state in the deep footholds notched by these women they did not know.

Margaret "Peggy" McCormick

First among them was Margaret "Peggy" McCormick, who arrived in Stephen F. Austin's colony, one of the early band now referred to by

Texans as the "Old Three Hundred." But reputation and honor did not draw her. In 1822, she joined her husband, Arthur, in the dream of an opportunity to own land, free of another man's bond. They crossed the azure waters of the Gulf of Mexico. On an early spring day, aboard a deep-draft schooner in the trade with Tejas, they hung off Galveston, awaiting high tide or southerly winds to wash them across the bar, passing to port of the ruins of pirate Jean LaFitte's Campeche.

Their life savings tied up in their passage from New Orleans and the payment to Austin for their grant, the McCormicks survived the flimsy sailing vessel that grounded on the reefs and bars as it lumbered toward their destination, the banks of the San Jacinto River. After official colony surveys, they filed for their league of land, 4,428 acres, at Austin's San Felipe office on the Brazos River. A couple years later, on August 10, 1824, the McCormick League was granted. The "labor" (pronounced lah-bour) of land, 177 acres for farming, would come later. They intended their grant—where the serpentine-like, deep-water Buffalo Bayou converged with the languid San Jacinto River before the river streamed into Galveston Bay—to be for ranching. They arrived with milk cows, seeds and crude tools. With these, Arthur built a two-room dogtrot cabin from the timbers on their land. Peggy brought a bolt of calico, a barrel of flour and a twenty-five-pound bag of green coffee beans for making what would become a rare treat in the province: roasted and brewed coffee.

Along the waterways bordering them, stands of magnolias, wild peach trees, laurels, cedars and pines crowded together. On a knoll above where grass and flowers flowed into the river, with the perfume of coral honeysuckle and yellow jasmine enveloping them, Peggy and Arthur admired their newfound wealth of coastal prairie and marshes. Below, like a jewel in an elaborate mounting, lay a pretty little lake, ringed with hyacinths (lily-like flowers with pink, blue and white blossoms) blown in from Africa or South America on the winds of a hurricane. Arthur named the pond Peggy's Lake, a touch of romance for a woman in her second foreign country with an infant on her hip and an older son as eager to explore as his pa.

Soon after settling, Arthur requested a redrawn survey of their missing acreage, the labor for farming. Johnson Hunter, doctor and surveyor, the first colonist on what is now called Morgan's Point, a peninsula across the river, redrew the lines. McCormick wrote that he promised "to pay…forty Eight Dollars in Cattle…for surveying of my Land, December 1, 1824."

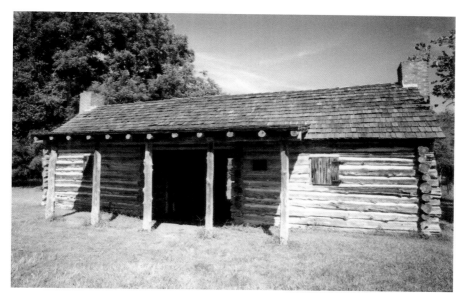

A two-room dogtrot cabin on the Coastal Plains.

Adopting the Spanish rancho practice, the McCormicks let their unbranded cows graze at will and breed with mission cattle turned loose by priests who had abandoned missions long ago, whipped by the frontier and western Indians. The McCormicks fenced a vegetable plot and grew corn on points of land at elevations above the frequent saltwater flooding. Indian tribes of this upland coastal area, mostly from the Caddoan Confederacy, were hunters, traders and farmers, not warring nomads. The Coushattas, Bidais, Caddos and Alabamas roamed and hunted the San Jacinto River valley, unlike the warring, cannibalistic Karankawas, who struck fear in settlers from Galveston to Corpus Christi. Pottery and tool remnants and mounds of harvested shells from this early life have been found here. In Peggy's day, Indian traders ventured into the new colony to swap the skins and meat of bear and deer for cloth, guns and cakes.

Since Peggy and her family were Irish Catholics, they had no quarrel with Mexico's requirement to practice Catholicism. But no priests were about to minister the sacraments. For a woman without contact with either other women or the church, a woman who could neither read nor write to family and friends in Ireland or more recent acquaintances

in the Eastern United States, loneliness must have been a formidable enemy. But it was one that gradually would soften as families such as the Lynchs, Vinces and Allens claimed grants and settled nearby. The Lynchs operated a ferry across the San Jacinto, while the Vinces built a bridge over Buffalo Bayou. A small, rustic general store opened, and the area grew up as San Jacinto, St. Hyacinth, named for those flowers around Peggy's Lake.

The McCormicks' milk cows bred with the wild Mexican longhorns. They built a herd to barter with local merchants and to trade with Indians for bear and venison. They drove cattle along the Atascosito Trail, known as the Opelousas Trail when it crossed to the east side of the Trinity River headed for Opelousas, Louisiana, north of New Orleans.

Nearby Harrisburg prospered, becoming a turning basin and wharf for supply-laden schooners, a welcome sight when tall masts rounded the turn from the San Jacinto River into Buffalo Bayou, a site that would beckon Arthur McCormick to sail his one-masted skiff across the bayou to pick up goods and enjoy a brew at a tavern. On one trip in November 1826, he returned on a freshening wind. A Texas norther brawled across the prairie and churned the bayou at its convergence with the San Jacinto into a raging chop. Arthur's boat capsized, and he drowned.

Within weeks of his death, Peggy launched a challenge to Johnson Hunter's bill for her medical and surveying fees. He sued her in December 1826, and she insisted he prove his "demand." Empresario Stephen F. Austin's agent in the San Jacinto District wrote him about the suit, adding that Peggy claimed she "never has received her Deed" for the labor.

After bemoaning that he "wish[ed] these colonists could get along," Austin instructed John Harris, founder of Harrisburg, to "admit the application of said widow for an appeal."

On January 13, 1827, miffed over being bypassed, the San Jacinto official wrote Austin the following: "Inclosed [sic] you have the Original bill of Dr. Hunter as it is very long and the widow waiting for those papers…the Widow is very anxious to have the proceedings to lay before you."

From Harrisburg, Harris penned a letter to Austin on April 15, 1827:

> At the request of the widow McCormick I have taken the liberty to address you on the subject of the difficulties with Johnson Hunter…I appointed six disintristed [sic] men to settle all difficulties between them…the Arbitrators awarded to John Hunter thirty Nine Dollars

with costs, of suit…Her object in visiting your place is to get an order
from you to the alcalde of San Jacinto to send the papers up to you and
have it try'd [sic] *before your honorable court at the next Term.*

In time, Peggy paid, but she would continue to bristle, challenge and ignore demands for payments to creditors and tax collectors.

Amid the petitioning for fairness, as she saw it, Peggy had to get on with stock raising. With the help of her growing sons, she ran the McCormick League, a prairie that sprawled between Harrisburg and Lynchburg. Nearby, in Mustang Slough, a handsome band of wild mustangs ran free. Having learned of the value of working cattle from horseback from her Mexican neighbors, Peggy and her older son, Mike, rounded up these steeds and then broke them to ride and, later, herd cattle.

Peggy trailed beeves overland to Louisiana, trading for goods and gold, which made the return trip dangerous. Robbers, like the Yokum Gang, hid in the breaks around the Sabine River and in the Neutral Ground between Louisiana and Spanish Texas. The north–south Alabama Trail from Nacogdoches and the Opelousas Trail crossed in this area. Once home, with coins in her purse, Peggy would purchase or trade for medicine, hardware, saddlery, candles, cotton cards, crockery, flour, sugar and salt at the general store of her friend John Harris. The finer commodities—dictionaries, grammar books, lace and silk—were not for her.

To travel among these "burgs," as the colonists called them, they sailed small craft up and down the rivers, bays and bayous. When a schooner landed at Harrisburg, the colonists set sail for supplies as Arthur had done, though the vessels now resembled an armada of mildewed canvas. With her goods gathered up on one such trip with her sons, Peggy took time to visit. She chuckled at a new settler's tale. It seems a Mrs. Rosa Kleberg moved her furnishings into her cabin and screamed. In the middle of her one-room, dirt-floor cabin, a half-naked Indian clasped a loaf of her homemade bread and stared. The new pilgrim froze. The Indian held two venison hams. He placed them on the table, held onto the bread and said, "Swap." It was a good trade for the newcomers.

Other contentions were arising by now, though. Peggy and other colonists chafed at new taxing laws by Mexico, having grown accustomed to years of improving the land in lieu of taxes. Skirmishes accompanied the grumbles. But when others spoke of resistance, Peggy aligned herself with Stephen F. Austin, her empresario. Even when

Anahuac, across the bay, revolted in 1831, she stood solid as a Mexican citizen with Austin. But when he voted for independence on March 2, 1836 (they learned of the declaration by news and gossip posted at the San Jacinto general store), the McCormicks fell in with the Texians. Peggy's older son, Mike, joined the Republic of Texas Army as a mounted courier posting messages between General Sam Houston and President David G. Burnet.

With no mail service, couriers carried information about Presidente Santa Anna's locations, his threats to "kill all Anglos," his victories at Goliad and the Alamo and the burning and pillaging of towns, homes and ranches in his path. Warned to evacuate, Peggy fled with her younger son, Johnny, joining the "Runaway Scrape." Locals called this act of crossing the eastern boundary of Texas into Louisiana for U.S. protection "taking the Sabine chute."

Waiting until the last minute to leave her livestock untended and roaming and her house barred, Peggy was caught in the tide of women, men and elderly bunched at Lynch's Ferry waiting to cross the flood-swollen San Jacinto River. Lynch, an opportunist, had boosted tolls. He knew that the alligator-infested river, coupled with floodwaters and the panic, would garner him riches. Some five thousand people gathered for the three-day wait. One person said, "The prairie near Lynch's resembled a camp meeting; it was covered with carts, wagons, horses, mules, tents, men, women and children, and all the baggage of a flying multitude." President Burnet established a refugee camp, but it was inadequate. He ordered food for the refugees. Beeves were slaughtered, some of them Peggy's.

About the time she reached the eastern shore of Louisiana, ahead of the Mexican army, Peggy's son galloped into New Washington, downstream, to warn President Burnet that Santa Anna had burned Harrisburg and was on the march. Mexican federal troops arrived on Mike's heels. They looted and burned the new town. Burnet sailed off with the de Zavala family for Galveston, and seventeen-year-old Mike spurred his mount into the copse of trees lining the river. He eluded enemy soldiers in the tangled growth of vines, shrubs and saplings. General Sam Houston had ferried his army of over seven hundred men across the swollen Brazos River in the west and retreated to the coast, where they would fight. Hearing of the Texian's army movement, the Mexican army burned New Washington. The troops fled through the thick woods between there and McCormick's prairie, where they bivouacked around Peggy's Lake, awaiting reinforcements.

On the afternoon of April 21, General Houston's troops slipped over a rise and charged into the unguarded Mexican camp where much of the Mexican Army, including Santa Anna, slept. The Texians fired and slashed their way through El Presidente's forces, screaming an officer's refrain, "Remember the Alamo; Remember Goliad."

Eighteen minutes later, the Texians had won. Santa Anna's slain soldiers lay sprawled in the pastures amid the hyacinths. Their bodies ringed Peggy's Lake, the water bloodied.

The thump of cannon and boom of rifle shot followed by victory cheers and huzzahs, rolling like thunder, carried to the eastern shore of the Sabine River. Peggy and others turned home. She drove her wagon up to her cabin—its door stood open as pigs, cattle and chickens rooted through her home. Dead soldiers were sprawled across the doorstep. Everywhere she looked, bodies, beginning to stink from the heat, lay scattered. No cattle. Later, she stormed into Houston's command tent and demanded, "When are you gonna move those stinkin' Mexicans?" Reclining on his camp bed, his ankle shattered by a bullet, Houston responded, "Why madam, you'll go down in history." "I want these bodies buried," she repeated.

After Santa Anna was caught, neither he nor Houston ordered a burial detail by their forces. Peggy, her sons and her slave gathered her cattle and penned them away from the dead. Houston and his officer cadre, overwhelmed by the stench, moved the army headquarters six miles north on the San Jacinto to George Patrick's land. This act forged a political liaison between the next president of the republic and the San Jacinto District's newest surveyor, a looming problem for Peggy.

Her immediate concern, though, as with all returning settlers, was to restore her land to grow crops for the winter and to round up her milk cows and half-wild beeves not run off by the fight or slaughtered for food by both armies. By autumn, she was forced to bury the skeletal remains in trenches to protect the cows' milk. On November 9, 1836, she billed the Republic sixty-five dollars for "damages," a claim audited and approved on April 10, 1838. In the meantime, cattle ranging the countryside following the floods and war were easy to gather and call her own. In the months that followed, the area boomed, with the new city of Houston being named the capital of the republic. After the war, Lynch built a saltworks, opened a store and, later that year, became postmaster for the area in the new nation.

Yet on the one-year anniversary of the battle, Peggy had to corral her stock again when the republic hosted a grand ball in Houston to celebrate independence and the victory at the Battle of San Jacinto. Revelers paraded through her pastures before and after the ball, drinking, reliving the glory and retelling and inventing legends. Only officers, their ladies and families and "certain guests" were invited to the ball, twenty-two miles north of her ranch. Peggy was not.

On lands unfenced, claimed only by survey lines and deeds, Peggy continued to raise stock. She shipped corn and beeves for the Texas Army aboard the steamboat *Cayuga*. An 1838 shipping bill of the republic reads, "Peggy McCormick made her 'x.'" Skirmishes continued across the new nation. Mexico and its citizens resisted the loss of the province and refuted the southern border, requiring the republic to outfit a standing army.

In this year, the new government ruled in Peggy's favor on her long held-up resurvey claim. Fourteen years after arriving, she received the "labor" of land due with the initial colonization grant. Yet tragedy paled her victory. The coastal marsh region's annual "malarial-type fever" epidemic claimed her younger son, Johnny.

Awash in land and veterans' claims and destitute of coin, the new republic resurveyed colonists' leagues to parcel out bounties of land to veterans in payment for service. Over the next ten years, while growing her cattle herd from scattered remnants to four hundred head, Peggy was on her way to becoming the largest rancher in Harris County and still trading in Louisiana. But the new county surveyor, Patrick, Houston's host after the battle, redrew her league's lines eastward, into the water. His swindle freed up higher and drier land for new veteran grants, a prime location along Buffalo Bayou claimed for himself. Apparently, Peggy did not know of these shenanigans, nor did her son, until years later. However, she continued to range her cattle, breed them, let them forage, round them up and sell in Louisiana.

The town of San Jacinto grew up along the river, across from Lynchburg, "laid out upon the edge of the old battlefield." Peggy sold three acres of her land to John Stamps for the New Hope sawmill in 1845. Alongside his sawmill, two shipyards nestled, their business to overhaul steamboats and build boats, fueling the town of San Jacinto's growth to three hundred. Also in 1845, the sheriff, a friend and benefactor of Patrick's resurvey, collected debts—auctioning land on which taxes were due the Republic. He sent a letter Peggy could not read and then sold 3,968 acres, all of her land but 50 acres surrounding her home.

However, her beautiful "Plains of St. Hyacinth" were open—no fences. Her cattle knew no property lines. Like many stockmen in years before fences, Peggy continued stock raising and gathering on land she and Arthur had claimed over twenty years earlier. And she continued to sell parcels to neighbors, not recognizing new ownership. This multiple deed letting created disputes and lawsuits for decades and might have led to her death.

Age and more prosperous circumstance must have gentled Peggy, because her neighbors in San Jacinto began calling her "Aunt Peggy" and grieved when the old colonist Margaret McCormick died in an 1854 house fire. Some say it was murder, arson and robbery, though that was never proved. Her surviving son, Mike, who had become a steamboat pilot between Houston and Galveston, did not know of the land swindles until her death. He sued the surveyor, Patrick, but lost in 1869. Peggy's land remained ranch country until 1883, when the state of Texas bought ten acres for what is now San Jacinto Museum and Park from owners who had purchased the land from the "northern syndicate," land rooked from Peggy via the resurvey.

The San Jacinto monument rises above Peggy's "Plains of St. Hyacinth," while her beautiful Peggy's Lake slipped into the water, a result of storm erosion and ship channel dredging. Today, the lake her husband named for her shows up on local maps as "Aunt Peggy's Bar."

RANCHING IN THE WILD HORSE PRAIRIE, 1850s–1900s

The thundering hooves of thousands of mustangs beguiled many a newcomer to Texas. These descendants of Spanish ponies raced and bred across wide swaths of grasslands, leading Texans in various sections of the state to call their ranging areas the "Wild Horse Prairie." But the land between the Gulf of Mexico that sprawled north and west through Cotulla to Batesville might have been the most prolific natural setting for this horse imported from the Iberian Peninsula in the sixteenth century.

Henrietta King, one of the earliest matriarchs in this land, fondly referred to her King Ranch that wraps around present-day Kingsville as being in the "Wild Horse Prairie." At the time of King's death, Mary Nan West entered the world, born about two hundred miles to the northwest, a tomboy groomed by her grandfather to take over the Rafter S Ranch out of Batesville.

Separated by decades and miles, both women, as rambunctious teens, would cringe at the boarding school life. Mrs. King wanted to teach, not while away dreaming of romance. Mrs. West yearned to ride, rope and cut. However, both came to accept the social, civic, business and political roles they occupied as powerful women wielding the reins of successful ranches in the Wild Horse Prairie.

Henrietta Chamberlain King (1832–1925)

The regal, straight-laced appearing woman who wore widow's black the last forty years of her life belied the perky, teenaged minister's daughter who kicked up her heels at a dance despite her father's teachings and who backed down a rowdy sternwheeler skipper over dock space. Henrietta King, born Henrietta Morse Chamberlain in Boonville, Missouri, on July 12, 1832, had ingested her father's strict diet of faith and acceptance. Both would stand her in good stead in her seventy-year reign in the Lower Rio Grande Valley.

Sent off to boarding school in Holly Springs, Mississippi, a fourteen-year-old without a mother, she wrote the Reverend Chamberlain. She was homesick. She wanted to come home. Her mother had died in childbirth. Her first stepmother died after several more children. Now Henrietta was hundreds of miles from family, but she wanted to return. Yet by return mail, Reverend Chamberlain instructed her in the art of stiff upper lip, a lesson that shadowed her in times of trials and stiffened her.

In a girls' school where lessons tilted toward social graces, poetry and the arts of feminine wiles, Henrietta bore down on the library like a ship in full sail. Teased by her classmates about being an old maid, she complained to her father. He wrote back, "You must rise above any unhappiness…we must wait until we get to heaven for that. (Perfect happiness.)"

Instead, Henrietta discovered the classics, such as Homer, and developed a lifetime love of poetry. World politics, history and philosophy drew her, not her schoolmates' forbidden romantic novels. Yet, as evidenced by her seventy-year reign as queen of the Lower Rio Grande Valley, she came to adapt the social graces of the time.

Henrietta wanted to teach; catching a husband was not her polar star. Her opportunity appeared when, on a summer visit home, the Presbyterian Church tempted her father with a mission stint in Texas. Known as a fervent Christian and static preacher, perhaps the frontier of the new state of Texas would fit his fervor as he built the first Protestant church at the Port of Brownsville. Reverend Chamberlain brought along his family, including Henrietta, who finally got to leave the boarding school, and her new stepmother to one of the busiest port towns on the Rio Grande.

In a town awash in bitterness from decades of fighting over who this land belonged to—Mexicans or Texans—the Chamberlains arrived

among hundreds of newcomers. The U.S. Army, while in a war with Mexico, extended the Texas border to the Rio Grande. Earlier, Mexicans defeated in the Texans' War for Independence believed the new country's border stopped at the Nueces or (Nut) River, 150 miles inland.

Heirs to Spanish land grants from the previous century claimed the land, the rights to which had been granted by the king of Spain and honored by succeeding governments of Mexico, Texas and the United States. However, opportunists and the well intentioned wheedled, schemed, bargained and litigated for clear title to portions of the old grants.

Some folks wondered why they should bother. The land was dusty, seemingly barren to some, but it was a grass kingdom to others. Salt-free water was scarce. But port traffic thrived, bringing in supplies and new arrivals, like the Chamberlains, from the United States and other countries and hauling out horses, silver and cattle.

Henrietta's family arrived in a town with no housing. They acquired the use of an old steamboat—the *Whiteville*, owned by Mifflin Kenedy—tied up at the main dock and moved aboard. Henrietta had grown into a teenager who would not be deterred; she was not intimidated by anything shy of harm or loss of a family member. Henrietta polished brass and scrubbed decks. She learned Spanish. She believed every girl (and boy) should be educated. Bucking border customs, she tried to recruit for coed classrooms. But parents insisted on separate education. Henrietta taught English to the Spanish-speaking girls and, in time, headed a classroom at the Rio Grande Female Institute in Brownsville.

As with many fathers and daughters, Henrietta's father could do no wrong in her eyes. While others yawned at Reverend Chamberlain's sermons, she yearned to be a man so she could preach just like him.

One day, a steamboat, the *Colonel Cross*, chugged up to the pier, and the captain barked, "Cast off that line and let loose that stinking rat trap," referring to the *Whiteville*. On deck, checking mooring lines after having polished her floating home's brass, Henrietta shouted, "And you sir are not a welcome visitor either. The *Whiteville* is a great sight, a very great sight, cleaner than the *Colonel Cross*." Laden with molasses barrels, the *Colonel Cross*'s deck swarmed with flies.

Slender and of medium height, Henrietta wore "a cotton work skirt with an apron." Her hair, parted in the middle and snubbed back into a tight bun at the nape of her long neck, accented her large brown eyes that throughout the years were known to "glow with excitement" or "soften in tenderness." This time, however, she glared at the rough captain's

A lighthouse in what would become the busy port of Brownsville.

vessel. "As for rats in the vicinity, I can guess where they are bred. Your shameless, profane tongue is unfit for the ears of decent folks."

Deckhands, ogling the tongue lashing of Captain Richard King, followed his orders to back down and pull down the dock to an empty tie-up. As King was known for his hot and flashing temper, the crew agreed that if a man had said that, King would have whipped him.

The *Whiteville* served as home and church for the Reverend Chamberlain—and the place where Captain King would meet again the feisty young lass who had roped his attention. Although church was not the venue King would have frequented (he was better known for drinking and fighting), he called on his partner in the steamboat business, Charles Kenedy, to introduce him to Henrietta. King could not shake the image of her that day on the pier. Kenedy obliged but told him it would have to be at church.

Although church never figured in King's interests, Henrietta did. On his trips to Brownsville, he attended hers. Orphaned himself at twelve, a stowaway on a sailing ship, the small-statured, dark-haired, big-voiced King had grown up on the decks of ships and along the rough-and-tumble wharves of port cities as a deckhand, bartender and, eventually, pilot. He was uneducated, profane and itinerant—matchmakers of the time would not have selected him for the pretty minister's daughter. Neither did the Reverend or Mrs. Chamberlain.

To her stepmother's dismay, Henrietta sent packing the quiet schoolteacher who had courted her and instead chose to dance with the volatile and exciting young skipper. When King's thoughts turned to settling down, cleaving to the land and not the sea, Henrietta anticipated his more frequent visits to Brownsville.

On a trip to a developer's fair and circus in Corpus Christi in 1852, King camped on Santa Gertrudis Creek. On the way back, he staked a claim and began the process of finding the owner, a Spanish grantee's widow, and clearing the title in the Wild Horse Desert, the grass kingdom. He hired a small army to protect the land and moved a village of vaqueros from Mexico to teach him ranching and to run the ranchero. He served as *el patron* in the Spanish and Mexican rancho tradition. The vaqueros came to be called *kiñenos*, or "king's men."

King was away from Brownsville even more now. But in 1854, he sought the Reverend Chamberlain's permission to marry Henrietta. She left her teaching role at the Rio Grande Female Institute, and on December 10, 1854, they married in Brownsville. She wore "a dress of peach-colored

ruffled silk, with a front of white silk mull...sleeves of white lace." The next day, "Etta," as he called her, and "Captain," as she called him, rode out of town in a private stagecoach surrounded by armed men for escort. They headed to the forted-up cow camp Rancho Santa Gertrudis for their honeymoon. It would be over twenty years before the Santa Gertrudis range in the Wild Horse Desert would be safe. Until then, war surplus steamboat cannons, mounted on the rise above the creek where a lookout could see for miles, stood sentry, more to warn and intimidate than to injure.

Alighting from the coach at the mesquite shrub corral, a three-room jackal (a mud-coated hut) built by a Mexican carpenter awaited Henrietta. She moved her trousseau, some family silver, a box of books and a Bible into her new home, where she would pick up the ancient tradition of Texas's earliest women: welcoming and feeding travelers passing through. Friends and strangers reported that there was "never anything to pay for hearty food and cheerful lodging at the stopping place on the Santa Gertrudis."

On this first day, though, shortly before Christmas, Henrietta surveyed the dirt-floored house, probably appreciating its windbreak from the cold. Rough, hand-hewn furniture lined thick walls that held in the hearth's warmth in winter and, come summer, offered coolness from the blistering sun. Copying the rancho tradition, her new home took advantage of prevailing breezes in summer. Besides, its thick walls could deflect arrows and bullets from raiding Indians and robbers, experiences she had yet to encounter.

On this day, though, twenty-two-year-old Henrietta itched to see the countryside, which had grown to fifty-three thousand acres acquired by her husband and a partner. She stepped out into the sunshine.

"I'll build you a mansion," King reportedly said.

"I don't need a mansion, Captain, just a larger pantry."

He held the reins of a pair of saddled horses. When she stood there eying them, he said, "Don't you ride?"

"I ride, but always sidesaddle. Don't worry, I'll manage."

And she did, despite her full calico skirt, muslin petticoat and enough ruffles "on her knee-length pantaloons to conceal all but an ankle." At day's end, Henrietta determined to fashion a more efficient riding skirt.

She sewed a divided corduroy skirt. King ordered her boots, but she preferred her more "ladylike buttoned shoes." Yet she learned that the western boot fit stirrups better and would wear longer in this brush country.

Henrietta had grown up with her father's instructions that she could "master her own destiny...that a girl didn't have to be a clinging vine." Her husband admired her for her strength and compassion when she had helped her Brownsville students in times of need. In years to come, she would help the families of the *kiñenos*. She called on them. She brought them medicine when they were ill. One time, dropping by a young mother's adobe house, she found the woman had just given birth and that the baby was struggling to breathe. Remembering a home remedy, Henrietta set a steam kettle on the fire, added a drop of turpentine and held the infant in her arms until its breathing came naturally. The young mother regarded Henrietta as a saint. Families summoned her in all emergencies. To them, she was "the healer." They dubbed her La Madame or La Patron.

Well before they married, King had spoken to Henrietta of his dreams, as an equal, vowing to raise cattle and somehow get them to market. When they rode the ranch together, stopping when she tired, he would spread a blanket, and they would plan for the ranch and its business, as partners.

They brought different values to the union. Henrietta brought the scriptures; King, the whiskey—but always out of her sight. She read the Bible on Sundays, and although he did not, he respected her practice. A lover of the arts and particularly poetry, Henrietta must have yearned for company with whom she could share these interests, but few travelers crossed the Wild Horse Desert in the mid-1850s. However, it is certain that she enjoyed the visits of military men and dignitaries, who both brought news and shared in her interests. One such man was the handsome young military officer Robert E. Lee. He visited Rancho Santa Gertrudis as a lieutenant and again as a colonel, serving in what had become a choice billet of the frontier defense, Fort Brown, because of international trade mushrooming along the border.

Because of valley trade proliferation, King spent many months back and forth between his steamboat business in Brownsville and his ranch. One day, he said, "I think we need two houses, Etta." He purchased a lot in Brownsville next door to his partner, Kenedy, in an affluent neighborhood known as the "Brick House Crowd"; engaged a builder; and left the planning to Henrietta.

Expecting their first child, she worked with the builder, attended her father's church and enjoyed his company. The couple's first daughter, Henrietta Marie (Nettie), arrived on April 17, 1856. Six months later,

Henrietta missed the ranch. This time, she and King traveled without a security guard.

From the brick house of Brownsville to her *jacal*, Henrietta watched over household tasks and ranch activities and tells this story. She noted that one day, with "little Nettie asleep in her cradle, I set out bread in the kitchen. I had a strange feeling." Henrietta turned to find an Indian with a club standing by the cradle. She handed him a loaf of fresh bread. "He pointed to the others, and I loaded him up. He left as silently as he came." King ordered a guard for the house after that.

When it came time for the birth of her next child, they returned to Brownsville. Ella Morse was born on April 13, 1858. When both were able to travel, the wide-open spaces of the Santa Gertrudis beckoned again.

At this time, in 1859, the Kings were safer on the ranch than in town. Juan Cortina—once an ally of Captain King's in the 1850 move for a separatist Rio Grande Valley—had gone to war. Estefana Cortina's renegade son, with fewer than one hundred men, felled Brownsville, a town of 2,500. He and his Cortinistas rode down Elizabeth Street, home to the Kings and Kenedys, posting sentinels with instructions to shoot any who appeared.

The Cortina Wars raged for months. U.S. Army troops were ordered to Brownsville to bring peace. The Texas Rangers tried. Both stopped over at Rancho Santa Gertrudis for a good meal and a remount for horses worn down by hard and fast riding across the Wild Horse Desert no man's land. Colonel Lee returned in April and paid a call on the ranch, which he described as "a beautiful place on a knoll in a mesquite plain." Closer to Brownsville, he noted that "nearly all ranches were burned."

That same month, the Kings' third child was born in town, and Henrietta decreed, "Our home is the ranch. Now I feel torn between two lives, but our children must grow up to love the land, to know it as we do." Richard King Jr. was born on December 15, 1860, just months before Abraham Lincoln's presidential inauguration and Colonel Lee's command of Confederate troops.

On his postings to Fort Brown, Lee had witnessed the prolific international trade at the mouth of the Rio Grande. He knew that Union forces might blockade Brownsville, preventing Southern cotton shipments, but the United States would hold off blockading Bagdad (across the river in Mexico) for fear of creating an international incident. Lee knew that King and Kenedy would keep the South's cash crop, cotton, flowing to England in return for guns, cloth and manufactured items.

Lines of wagons rolled across the Rancho Santa Gertrudis. The Military Board of Texas decreed the "King Ranch" as collection point for cotton. As usual, Henrietta saw that pots of tasty stew and coffee were on hand, while King formed the wagons into trains for safe passage. Cortina, no longer raiding, had become governor of Tamaupilas in Mexico. In 1862, a year into the Civil War, Henrietta gave birth to their fourth child, Alice Gertrudis, on April 29. Simultaneously, "a terrible drought" gripped the grass kingdom. "Cattle thin and bitter water," King recounted. Sheep and salt, along with a ramped-up cotton trade, became mainstays of the Santa Gertrudis and other ranches.

Under cover of the Civil War, cattle and horse thieves—Anglos, Indians and Mexicans—stepped up activities. Rangers organized to retrieve livestock and hang the thieves. Ranger Rip Ford said that the Kings' ranch was "a stopping place for wayfarers...a refuge for all classes, the timorous and the hungry."

With Indians no longer a threat, danger still lurked for Henrietta when her husband was away pursuing rustlers or overseeing the cotton train or the bleakness of his pastures. The Union army raided Rancho Santa Gertrudis. Seven months pregnant, Henrietta, her four children and a visitor, wife of Fort Brown's Confederate army commandant, huddled in the main house. Livestock were stolen, the house plundered and Negroes freed. Two days later, on Christmas Day, Henrietta and her four children, all under the age of seven, left for safety in San Antonio. Named for family friend General Robert E. Lee, Robert E. Lee King, the fifth and last child, arrived in February 1864. A year later, Brownsville fell to the Union. Less than a year later, the war ended. King somehow managed to re-enter the good graces of the federal government and, when he did, asked for the return of his and Henrietta's Brownsville house, evicting the Union tenant.

Returning to the ranch, they prospered, and Rangers continued to look for ranch livestock that had been run off or stolen. At thirty-three, Henrietta came home to her "Big House," a long way from her first *jacal*. Her ranch life and hospitality included serving meals to rangers, strangers and dignitaries in the great hall, where "four tables could serve a hundred some of the best beef stew and coffee."

Five years after the Civil War, King was the undisputed "richest man in Texas," due to shrewd deals and gross power plays, the records of which have been burned, lost or sealed. The Kings entertained. He was crude and demanding, according to a Corpus Christi reporter, while

Henrietta was formal and proper. In the 1870s, they began sending their children to Kentucky and St. Louis for more formal education while the nation sank into a panic and depression in 1873 and 1874, respectively. King sought to spoil and lavish the children with wealth and privilege; Henrietta applied a stricter rein.

Yet their home had grown to resemble a small city of vaqueros. Armed guards perched on a rise above Santa Gertrudis Creek prevailed in a region known for violence and outlaws. In 1870, a facet of the business—cattle drives to Kansas for shipment north—would propel Texas ranchers into national prominence, switching the nation from pork to beef. Santa Gertrudis cattle, sporting a new brand, the Running W, streamed out of the grasslands headed north. Henrietta could look out from her porch to the line of their Running W–branded longhorns strung out as far as she could see. These drives lasted from 1870 to 1885. In 1884, they sent the last herd, 5,600 cattle, up the trail, yielding the future to barbed-wire fencing, invented in 1874, and the railroad that chugged into Brownsville in 1881.

At the same time, Henrietta's treasure, her family, was scattering. Older daughters went away to school, married and lived in St. Louis. Lee, the youngest, attended college there, contracted pneumonia and died at nineteen in 1883, shortly after Henrietta and Captain King arrived. Grief-stricken, Henrietta remained for several months, ministered to by her daughters, Nettie and Ella. Captain King returned to their once again drought-plagued ranch. Lee had been his hope for a successor. King put the famed ranch up for sale with an asking price of $6.5 million. Henrietta remained in St. Louis. The high price failed to attract buyers, and the drought broke.

Henrietta came home. Richard, the older son, married a St. Louis woman. He wanted to break sod and turn the grasslands into cotton fields, and he got his chance when Henrietta and King gave him forty thousand acres for a wedding present that July.

A year and a half later, Henrietta's captain grew ill. They traveled to San Antonio and their favorite hostelry, the Minger Hotel, still thriving today. Two weeks later, Captain King died from stomach cancer. Henrietta turned to their beloved old friend, matchmaker and partner, Miflin Kenedy, to help with final arrangements and accompany her home to the Santa Gertrudis.

Unlike many women of this period, Henrietta did not have to battle in the courts for her property. King had prepared a will days before leaving the ranch. Everything went to Etta. Everything included 500,000

acres well stocked with cattle, hogs, sheep and horses and hundreds of thousands of dollars in debt.

A lawyer King fancied, Robert Kleberg, who processed many of the papers defending title to the King Ranch lands, had drawn up the will. King instructed him and Etta not to "let a foot of dear old Santa Gertrudis get away." Henrietta brought Kleberg in to manage the business, and the following year, he married her youngest daughter, Alice Gertrudis, who had remained at home.

Separated from her captain in death but not in memory, Henrietta adorned her black, high-collared dresses with a brooch engraved with his likeness. She decorated her favorite rooms in the house with his portraits. Shadowed by death, she showed the spirit her father had inspired: "Show the spirit of a soldier…make everything yield to a sense of duty and live a life of prayer." She soldiered on, renaming the Santa Gertrudis the King Ranch, Kleberg at her side. For nearly a decade, they worked together, swapping parcels of land, buying more, paying off the debt and developing the Santa Gertrudis breed. After deciding it was time, she gave Kleberg power of attorney, though she remained involved in King Ranch business.

She also continued to entertain presidents and rangers, businessmen and friends and grandchildren. Boots and slippers mingled on the floors of the Big House. Henrietta followed traditional, formal dining customs, perhaps those she learned so long ago when she preferred poetry and politics to romance and social graces. All must be "properly dressed and on time when the bells rang." The bells tolled three times before each meal. The first signaled diners to clean up and get ready. It was dresses for the ladies and coats for the men, "whether booted or not." On the second toll of the bell, all gathered at the big parlor to walk "across the court to the large dining hall." When the third bell rang, Henrietta led the promenade to the dining hall, no matter the weather, no matter her age. Sole owner and matriarch, she presided, serving the meal from her chair at the head of the table. Alice sat next to her and Kleberg at the other end. In the formality of this setting, it's been said that Henrietta tamed the tales of her beloved captain, sprucing up the image of his early beginnings with some fancied tall tales in the Texas tradition. At the end of evening meals, family, friends and strangers walked across the courtyard to the larger parlor. Some played the piano, while others sang. But on Wednesday evenings, only hymns were sung and family prayers recited.

Around the turn of the century, Henrietta broadened her spirit of helping the community from the ranch to the surrounding countryside. In 1904, she donated land for the city of Kingsville and would give land to any denomination wishing to build churches. She designed and donated the first school in Kingsville, though she had employed teachers at the ranch for years. With her gift to the school board in 1909 of a building stout enough to withstand hurricanes, she implored the board "to employ great care in selection of the character builders for the work within." Touched with nostalgia and pride, she added, "Civilization has finally arrived on the Wild Horse Desert."

Three years later, her beloved Big House burned, the result of arson, and Henrietta wasted no time before ordering a new one to be built, "where men could feel comfortable wearing boots." Completed in 1915, it carried the name of Casa Grande. She lived there the last ten years of her life, alternating with her mansion in Corpus Christi.

Together, she and Kleberg grew the ranch to 1 million acres with numerous far-flung interests. Twice a year, she rode out to oversee roundups in the corners of the ranch. She loved the ranch, yet she was also a town builder, donating for hospitals, schools and colleges throughout the valley.

Henrietta Chamberlain King, La Patrona, died at ninety-two, owner and matriarch of the world's largest ranch, the King Ranch. Her seventy-year reign ended, but she bequeathed an intertwined life of family and ranching that has lasted for generations. At her funeral, people thronged from far and wide, the prominent and the ordinary. Perhaps none were more eloquent than the mounted *kiñenos*, who circled her grave while paying the highest respect to the woman many called "the healer."

In later years, Henrietta's grandson Bob Kleberg, who managed the ranch and was a congressman from the valley, wrote, "In this family, it's the women who make the difference."

Mary Nan West

In the middle of another drought, some fifteen years after Henrietta's death and shortly after the end of World War II, Mary Nan West took over the thirty-six-thousand-acre Rafter S Ranch from her

grandfather. She had come to admire the early ranchers and especially the women, saying:

> *The female role in ranching goes much farther back than the ranching itself. The West would never have been settled as quickly if it had not been for the women. They stayed home and took care of the children, took care of the homestead while the husbands were off fighting the Indians, the desperados and whatever.*

As a young girl reared by her grandparents, Mary Nan, a tomboy, had learned to ride, rope and brand. Gathering skills for running her ranch, she also fixed fences and windmills and castrated calves. Her grandfather taught her that if she were to direct operations, she needed to do these things. And she did so, up and through the arrival of rural electrification, telephones and, later, the era of cattle roundups with planes and helicopters, when a grandson joined the ranch as foreman.

In her early years, though, Mary Nan often squared off with her grandmother Robbie Beddell West, who sought to polish her tomboy ways into that of a young lady with finishing schools, needlecraft and piano lessons. Mary Nan argued, "A needle just didn't fit in my hands." She also did her best to skip piano practice. Her grandfather George Washington West weighed in on this running argument by saying, "You are going to have to learn to be as much at home in someone's parlor as you are on the corral fence or on a horse."

Another point of contention between the grandmother who tried to shape a young lady and a young girl who loved the corral was that of leaving the Rafter S for school. At her grandmother's insistence, Mary Nan was sent off to San Antonio to attend boarding school, finishing school and, later, college. Mary Nan, however, chafed at long stints away from the ranch.

When her grandfather's failing health prompted her to assume the ranching responsibilities, Mary Nan planted both feet on the thirty-six thousand acres of the Rafter S. "I wouldn't have lived anywhere else," she said of the brush country land and its rolling plains along the Leona River, stocked with thorny plants such as mesquite trees, catclaw and *guajillo*, a desert brush.

Aware that female ranchers had come before her in this man's world of business and agriculture, she tipped her hat to predecessors such as

Henrietta King and trail-driving women such as Amanda Burks and Margaret Borland, other Wild Horse Prairie ranch women:

> *Women had to learn to ride horseback, to work cattle, to work outside…that was a given in that day and time. The female role in ranching goes much farther back than the ranching itself. The West would never have been settled as quickly if it had not been for the women.*

That description also explained Mary Nan's life. She learned from her grandfather that if she wanted to stay in the ranching and cattle business, she would have to survive droughts and not move away. She also conducted business as her grandfather did, settling deals and other matters with a handshake, not a contract. "My word was my bond," she said.

Yet that convention paled as the twentieth century aged. In her later years, Mary Nan acknowledged that ranching required not only keeping an "in" in the political world but also staying abreast of government regulations, tax laws and bookkeeping. And then there were the day-to-day needs that she, as droves of ranch women before her, performed. In addition to the cattle operations, Mary Nan assumed the role of "half doctor, half nurse." Without phones and nearby doctors in the early years, ranch women took care of their family, the ranch hands and their families. Divorced, Mary Nan reared her two daughters in and around the cattle pens, whether on the Rafter S or on her other ten-thousand-acre spread nearby.

No matter the advancing technology of ranching, managing her Hereford herd and the grasslands, she would spend time in the cattle pens branding, castrating and vaccinating, as well as more gently hand-feeding some pet steers like one she named "Patches," a spotted steer with an eye patch. He and a couple others would never leave the ranch on a cattle truck bound for sale. Mary Nan said she needed two or three "gentle ones to help tame the others." When her grandson graduated from nearby Texas A&M University and became her foreman, she adopted his suggestions about new grass, saying, "I wonder why I didn't think of that. Agriculture will only survive as long as the land is preserved and renewed." She moved to adopt other technologies (roundups by plane and helicopter, for instance) that would contribute to the health of her ranch.

Successful in herding the Rafter S, Mrs. West would bear out her grandfather's advice, finding herself as comfortable in boardrooms, parlors and political offices as corral fences.

With her children grown or nearly so, Mary Nan stepped into other arenas, specifically the San Antonio Stock Show & Rodeo. By 1981, she took charge of the rodeo, establishing new precedents by becoming the first female to chair the annual event in 1984 and also becoming the first female president of the San Antonio Life Stock Exposition (SALE). She led that organization for nearly twenty years, a role that gave her the platform she needed to push through some of her ideas, including a scholarship program that, in her lifetime, awarded more than $8 million in scholarships for 1,100 agricultural students. A Bexar County judge said of her, "Education was so much of what she did. Hundreds and hundreds of students around the state will go to college and their dreams will become reality because of Mary Nan West."

But she did not stop there. On her own, Mary Nan established a $40,000 scholarship endowment for Mexican national students to enroll in the College of Agricultural and Life Sciences at Texas A&M University. She believed that being a good neighbor to the citizens of Mexico meant inviting them to Texas to get acquainted, an idea that fostered these scholarship opportunities. "The real purpose of the stock show is to further the education of young people in business," she said.

As one man who worked with her at SALE said, "If Mary Nan feels strongly about something, she'll get it done."

Besides education, one matter in particular she felt strongly about was paying barrel racers the same as other competitors. Historically, the all-girl event's "purse" was a good bit lighter than the men's. Under Mary Nan's leadership, that changed. The San Antonio rodeo became the first to pay equally.

Throughout the rest of the 1980s and '90s, Mary Nan would continue notching "first female" titles and honors. In recognition of her generosity of the scholarships, the San Antonio Chamber of Commerce presented her with its Leadership Award in 1989. Other "first female" roles included: first female president of the Alamo Quarter Horse Breeders Association, first female to serve on the Texas Animal Health Commission and first female to serve on the board of trustees of the Marine Military Academy.

But perhaps one honor in particular could be called her capstone. In her college days, the 1940s, Mary Nan could not have enrolled at the all-male Texas A&M College—not until 1971 would women be granted

unfettered access to that school. Twenty years after that landmark change, Governor Ann Richards appointed Mary Nan as the first woman to serve on the school's board of regents. Later, in 1994, she became the first woman to chair Texas A&M University's board. The same year, San Antonio made her the first female recipient of the city's Golden Deed Award.

Because of her service in agribusiness and education, awards flocked her way, beginning with induction into the Texas Woman's Hall of Fame in 1987. When Mary Nan became the first woman to receive the Texas County Agricultural Agents Association's Man of the Year award, she was asked if she preferred "Woman of the Year." She said no and stuck with the traditional title, also earning the Joe Freeman Award for her "outstanding service to agriculture."

From Girl Scouts to the Texas Rangers and the National Conference of Christians and Jews, Mary Nan West served and was honored. In 1992, Dallas's Heritage Hall of Honor inducted her. In 1998, the National Cowgirl Museum's Hall of Fame in Fort Worth named her an honoree, and the following year, she received the Spirit of Philanthropy Award from the Nonprofit Resource Center of Texas.

In early October 2000, Mary Nan West stepped down as chairman of SALE after nearly twenty years. "When you come to a crossroads, you have to decide which way to go. I've decided to go home."

Her crossroads? Health. At 75, she had been diagnosed with cancer, and as she mentioned often, "There is something about this brush country that draws me back to it." Mary Nan West returned to her "brush country," the Rafter S Ranch. She died on January 1, 2001. The 111-year-old Rafter S Ranch continues today in the hands of a daughter, Mary West Traylor, and her family.

As Mrs. West's good friend Jackie Van de Walle said at Mary Nan's death, "The whole state of Texas has lost a wonderful citizen. She was one of a kind."

This one-of-a-kind Texas ranch woman, Mary Nan West, said of her industry, "Ranching covers more than just the actual fenced boundaries. It covers our history."

CHAPTER 5

WOMEN HIT THE TRAIL

After the Civil War, Texas cattle, specifically their beef, brought wealth-producing prices in the nation's midsection and along the East Coast via train. Ranchers formed up and often joined herds for the three-month drive from South Texas to Kansas. Sometimes women joined their husbands on the Chisholm or Western Trails—women like Amanda Nite Burks, who left a written account of her adventure, and Lizzie Johnson Williams, who financed her first herd with the sales of short stories. Margaret Heffernan Hardy Borland and Lizzie Williams bossed their own brands up the trail.

Unlike a cinematic shot of a trail, cattle herds wandered, ambling in a generally northward direction while grazing and heading for water at a pace of ten to twelve miles a day. From the Rio Grande Valley, herds followed the Shawnee Trail around San Antonio, Austin and Waco. There, they split. The Chisholm Trail hiked north through Fort Worth, crossed the Red River at Red River Station and continued on to Abilene, Kansas. The Western Trail veered west of that line, going by way of Fort Griffin (near Jacksboro) and Doan's Store before ending at Dodge City.

Amanda Nite Burks, Native Texan (1841–1932)

Amanda Nite, first of the new, native-born Anglo Texan generation, grew up in the woodlands of the new nation on the Trinity River near Crockett. In years to come, she would join her husband on the Chisholm Trail in an area far different than what she knew, the open grasslands of the Wild Horse Prairie. And she would leave a written account describing the three-month journey.

Her Texas heritage began in 1835, when her parents, John and Lucy Nite, left Alabama with a band of "brave and daring people" and "about eighteen hundred dollars in gold." They hid this fortune in a small trunk in the wagon, but thieves stole it, leaving them broke. On arrival, they built a log cabin on the 1,506 acres they claimed near Alabama Bluff on the Trinity, where steamboats tied up to receive boatloads of cotton. Three years later, the Republic of Texas granted them another league of land.

Her father and brothers added two more rooms to the house as the family grew, and Amanda was born on February 8, 1841. She grew up in these piney woods in the comfortable log home of a large landowner. Her father did not believe in slavery, so they "had one elderly Negro woman, Mary, who did the cooking for the family and took care of the small children."

Fitting into this section of East Texas had not been easy. Suspicion and mistrust created tension in the surrounding hardwood and pine thickets and its streams and valleys, which new settlers like the Nites shared with bands of Cherokees, Alabama-Coushattas and Angelina's people, the Caddos. Settlers built forts and blockhouses for protection, and Amanda's father joined the Home Guard as captain to protect his family. On occasion, Mrs. Nite and the "children would pile in a wagon with a few treasures" and move into the stockade with other settlers while the Home Guard pursued raiding Indians. A religious and devout woman, Amanda's mother "instilled in their children reverence for God, truth and honesty." These nighttime trips to shelter might well have provoked what Amanda and her seven sisters and brothers later remembered hearing: their mother praying at night, loud and often, after they were in bed.

One day, a man arrived at the Nites' home with books and saddlebags and announced he was a teacher. Eager to give their children an

education on this frontier, Amanda's father and neighbors threw up a log schoolhouse right away. It included "homemade benches, water buckets and [a] dipper." Because of this good fortune, Amanda would be able to write about her days on a trail drive many years later, a chronicle long cherished in Texas lore. This southern part of Houston County grew prosperous throughout the 1840s and was fairly peaceful after the republic removed the Cherokee to the Indian Nation (now Oklahoma) in 1838.

But the Cherokee were not the only problem. In 1849, when Amanda was eight, a man stabbed her father to death. John Nite called out the name of the attacker as he died: Elisha Clapp. For the rest of her life, Mrs. Nite saved her husband's coat with the hole in it from the knife. With seven children ranging in age from two to twenty-two, she turned the cotton farming over to her older sons, and Amanda and her older sister Lucy helped with the two younger children. Although the family tragedy was great, they continued to prosper in the peaceful and bountiful 1850s, planting, growing and shipping cotton.

When she was sixteen, Amanda attended a dance in Crockett and met a young Arkansas man living in an adjoining county. Love-struck, they announced their engagement a week later. On October 14, 1858, she married eighteen-year-old William Franklin (Bud) Burks in Crockett. They moved to Old Jonesville in Angelina County, near his father on Shawnee Prairie. A few saloons, general stores and a post office lined the town, where horse races ran every Saturday. Heats ran until the town founder, "Turkey" Jones, had imbibed enough spirits to gobble, ending the races and sending folks home.

Home for the Burks was a horse and cattle ranch in the verdant, rolling pastures and forests of the Angelina and Neches River valleys, "with very little furniture to start out." Bud drove the cattle to the nearest market and kept an eye out for good horses. In 1859, a son, John, was born. But he died nine months later from typhoid fever.

In Angelina County, with few slaveholders, people raised livestock, not cotton. Bud bought and traded horses and cattle, showing a penchant for horses. Unlike Amanda's father, though, they owned a few slaves to help with home and livestock. When his father died suddenly, Bud's six brothers and sisters moved in. Then, he and Amanda had a daughter, Lucy, born in July 1861.

The year before, Amanda's home county had overwhelmingly voted to secede, yet Angelina residents remained less enthusiastic. Bud, however,

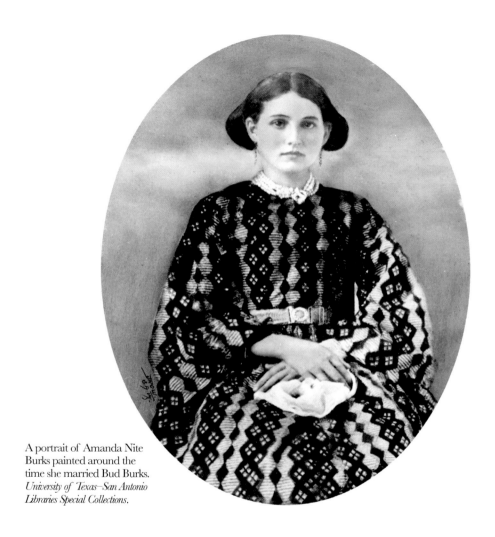

A portrait of Amanda Nite
Burks painted around the
time she married Bud Burks.
*University of Texas–San Antonio
Libraries Special Collections.*

joined the cavalry in May 1862. In October, he wrote Amanda that he
was in Desare, Arkansas, with the Thirteenth Texas Cavalry with "our
brother-in-law" and had been allowed time to visit his mother's grave.
Months before the Civil War ended, Bud came home on furlough for
a few days. When his leave expired, to save him a long walk back to his
unit, Amanda accompanied him for a day in the wagon while family took
care of their daughter. She rode back that night, leading Bud's horse.
Someone approached. She ordered them to "halt and identify yourself."
The man said he was "going to meet Mrs. Burks and tell her her baby

was dead. The neighbors were preparing the little girl for burial." Four-year-old Lucy had died, probably of diphtheria.

Grief-stricken from the wrenching loss of her only surviving child, her husband away in the Confederate army, another loss would strike Amanda. Her mother died the following year, 1865.

With these losses, it's not surprising that when Bud came home from the war with ideas of resettling, Amanda might have been as eager as him to pick up and move. He told her that while with the army, he had found a place in South Texas where the grass grew high and mustangs roamed free. Bud had come home with a common wartime malady, tuberculosis. He also thought the drier climate might help.

So, they sold some stock, rounded up the rest and began their trip south, establishing a ranch near Banquette, west of Corpus Christi on the Nueces River. Badlands country. Wild horse country. Banquette was named for a four-day feast celebrating completion of the road between San Patricio and Mexico, in Mexican Texas. When the Burks moved there, outlaws and rangers called Banquette the "sheriff's deadline," since outlaws believed that if they could reach Banquette before the sheriff, they could slip into Mexico. The border country between the Nueces and the Rio Grande had been rife with outlaws since the Texas Revolution. Indians raided. Juan Cortina's Cortinistas raided Anglos' herds. Yet it was here that the Burks settled. Bud concentrated on the horse business and traveled at length, buying and selling. Amanda ran the homefront. Having no children of her own now, she threw herself into rearing Bud's younger sisters and brothers.

"These were happy years, for we had some good neighbors and a jolly crowd of young folks always around," she wrote of their time in Banquette. "However, joy and sorrow go hand in hand, for while living here we lost two of our family," referring to her sister-in-law and brother-in-law.

Ranchers were shipping cattle to New Orleans, which was now poor from the ravages of the Civil War, or trailed them north to Kansas, over the Old Kansas Trail, where they could bring three or four times the Texas price. "At this time in this section of the country good steers could be bought for fifteen dollars and were often killed for the hides and tallow. The meat was fed to the hogs," Amanda wrote.

The year 1870 had been a banner one for Texas ranchers selling longhorns in Kansas. Trail-fattened cattle sold for three or four times the Texas price. The next year, Bud and a neighboring rancher joined their herds after roundup and agreed to take them up the trail themselves rather

than via a contract. In April 1871, they headed out with about twenty cowboys, "mostly Mexican," and the cooks. They "roadbranded cattle at Piñitas" and started out on the well-worn trail. Amanda recorded, "They were only a day out when my brother-in-law came back with a note to me…Mr. Burks asking me to get ready as soon as possible and catch up with the bunch. He also said to bring either Eliza or Nick (a black girl and boy who worked for us) to look out for my comfort." She started out in "my little buggy drawn by two good ponies and overtook the herd in a day's time. Nick, being more skilled than the camp cook, prepared my meals. He also put up my tent evenings and took it down when we broke for camp."

Bud and his trail-driving partner pushed the cattle slowly, about ten miles a day, "to have plenty of time to graze and fatten along the way. They were in good condition when they reached Kansas."

In her recollections, Amanda said, "Except when I was lost, I left the bunch only once after starting. On this occasion I went to Concrete, where my sister lived, to have a tent made for the trip."

Near Beeville, the two herds split when the neighbor's cattle stampeded. Near Lockhart, the Burks "lost thirty cows in the timber." Amanda noted that during springtime, "the weather was delightful until we reached Central Texas. Some of the worst electrical and hailstorms I have ever witnessed were in this part and also in North Texas. The lightning seemed to settle on the ground and creep along like something alive."

Moving into the area around Meridian in Bosque County, they encountered one of these storms. Bud drove her buggy into a copse of trees for protection and returned to help his men contain the cattle. Rain poured. Hail pounded. "I got back in the buggy and sat there cold and wet and hungry and all alone in the dark. Homesick! This is the only time of all the months of my trip that I wished I was back at the old ranch at Banquette."

Wending their way north through Johnson County, the Burks stopped in Fort Worth for several days, "waiting for the Trinity River to fall low enough to cross our cattle. I counted fifteen herds here waiting." Crossing the Red River, she added, "We seemed to have left all civilization behind…no more fresh fields, green meadows and timber lands. The sun was so blistering that we hung a cloth inside the top of my buggy to break the heat that came through."

While the Burks were always on the lookout for hostile Indians, the only ones they met came to camp to trade. Rustlers, though, could have

caused more problems: "While alone in camp one afternoon two men came and were throwing rocks in among the grazing cattle. I called to them to stop and said, 'Don't you know you'll stampede the cattle?' and they answered, 'That's what we're trying to do.' Just then some of the men rode up and the rustlers left hurriedly."

Bud kept his horse saddled for emergencies at night and often rode with his men when the cattle were restless. "I was sometimes alone in my tent till late at night. On these occasions I sat up dressed for any emergency," Amanda wrote. On one night like this, after their herd had caught up with their neighbors', either Indians or rustlers stampeded both. "Horrible yet fascinating sight. Frantic cowboys did all in their power to stop the wild flight, but nothing but exhaustion could check it. By working almost constantly the men gathered the cattle in about a week's time."

She later wrote, "On one occasion a prairie fire ran us out of camp before breakfast. We escaped by fleeing to a part of the plain, which had been burned before, called 'a burn' by people of that section" to discourage Texas cattle from lingering. "Two days later my ignorance was the cause of an immense prairie fire. I thought I would build a fire in a gulley while the cowboys had gone for water. No later than I had struck the match than the grass all around was in a blaze which spread so quickly the men could not stop it."

Cool, inviting streams afforded brief respites to summer's heat and prairie fires:

When we came to the Canadian River, the red, blue and yellow plums were so tempting I had one of the Mexicans stop with me to gather some. We wandered farther away from the buggy than I realized and when we had gone back a short way, I thought the horses had run away and left us...The Mexican insisted we go farther upstream and soon found the horses standing just as they were left...The cook served me with delicious plum pie made from the fruit I had gathered. Being the only woman in camp, the men rivaled each other in attentiveness to me. They were always on the lookout for something to please me, a surprise of some delicacy of the wild fruit, or prairie chicken, or antelope tongue...I didn't cook, except to make pies.

Misunderstanding a caution for a signal to go forward, Amanda plunged her horse and buggy into a swollen creek. The buggy tipped,

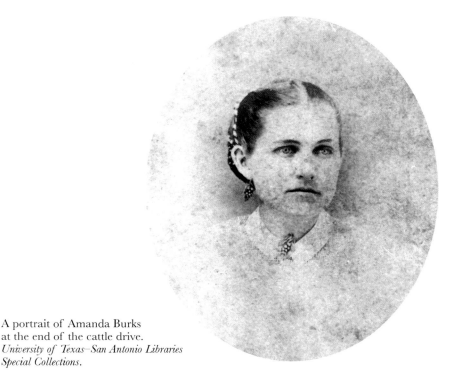

A portrait of Amanda Burks
at the end of the cattle drive.
*University of Texas–San Antonio Libraries
Special Collections.*

but the horses righted it and made it across. "The crossing was so bad that the bank had to be chopped down to make it safe for crossing the cattle," she said afterward.

Three months after leaving Banquette, the Burks and their herd reached Emmet Creek, twenty-two miles from Newton, Kansas. They planned to summer the cattle, fatten them and then sell, but the market had broken, so Bud decided to wait out the price. Cold weather arrived first, though. Horses were lost in the first snowstorm. "Many of the young cattle lost their horns…Blocks of ice had to be chopped…in order that the cattle could drink."

Burks decided to sell the cattle and leave for what Amanda described as "Sunny Texas." "He met with no discouragement of his plans from me," she wrote, "for never had I endured such cold."

They left Kansas in December, "dressed as if we were Esquimaux [*sic*] and carrying a bucket of frozen buffalo tongues as a souvenir for my friends in Texas. Our homeward journey was made by rail to New

Orleans via St. Louis and by water from New Orleans to Corpus Christi via Galveston and Indianola. I arrived home in much better health than when I left it nine months before."

Five years later, she and Bud left Banquette to establish a ranch farther west in the *brasada*, or "brush country," near what would become Cotulla in LaSalle County. Fences were cropping up around Banquette. Out in the brush country, wild horses, Bud's favorite, ran free. He found the place while with a party of surveyors, claimed the land and came home to tell Amanda. "When Mr. Burks came home he told me he had found a place with plenty of wood and water, as I was always grumbling about the scarcity of both at Banquette," she said.

They named their new horse and cattle spread La Mota (meaning "a grove of trees") for trees that surrounded a lake in front of the house they built. They "brought carpenters with them and had Mexican freighters haul lumber enough from Banquette to build two rooms." That fall, they moved the sheep after shearing, and in November, Bud, Amanda and his sister moved to La Mota.

The tuberculosis Bud had contracted during the Civil War reared up, and his health failed. He asked Amanda what she would do "after I'm gone."

"What do you want me to do?"

"I want you to remain right here, but do sell the horses as I feel you can run a sheep ranch as well as I."

He died in January 1877, while the hands were en route to Banquette for the remainder of the Burks' horses and sheep. Amanda and Bud's sister were left to run this four-section (2,560-acre) ranch. In the fall, Amanda began to sell the horse herd, including some of the first polo ponies to leave Texas for New York. Later, she sold one thousand head of horses to her neighbor for $1,000. Twice a year, she took two wagons of wool to Corpus Christi and "brought back enough provisions for six months." She traveled "in her buggy with a driver, a female companion and an 'outrider' besides the buggy." If heavy rains came, they might be weeks on the road.

Bud's brother, John, came from Louisiana to help. Within a year, however, Peg-Leg Stewart, a prominent landowner in the area, ambushed John and shot him at the saloon at Wahooka, according to local stories.

Three youngsters lived and worked on La Mota, orphans taken in by Amanda. Bud's sister, Rhoda, married one, J.W. Baylor, and they continued helping "Auntie Amanda" with sheepherding, which was

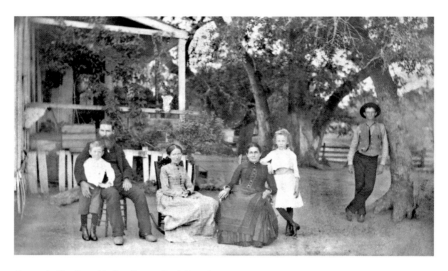

Amanda Burks with family on La Mota Ranch. *University of Texas–San Antonio Libraries Special Collections.*

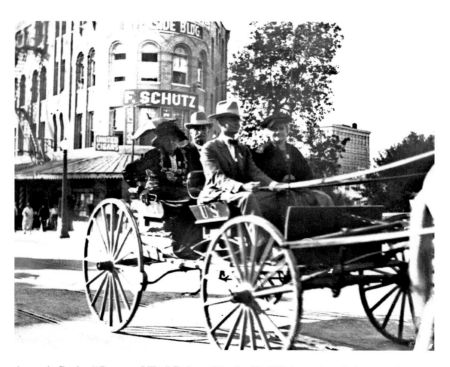

Amanda Burks, "Queen of Trail Drivers," in the Trail Drivers Association reunion parade in San Antonio. *University of Texas–San Antonio Libraries Special Collections.*

extremely profitable in the late 1870s until barbed-wire fencing closed the open range, at which point she switched back to cattle.

Unlike many of her era, Amanda never remarried and continued to wear black, sometimes mixed with white, for the remaining fifty-four years of her life. She embraced her family and Bud's and set about enlarging her spread from its initial four sections. She bought neighboring ranches until the La Mota brand could be seen on over three thousand head of cattle roaming over forty-three thousand acres of grasslands. Clumps of mesquite, oak and ash trees offered shelter to the deer, turkeys, wild horses and mountain lions that speckled La Mota's landscape. Underground water fed the streams and waterholes in this land of the early Coahuiltecan Indians. Enjoying her success, Amanda built a two-story house and purchased the ten-thousand-acre Los Pintos Ranch—named for an early tribe of Coahuiltecans—in neighboring Webb County that stretched to the Rio Grande, Laredo being the county seat.

By 1882, the town of Cotulla had begun. The railroad whistled in with the conductor announcing, "Cotulla! Everybody get your guns ready." Three sheriffs and nineteen residents had been killed in gunfights. Yet three years later, a school began, a debating society formed, a hotel opened and daily stage service began, along with the emergence of more bars and general stores.

When Amanda's in-laws, the Baylors, died, she took in their children to raise. When her nephews grew up and "relieved her" of many ranch obligations, Amanda joined other trail drivers to recount and enjoy the memories. The fellows named her "Queen of the Trail Drivers." She helped spin the tales of cattle driving, both the hardships and fun times, to journalists, authors and movie producers. She attended reunions and rode in the Trail Drivers Association parades. Amanda also tended to business, seeing that her land was cross-fenced and well stocked. It is said that she continued running the business of La Mota even after becoming bedridden from a fall.

Amanda Nite Burks died at age ninety and was buried alongside Bud in the family cemetery on La Mota. Her nephews continued La Mota.

Margaret Heffernan Dunbar Hardy Borland, Texian (1830–1873)

Two years after the Burks, and after the boon of cattle drives, another South Texas woman, an older woman, would take to the trail as her own trail boss, believed to be the first woman to do so.

Margaret Heffernan had sailed into Texas in 1830 with her father, a candle maker, at the helm of a worm-eaten vessel. John Heffernan brought his wife and two daughters into Copano Bay on the Texas coast. The family had left Ireland for New York, where Margaret was born. A pair of Irishmen had petitioned the Mexican government for empresario grants to settle two hundred in a Texas colony, San Patricio de Hibernia, or St. Patrick of Ireland, now roughly San Patricio County, inland from Corpus Christi and part of the "Wild Horse Prairie." Two vessels landed in 1829, but Heffernan captained his own boat. Planning to continue his trade, he scheduled his sail to meet a shipment of tallow that never arrived. His boat foundered in the bay.

Lugging their scant belongings, the family waded ashore and trekked overland to a spot near Margaritas Crossing of the Nueces River, where they settled on a league and a labor, land once ranched by the de Leóns at the beginning of the nineteenth century. That first year, copying earlier colonists, Heffernan threw up a *jacal* for a house, a brush-, mud- and grass-thatch hut. Later, they built a picket house—common among these Irish settlers—by digging trenches and standing small tree trunks upright in the ditch. They chinked cracks with mud and made roofs of grass thatch.

With all the wild horses and mission cattle around, and no tallow, Margaret's father learned from their Mexican neighbors to catch and train horses and round up cattle. For five years, the Irish settled into a fairly prosperous routine, sending cattle over the Atascocito Trail to Louisiana, growing their herd and the crops they needed for food. Except during droughts, the area proved bountiful; the high grass waved, its tips tickling the bellies of their horses. All of the family learned to ride. The Heffernan family grew by two in those first years in Texas, years before the revolution.

In October 1831, the colonists laid out a town on the east bank of the Nueces. While at first this colony did not rush to join Texas's revolutionaries, it did send representatives to the consultations. John

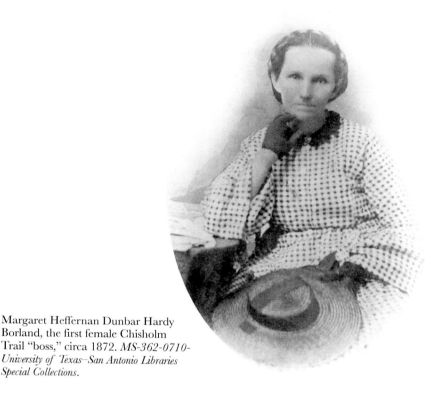

Margaret Heffernan Dunbar Hardy
Borland, the first female Chisholm
Trail "boss," circa 1872. *MS-362-0710-*
University of Texas–San Antonio Libraries
Special Collections.

Heffernan left home one day to help his brother James harvest at his place near the present town of Beeville. John did not return; instead, he was killed.

A neighbor checked on the James Heffernan place and discovered that all gathered there had been slain by General Jose Urrea, leading an advance of Santa Anna's army toward Goliad in February 1836.

Margaret, twelve at the time; her older sister; younger brothers; and their mother limped into Goliad along the dusty cart path behind their wooden cart pulled by one horse, laden with what goods they could carry. They cautioned one another not to speak English. Distraught with grief, sunburned and speaking Spanish like the locals, they passed for Mexicans and escaped the slaughter, reaching Goliad in time to witness the execution of Colonel James Walker Fannin's troops at the La Bahai mission on March 27. Local stories report that Margaret's family drifted over to the Brazos River after the San Jacinto victory and put in a corn

crop on some land. The date and specific place is not known, but at some time, they returned to Victoria.

Coinciding with the Texas Revolution, colonists faced yet another threat from the coast. Karankawa Indians, hostile toward Europeans, stalked the Gulf Coast. Their large size, ferocity during battle, false reputation as cannibals and stealth (they were able to slip up on settlers by their skillful paddling of dugout canoes across lagoons and bayous) struck fear in settlers. Largely, the Copanos and Karankawas were coastal peoples, living on the Matagorda Peninsula and the bays along the coast. They had no tolerance for insult or broken promises, and inland wild game supplies were sparse—all causes for conflict with Anglo settlers.

Surviving colonists of San Patricio fled before Santa Anna and did not return until after the Mexican War of 1848, when U.S. troops brought a sense of safety to this country on the Nueces. In addition to Indian fears, Mexicans still claimed the land south of the Nueces River.

The next record of the Heffernan family in Victoria appears when Margaret married Harrison Dunbar on August 16, 1843. Dunbar owned about thirty head of cattle. Shortly after she gave birth to a daughter, Dunbar lost a pistol duel on Victoria's Main Street.

Next, on October 16, 1845, she married Milton Hardy, son of an old settler and cattle raiser and owner of 2,912 acres of land and five town lots in Victoria. Hardy's mother possessed one of the original brands registered under the Republic of Texas. Margaret and Milton settled on a place near the DeWitt County line, running longhorns until Hardy's death from a common coastal plague, cholera, in 1855. Margaret had "several children" with Hardy, although "all but two died in infancy."

Three years later, she married her third and last husband, Alex Borland, a North Carolinian with a substantial personal estate and twelve slaves. With him, she had four more children. Times were good around Victoria. Cattle and cotton brought good returns to landowners. Margaret retained the "H" brand for cattle. The war that would disrupt this prosperity, the Civil War, loomed. Texas voted to secede, and companies began forming up. Borland escaped the first call-up, and the second, due to his age. But the following one, issued in 1863, would snag him. That same year, he bought a plantation on Spring Creek and "failed to present himself for enrollment in obedience to the notice" for service to the Confederacy.

When the war ended, he had land, on which he gathered and bred about eight thousand head of cattle and maintained a personal estate,

although he lost his slaves. Whether they lived on the Hardy Ranch near the DeWitt County line or on Borland's riverside plantation is not known.

In the aftermath of the war, when cattle were dirt cheap in Texas and workers had to be hired to plant and harvest cotton, Margaret and Alex opened a meat market in Victoria in 1867 to increase their revenue. She applied to the U.S. government for a license to butcher and hired two men to do the job. Her husband grew ill—of what, little is known except that he sailed for New Orleans to consult with a surgeon but died on the trip.

Later that year, Margaret moved the family from the ranch to Victoria and "assumed full responsibility for the estate," running the Hardy-Borland ranch, which she had assisted Alex with throughout their marriage. That fall, a yellow fever epidemic swept Victoria. All of Margaret's family came down with the scourge. She nursed them and became ill herself but survived. Physicians and friends attended to the family, yet she lost three daughters, a son and a grandson to the disease. One daughter left behind an infant daughter, whom Margaret reared.

Doing what she had to do for the ranch and her family, taking charge of buying and selling cattle and horses, Margaret earned a reputation as a good horse trader and managed her business, according to the records, with as keen a penchant for detail as her eye for livestock. Her top hand on the Hardy-Borland Ranch was her brother John, who earned $15 a week. She hired another family member for "one month collecting horses." In April 1868, she bought seven stock horses for $230—"one black and white paint, one brown mouse colored dun, small, and one gray with black mane and tail." She paid $40 for a sorrel that she later gave her grandson. In 1870, Margaret's real property was valued at $1,500 and her cattle at $16,384. By 1873, she owned a herd of over ten thousand cattle, one of the largest in Texas. A financial panic hit the United States in 1873, and the value of her herd declined. Like many others who lived in this "cradle of the cattle industry," she decided that she needed to trail her beeves north in order to sell them for profit.

Although many stock raisers contracted with experienced trail bosses to drive their herds, Margaret opted to be her own trail boss, probably to save the fee split. She hired nine hands to "gather and drive H beeves" and moved a fourth of her herd over the Chisholm Trail to Wichita, Kansas, leaving in April 1873. Railroads reached into Texas by then, but their freight rates made drives attractive. Besides, men of the day

enhanced their image when they could boast that they had been "up the trail."

It's doubtful Margaret went up the trail for her reputation. She moved in Victoria's upscale society. She had youngsters to rear and a ranch with more cattle grazing. Most likely, she chose the trail drive in order to turn stock on the hoof into cash. At forty-eight, she set out with her children—two boys under fifteen; a daughter, seven; and a four-year-old granddaughter—and her hands.

Contract trail bosses took eleven cowboys to manage a herd that size. Margaret arrived in Wichita after about three months, in July, one of the hottest months on the plains. Wichita had reached its peak as a cattle center that year with about 400,000 Texas longhorns raising "the dust on the trails into the community that year." The mass of cattle had to be held on Cowskin Creek. Arriving at the peak season, Margaret pushed her herd onto Cowskin Creek along with other cattle bosses, letting the "H brand" cattle water and graze until allowed to cross the wooden toll bridge built the year before to be shuttled into stockyard sale pens.

Probably as eager as any cowboy to clean up, come to town and get away from the constant lowing of thousands of cattle, Margaret headed into Wichita. A merchant reputed to have the "finest establishment west of Kansas City" drew her attention first to the "expensive plate-glass show windows and to purchase a 'skirt' priced at $3.50 and a 'chemise' at $4."

Yet on that venture and before she could sell her stock, Margaret came down with what was called "trail fever" or "congestion of the brain" (possibly heat stroke) and died on July 5, 1873. The wealthy female rancher and early Chisholm Trail driver was returned to Victoria for burial in the town's cemetery. The inventory of her estate included a piano, a marble-top bureau, a broken candle stand, a walnut safe, linens, dishes and other items valued at $554.80, plus her cattle, valued over $16,000.

Victoria journalist Victor Rose, Margaret's son-in-law, widower of her daughter lost in the yellow fever epidemic and father of the granddaughter she raised, wrote of Margaret:

> She was a woman of resolute will and self-reliance; yet was she not one of the kindest mothers. She had, unaided, acquired a good education; her manners were lady-like and when fortune smiled upon her at last in a pecuniary sense, she was as perfectly at home in the drawing rooms of

the cultured as if refinement had engrafted its polishing touches upon her mind and maidenhood.

Margaret's sons continued ranching on the Hardy-Borland Ranch, and her surviving daughter became a teacher in Victoria after graduating. Like many of her time, Margaret Heffernan Dunbar Hardy Borland left no notes, diaries or letters about her life or her adventures on the cattle trail. We know her by her court records, commercial receipts, acclaims from local citizens and accounts of a loving son-in-law.

Elizabeth "Lizzie" Johnson Williams

A schoolteacher, bookkeeper and short story writer, Elizabeth "Lizzie" Johnson got her start in the cattle business from proceeds of her short story sales to national magazines such as *Frank Leslie's Illustrated Weekly* (sometimes alternately titled *Frank Leslie's Magazine*).

She purchased land near Austin, began stocking it with cattle and registered her own brand, the CY. Enjoying a reputation as scholar and teacher of math, cattlemen recruited Lizzie to keep their books. In doing so, she learned the business side of cattle raising, the profits that could be made.

Born in Jefferson City, Missouri, "around 1843," Lizzie's family moved to Texas in 1846, settling first in Huntsville for its good schools and then a flock of communities in Central Texas, where her father would teach. He located his Johnson Institute in Hays County (San Marcos is now the county seat), about a day's ride southwest of Austin in 1852. He taught, his wife served as dorm mother of the co-educational school and as their children grew up and were educated, they, too, taught, including Lizzie. She studied at Chappell Hill Female Institute. During the Civil War, her brother joined the Confederacy, and she continued to teach at her father's school until 1863, when she began a ten-year career among sundry schools in Austin's surroundings.

Her stint at Lockhart, from 1865 to 1868, the beginning of cattle drives north, brought her into contact with cattlemen. Herds from South Texas, "the brush country," converged there. Later, while teaching in Austin and continuing to keep books for ranchers, she took up a somewhat latent yen—fiction writing.

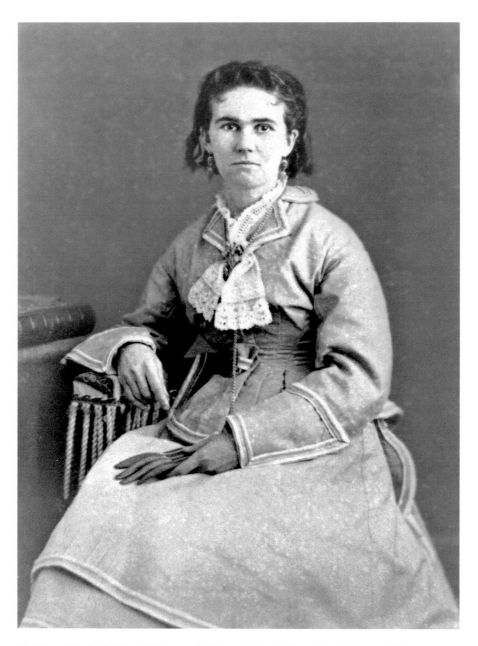

Trail boss Elizabeth "Lizzie" Johnson Williams of Austin "loved the old buzzard" but competed with him. *MS-362-082-0710 University of Texas–San Antonio Libraries Special Collections.*

Publishing short stories such as "The Sister's Secret," "The Haunted House among the Mountains" and "Lady Inez; or the Passion Flower, an American Romance," she garnered a wide audience. She largely published anonymously or under a pseudonym in a seemingly favorite publication such as *Frank Leslie's Illustrated Weekly*. A newspaper of New York and a literary journal, the publication became national in audience, debuting in 1852 and lasting until 1891. One of Lizzie's fellow authors, who published under her own name, was Louisa May Alcott. Renowned illustrator Norman Rockwell drew many of the magazine's covers.

Lizzie pocketed $2,500 from her writings and used that to bankroll her first cattle investment, pouring it into Evans, Snider, Bewell Cattle Company of Chicago. She earned a reported 100 percent in dividends each year for three years and sold in 1871 for $20,000. She registered her CY brand in Travis County and reinvested her earnings in land and cattle.

When just teaching for a livelihood, Lizzie was bored. But now, with three endeavors to keep her engaged—teaching, writing and cattle brokering—she profited. She bought a house in Austin at 1105 East Live Oak in 1872, a single, educated woman in her early thirties. She bought land and hired cowboys to round up stray longhorns that still roamed free across Texas and slap her CY brand on them, registering the brand also in Hays County in 1873. (Cattle brands were registered county by county.) Weathering the glut of beef and the economic downturn of 1873, Lizzie hung on and started sending her cattle up the trail. Many stock raisers contracted with a stock driver, and she did, too—at first.

In the last five years of trailing livestock north, her herds would have been met in northwest Texas with a "Winchester Quarantine" by armed cowboys from Panhandle ranches. Texas longhorn cattle, immune to a virulent tick, carried the bloodsuckers with them, dropping off and devastating herds of Herefords that were not immune. For that reason, it is reported that Lizzie went up the Chisholm Trail, the more eastern route to market.

In 1879, she met and married the Reverend Hezekiah George Williams, a retired Baptist minister who drank and gambled. He was a stock driver from Seguin.

Before she married him, though, Lizzie extracted, it is believed, Texas's first prenuptial agreement. She retained all rights to the property she brought into the marriage. At this time in Texas, a woman's property became her husband's to buy, sell, trade and pass along in inheritance. Not so with Lizzie's.

An 1850s issue of Frank Leslie's national newspaper, for which Lizzie wrote fictional stories. *Courtesy Star of Texas Museum, Washington-on-the-Brazos, Texas.*

With wealth accruing from all her pursuits, she had bought another house in Austin, a two-story, and that's where Hezekiah moved in after the wedding, presided over by a minister of her childhood faith, Presbyterian. Similar to Henrietta King and her "Captain" King, Lizzie read the scriptures daily while Hezekiah drank, but not in her presence. As with the older couple, they respected each other.

Vastly different from the Kings in other ways, Lizzie Johnson Williams and Hezekiah Williams operated as competitors. They were friendly but competitive. One hand who worked for them, Bill Bob, told of often competing instructions: "Lizzie would instruct [me] to steal Hezekiah's unbranded calves and burn her brand on them…Hezekiah gave [me] the same instructions regarding Lizzie's calves. So [I] was kept busy branding Hezekiah's calves with Lizzie's brand and Lizzie's calves with Hezekiah's road brand." The road brand was a traveling brand, required by law in Texas, for herds setting out along the trail. Hezekiah did not register his brand until 1881, a decade after Lizzie's.

When they bought cattle, Lizzie and Hezekiah drove together in their buggy and then conducted separate purchases. "She might stand all day long, pointing out the steers she wanted and displaying excellent judgment," said an unnamed cattleman. She appeared to be savvier than Hezekiah about assessing cattle, as well as knowing when to sell. Eventually, he yielded his operations to her. But for several years, they followed their herds up the Chisholm Trail, riding in the same buggy and selling in separate lots. Each morning, she rose "before the cattle" to count her herd and make note in her tally book. She also kept tally of what she spent, especially on the hands, and would deduct that from their end-of-trail pay. Parsimonious, yes, but trusted. Other stock raisers consigned their herds to the Williamses in what was called a "community herd," knowing they would receive a good price and fair accounting when she returned. (Each herd carried its owner's brand and the stock driver's road brand.)

Lizzie and Hezekiah enjoyed the good life, swapping camp life for the finest hotels in Abilene and ventures by rail to St. Louis and New York. For Lizzie, it also meant shucking her trail clothes of cotton and long, gathered calico skirts with many petticoats and a bonnet for satins and silks in the latest fashions. The magazines she wrote for brought her weekly ads showing the latest. She purchased high-buttoned shoes for daytime and slippers with spool heels for the evening. Her hats—flowered, ribboned and plumed—changed with the seasons and were secured by twin jeweled hatpins.

In Manhattan, Lizzie indulged another passion: jewelry. On one trip, she bought $10,000 worth, including a pair of two-carat diamond earrings, a tiara with a three-carat center stone surrounded by nine half-carat stones, a sunburst pin of eighty-four diamonds in a gold setting and a diamond and emerald dinner ring mounted in antique gold.

In the mid-1880s, trail drives closed because of quarantines, the barbed-wire fencing of range land and the arrival of railroads. Another lucrative market had opened up, though, and Lizzie seized on it: Cuba. In the 1890s, she and Hezekiah began selling cattle to Cuba, shipping from Indianola and Galveston. In 1904, they moved to the Caribbean Isle, purchasing a farm, but stayed for only a year.

Theirs seemed to be a marriage of not only competitiveness but also personality differences. He was the gregarious charmer; she stayed behind the curtain, tending to details of business that now included significant real estate investments in Austin as well as ranching and cattle. Also, she bailed out Hezekiah from troubles and debt, which she always made him repay.

After returning from Cuba, and with Hezekiah's health declining, they visited water cures such as Hot Springs, Arkansas, and drier climates like El Paso, where he died in 1914. A favorite story often repeated about Lizzie is that she bought Hezekiah's casket for $600 and brought his body back to Austin. Scrawling a note across the undertaker's bill, she wrote, "I loved the old buzzard this much."

At that time, Lizzie was in her seventies. Now without her gregarious husband of thirty-five years and alone, she continued to manage her affairs as a recluse until a niece took Lizzie in during the last six months of her life after determining that she was suffering from dementia and starving herself.

Elizabeth "Lizzie" Johnson Williams died on January 5, 1924, in Austin without a will, labeled an eccentric and sending her niece and family diving into wallboards, basements and crevices of her home for cash and jewels she had squirreled away. She had told no one, for she had determined early on to accept neither advice nor requests for loans from family.

CHAPTER 6

MOVING NORTH AND WEST INTO TEXAS, 1840s–'70s

Whether spared the pain of Indian seizure or brutalized by attacks spawned by revenge, these women toiled the soils of North Central Texas, planting seeds of friendliness, courage, selflessness and heroism. Their stories and their survival flagged fears of women who, with their husbands, fathers, sons and brothers, would push westward the frontier. The 1850s were particularly raw. Settlers staked claims in growing numbers. Some Indians, such as the Caddos, Tonkawas and a few remaining Cherokees, were peaceful yet sometimes mischievous; others, like the Comanche and Kiowa, never spotted a horse they didn't want. Those small acts escalated. Revenge set in.

The U.S. Army arrived, establishing military forts with a primary mission of getting the Indians to agree to and live on reservations, becoming farmers rather than hunters and warriors. But they soon began to starve; the army needed to provide basic commodities. Then some Anglos wanted reservation lands and began stirring up trouble, for which other Anglos paid the price. It was a dangerous time on these rolling prairie hills between the Trinity and Brazos Rivers of North Central Texas. It was a time for intrepid souls like Mary Hampton Johnson and Elizabeth Clifton.

Mary Hampton Johnson

A few months before Elizabeth arrived in the prairie between the rivers, Mary Hampton Johnson pulled her team to a stop on land granted to her husband for his service in the Texas Army at the Battle of San Jacinto. Years before, Hezekiah Johnson had left North Carolina to volunteer for the Texas Army, probably drawn by the offer of free land, an offer that swelled Texas troops. Before statehood, however, he grew disillusioned with the Republic of Texas and returned home in 1843, marrying Mary in Jonesville, North Carolina, a few months afterward.

A dozen years and four children later, Hezekiah died. Mary, in her thirties at the time of her marriage, of course knew of the Texas headrights for veterans. Described as "gentle" by those who knew her, she must have been determined not to be dependent on family for her support, as would be expected had she stayed around Jonesville. Hezekiah's headright offered a solution.

So, she packed the four kids—one son and three daughters—into a wagon to head for what he had described as a land of "blue-bonnets and fireweels and butter-cups," the land that looked to offer a solution as to how she would care for herself and her children.

Although he had left Texas disillusioned, Hezekiah had spun tales about the Alamo, Goliad and San Jacinto, imbuing Mary and the children with stories of heroism.

On September 10, 1856, she recorded in her journal:

> *Leaving tomorrow for Texas with Bynum, Mary, Julia, Alveda in four wagons driven by Bill, Amanda, Phoebe and Solomon. I am to ride with Solomon's wagon (a negro), the three girls in Almeda's (another negro) and Bynum with Bill. Am taking all my feather-beds and quilts. Fifty bushels of corn, five hundred pounds of hog-meat, two barrels of flour, and some furniture and clothing. Hope to reach Weatherford, Texas in about four weeks.*

A woman who heard Mary's story years later wrote, "[This woman found] few roads to guide, no bridges to help at the streams, and no ferries. These things seemed of little weight in her mind, but at some time in September she makes this entry in her diary: 'My expenses so far have been $6.25. This is awful.'"

Texas bluebonnets, the state flower of Texas.

Reaching Weatherford, Mary claimed her veteran's land and set about making it productive so that she could "make both ends meet." In her methodical manner, she orchestrated children and adults to fence fields, build barns, plant crops and round up beef cattle. Winter hovered. She needed to feed ten hardworking people, herself, her children and her slaves. It took a lot of food. In these verdant fields, deer and wild hogs were plentiful. The rivers carried plenty of fish, and free cattle ranged.

Another threat existed, though: Indians. In this pocket of Texas, they were largely Tonkawas, who were peaceful. They did, however, raid the barns and chicken coops for food.

Resisting the warmongering against all Indians that Captain John R. Baylor espoused in his White Paper, published in Weatherford (one of three newspapers in this largest town in the region), Mary recognized the difference between the peaceful ways of the Tonkawas and the marauding manner of plains Indians. The Tonkawas could be helpful. In that view, she aligned with Sam Houston's appointed Indian agent Robert S. Neighbors, who condemned Baylor's actions and saw his own duty as one of protecting Indians. As women before

her, women like Peggy McCormick near the coast, Mary traded her baked foods for meats the Tonkawas hunted. And she didn't object to some nighttime mischief in the pens and coops. Yet from time to time, when they were about at night, she would fire her husband's gun to remind them that "a firearm was on the place and she knew how to use it. And dared to."

Mary Johnson nurtured a friendship with these Tonkawas, offering them gifts from her pantry such as berries and vegetables, as well as some baubles and beads, because they buffered her family from the raging and often-violent Comanches that roamed a few miles farther west.

Although Mary lived not far from Weatherford, it still was a long way to a railroad. And it wouldn't be until 1880 that trains began to travel into Weatherford, bringing in basic goods such as sugar, tea, coffee, flour and molasses, the goods she could not grow.

Despite the hard work that her land and her family required of her, Mary, like the women before her, tended to the softer side of her children's needs: church and school. She taught her children, and they attended the Clear Fork Baptist Church, seven miles northeast of Weatherford. Another area rancher occupied the pulpit, the Reverend George E. Slaughter, father of men who built grand ranches in West Texas. Mary remained a consistent member of this church, and as she prospered, she gave, gifting Weatherford's Baptist Church with its first organ.

While not much is known of Mary's young life, she must have been well educated or at least had an appreciation for education, for she saw that her children learned well and then sent all four, when they finished local schools, back to North Carolina's Dawson College for more.

Mary Hampton Johnson survived and then thrived on her veteran's headright out of Weatherford. In her time in this Cross Timber countryside, she lived through the Indian wars, the Civil War and Reconstruction, removal of the Indians, cattle drives on the way to Kansas and, presumably, the coming of the railroad. At some point, she moved to Austin to live with her daughter, Mary, and this is when her story and her diary became known. Despite the ruggedness of life, it was said that she remained "gentle" with "her white hair glistening above eyes still bright, still alive to daily happenings," telling her story for future generations.

Elizabeth Ann Carter Sprague Fitzpatrick Clifton, Texan (1842–1882)

A headstrong Alabama white girl with epilepsy, sixteen-year-old Elizabeth Ann married twenty-five-year-old Alexander Joseph Carter, a free mulatto from Texas with successful farming parents, in 1842. She could not have anticipated that life's forge would shape a will within her to sustain heroic and self-sacrificing feats.

Whether she was turned out by her family for her disease, considered then to be one possessed by demons or hopelessly insane, or displaced by their deaths is not known. How she met and came to love Alexander is not known. Her life story picks up when she married and moved in with her in-laws in Red River County in northeast Texas. In this Spanish province, under both Mexican and Spanish flags, blacks were not discriminated against. In fact, many blacks came with the Spanish and stayed, making a home among the Indians.

Before 1839, in Red River County and south to Nacogdoches, between the East Texas forests and the Sabine River lay the Cherokee Trace, a string of Indian villages—Cherokee, Caddo, Keechi, Tonkawa and Waco. A traveler along the trace could leave one Indian town site and soon find himself in another. Carter family history also lay quiet about their arrival and life in Texas. What is known, however, is that they numbered among some four hundred free blacks in the republic. They farmed and raised stock in sprawling Red River County until 1843, when the Carters moved west to Navarro County. In time, Corsicana was designated the county seat. While her husband and father-in-law freighted goods to settlers from the ports of East Texas, Elizabeth and her mother-in-law planted and tended crops of corn, squash and pumpkin. Elizabeth bore two children: a daughter, Millie, and then a son, Elijah.

While the Carters freighted and farmed in relative peace, Texas joined the United States, and the U.S. Army built a line of forts from Brownsville along the Rio Grande River, arcing west and north toward the Red River in the tree-starved western half of the state. Here, mesquites, hackberry, cottonwood and willow flanked streams that shrank to dry beds during summers. Yet it was a land of tall grass, ripe for foraging cattle. Settlers, including the Carters, came and claimed the land at a time when Indians along the upper Brazos River and west were hungry. One Indian agent noted, "They had to choose between stealing and starving." An army

general agreed: "They cannot observe the treaties they made without subsistence and clothing." A newspaper editor chided the federal government for giving Indians trinkets instead of food. "Their need is for bacon, corn and farming tools," he wrote.

In 1853, U.S. Secretary of War Jefferson Davis turned his sights on defending the western frontier, the protection of which he deemed the most significant problem facing the army. "Nowhere has it been found more difficult than on the Western frontier of Texas," he wrote.

More nomadic Indians—Comanches and Kiowas, known as superb horsemen—reigned along the plains, traversing the Comanche War Trail into Mexico. When they lost horses, the army's handsome stock proved tempting.

The four cavalry companies posted at forts rode mounts of uniform color. One company rode all gray horses, while the others rode black, sorrel and bay horses, respectively. Not surprising, Comanches and Kiowas, when united, could muster an army of seven hundred to one thousand warriors who could not resist the temptation. Stealing 250 of the army and settlers' finest steeds on a moonlit night typified "Indian harassment."

To contain this harassment, to feed Indians and protect them from hostile attacks by whites, reservations were established in 1854 along the Brazos River. The army set aside twelve leagues of land, some thirty-thousand-plus acres, for three reservations. Two, about twelve miles below Fort Belknap, were designated the Brazos Reservations for farming Indians. The third, Clear Fork, designated for southern Comanches, was located about forty miles southwest of the fort in what is now Shackleford and Throckmorton Counties. As in the republic's days, some officials wanted to rout the Indians one and all. Others proffered peaceful coexistence.

Whites who wanted Indians gone opened up reservation land for larger ranches and raided Indian camps, killing and maiming. Indians, many with a culture that honored revenge, struck back. The greedy fostered fear on reservations by telling Indians they were being rounded up for extermination. By the time Elizabeth and the Carters staked a claim about two miles north of Fort Belknap in Young County in 1857, the military's greatest task was to protect and feed the Indians. The army placed orders for storehouses of corn. The Carters, father and son, contracted to haul corn between their Carter's Trading House, Fort Belknap and the reservations. Elizabeth ranched. She raised the

In the rolling hills around Fort Belknap, North Central Texas settlers built houses and barns with pickets like this.

livestock—horses, mules and cattle—and farmed. "I acquired a plough to bust up the sod," she said, for a vegetable garden and a crop of corn. She helped with Carter's Trading House despite not being able to read or write and occasionally incapacitated by epileptic seizure. Her husband was the freighter. She was the stock raiser and ran the Carter Ranch in an equal partnership with her father-in-law.

Elizabeth Ann Carter, by nature or by observation and trial-and-error education, matured into a smart businesswoman and learned to ignore catcalls of "nigger lover" and "demon" flung her way. She rounded up cattle and sent them to market in Louisiana with Alex and their cowboys, other free blacks in the neighborhood and Mexican neighbors riding herd.

The Carter family enriched themselves on this land, becoming the wealthiest family in Young County in their first year. They owned land; nine horses, including two prize stallions; mules, twelve yoke of oxen; wagons; and seven hundred head of cattle. In a time when only a handful of people had "money at interest," the senior Carter banked $1,360 compared to the $200 to $400 of other prosperous folk in the region.

Jealousy and prejudice teamed to dent that wealth. For those reasons, a man named Draper shot and killed Alexander and wounded his father. Elizabeth, an accomplished seamstress, sewed mourning clothes for Alex's burial while she nursed her father-in-law's injuries, only to lose him from gangrene.

Before Carter's death, an intrigue of litigation took place that left Elizabeth Ann surrendering her half of the ranch to her father-in-law, while he willed his property to be divided between her daughter and her son. Guardians were appointed both for the estate and for her son, perhaps because she could neither read nor write. Elizabeth Ann trusted the clerk of the county, a mercantile-owner for whom she worked occasionally.

Draper, well known as the murderer, never spent a night in jail. Elizabeth Ann buried her father-in-law, and while the settlement of the estate went on for years, she continued to do what she did best: raise livestock, manage the Carter Trading House and rear her children. She did this for four months.

She married a soldier, a newcomer at Fort Belknap, Lieutenant Owen Sprague. Having married "the richest woman in the county," Sprague was known for smoking cigars, drinking heavily, eating lobster and sardines when he could and consuming quantities of quinine. This last,

plus liquor, suggested he suffered the "Brazos Bottoms," a "bilious fever" acquired from insects and impure water and food. Eight months later, Sprague disappeared, perhaps because of Elizabeth's previous mixed-race marriage and children; her "fits" or testy, "extroverted" nature; or his bouts with the fever.

In the fall of 1858, the Butterfield Stage began stopping near the fort. At this frontier curtain, travelers swapped horses for mules before heading across the plains to California. Indians preferred to steal teams of horses rather than mules, so California-bound stages harnessed mules for the drive west. On the way back, eastbound drivers exchanged mules for horses. Elizabeth turned the teams loose to graze and fatten up, continuing to operate Carter Ranch and Carter Trading House profitably. Her fourteen-year-old daughter, Millie, married and soon after sued the courts to have Elizabeth declared incompetent, contesting for the guardianship of her brother. But when Millie's first daughter was born, she named her for Elizabeth. They called Elizabeth's grandchild "Lottie."

As tumultuous and tragic as Elizabeth's family life, hers and Young County's upheaval was just beginning. At the Brazos Reserve, in the fall and winter of 1858, Captain John Baylor instigated a raid on the reservation and "in cold blood killed seven Caddo and Anadarko Indians while these peaceful and nonaggressive women, children and an old man slept in their tents."

In the spring of 1859, the fort dispatched cannons and soldiers to protect these Indians from more "possible massacre by excited white settlers organized under bloodthirsty Captain John R. Baylor."

Tempers on both sides broiled. Near the fort was a "whiskey ranch," populated by "about 150 rowdies and border ruffians." Young County's sheriff started selling whiskey to the troops, whose commander could not control them. A band of Indians mixed with whites massacred families east of the fort, in Jack County.

Whites, who wanted the Indians gone, won. In August 1859, Indians were led single-file from the Brazos River to Indian Territory. Without reservations to protect and supply, and with the nation heating up for a civil war, the army pulled out. Fort Belknap closed. Trade dwindled. Many pioneering settlers left, retreating to more populated Parker County lands around Weatherford. Elizabeth continued ranching despite Comanche "wild ones" who stepped up attacks on settlers. Generally, these Indians did not attack black settlers, but without her husband's family, Elizabeth no longer enjoyed the protection she once had.

A national dispute embroiled Texans. Citizens warred over the question of secession. Young County voted yes, in contradiction to neighboring Jack County's vote, a common split throughout non-plantation sections. The U.S. Army pulled out of all Texas forts. By Christmas 1860, Belknap was deserted.

Upriver on the Carter Ranch, as in years past, Elizabeth's family celebrated Christmas by inviting friends to join them in dancing to fiddle music accompanied by Jew's harp and harmonica. At an all-night party, common in areas with long distances between ranches, they do-si-doed and ate candy apples. A tangy drink of apple cider spiced the evening, along with a mix of "rich cow's cream, raw eggs and whiskey." "'Black Tea,' however, was the favorite, made from a spoonful of black tea in a 'large china bowl' to which a half dozen sliced lemons were added along with 'two bottles of claret wine and one each of a bottle of champagne, whiskey and rum. Cream was not used.'"

Rangers tried to protect settlers, women and children whose men were away serving in the Confederacy. Citizens met to broker with Mexico for guns and ammunition because trade relations with the North and England had been blocked. They needed weapons to defend this frontier fringe from Indian attack. Elizabeth hired an Irish cowhand to help her, and in 1862, she married Thomas Fitzpatrick. Eighteen months later, he was murdered.

In October 1864, a band of seven hundred Comanches and Kiowas swept down on the Clear Fork of the Brazos, killing, scalping and taking prisoners. Carter Ranch fell during the last hit of the daylong siege known as the Elm Creek Raid, led by Chief Little Buffalo.

With little defense, Elizabeth, her daughter Millie and their cowhands hid the grandbabies, age two and five, and fired their guns, a handful against hundreds that killed and scalped Millie. Elizabeth's boy, Elijah, was slain before her eyes. The warriors took Elizabeth and her granddaughters captive; they were strapped to a horse and forced to ride without stopping for two days. She called the Indian who enslaved her "Satine," probably Satanta, or White Bear, of the Kiowa.

One chief on the raid later said, "A woman was worth fifty horses" in trading capital. But for Elizabeth and her grandchildren, no family remained to barter for them; they were split up among different tribes. Elizabeth became a slave and was beaten, burned and scarred for eighteen months. She lived on what the Indians gave her to eat: "raw liver, boiled greasy buffalo meat and charcoal roasted tortoise and dog meat."

Finally, with the Civil War over, the U.S. Army once again turned its attention to the frontier Indians and their enslaved prisoners. In Kansas, army commandants and Indian chieftains signed treaties, exchanging food for captives. On a brisk November morning in 1865, the U.S. Army rode into a Kiowa camp between Fort Dodge and Cow Creek Ranch. Elizabeth, carting wood and water, looked up when she heard the sound of hoofbeats. "They must have been beings from another world," she recounted years later to a neighbor. "Their white faces and blue uniforms looked so beautiful." The troop took her into the Kaw Mission at Council Grove, Kansas, in an army ambulance.

Known as the "grandmother," Elizabeth, herself weakened and pregnant (a pregnancy of which she never spoke—nor is it known whether she gave birth), assisted younger captives who arrived in worse shape. At Council Grove, she learned that Lottie, her namesake granddaughter, had been returned to friends in Texas four months earlier. Elizabeth cooked, nursed and sewed clothes for women and children being returned to the mission in half-starved, near-naked conditions. And she badgered the army. She told them about others in the camps where she had been. "They shiver in the wind," she said. One captive was the daughter of a woman Elizabeth nursed. Another was her granddaughter Milly Jane, whom she believed was still out there. The Indians, however, reported the toddler had died along with massive numbers of children—Indian and white—in the bitter winter.

Elizabeth did not believe them. One day, Colonel Jesse H. Leavenworth arranged for her to accompany him on a search for those she had seen. They left the compound riding side by side, Elizabeth directing him to the Little Arkansas River, where she had seen the girl. Two weeks later, they returned with the McDonald child. Continuing to press for her grandchild, Elizabeth refused to believe the Indians did not have her. She also stepped up her badgering of the army to go home to Texas. They needed to travel before winter set in again. In a bureaucratic nightmare in which Indian agents and army officers negotiated for their own power and prestige rather than the return of the hostages, Elizabeth took charge. "If all the captives still unaccounted for belonged to those whom the business of rescuing them was committed, they would have been rescued months ago," she said. She put her money where her mouth was.

The Council Grove agency paid Elizabeth $3.50 a week for the help she provided. A Texas man drove in to recover a couple lads. She made a deal with him, stating that she would pay expenses for all of the Texas

The mission house at Council Grove, Kansas, where the U.S. Cavalry rescued Elizabeth Carter from Kiowa captivity.

captives to return if he would take them. Her initiative coaxed, or rather shamed, the army off dead center, and an officer agreed to put together a string of four wagons with food and spare horses.

Leaving Kansas in August, Elizabeth drove one wagon and saw to all the children on that small caravan. She did not return to her home area until all of the thirteen Texas captives were reunited with family or friends in Decatur, Wise County, and Austin, Texas. She left the army wagon in Hood County in October to rest and regain her health before meeting her granddaughter in Parker County. Old friends from

the Carter Ranch area in Young County, Lucinda and Joel Miers, had met Lottie in Decatur and took her home to tend and possibly rear the tattooed and burned little girl, sole heir to the remnants of Carter Ranch and Trading House. The Miers had admired Elizabeth's strength and determination when they were neighbors.

Restless for a time, she did not settle down, nor did she return to Carter Ranch. Reunited with Lottie, she moved a couple times and then met the Mierses' neighbor Isiah Clifton and married him, her fourth and last husband, in 1869. They lived at his place near Fort Griffin in Shackleford County. Elizabeth dictated a letter to the clerk in Young County to dispose of her assets. For that, she received $1,200.

Comfortably married, the Cliftons enjoyed a quiet decade, disturbed only by her step-children, who did not favor their father's marriage nor Elizabeth's "quadroon" grandchild, who attended school in this country just beginning to settle down. Elizabeth continued to dictate letters to the department of Indian affairs seeking her other granddaughter, whom she believed was still alive.

She enjoyed the company of a neighbor, Anne Reynolds, another early settler whose family married Matthews family members and started what became and still is the famous Lambshead Ranch. The two women visited often, and Elizabeth told the story of her early years in Young County, her capture and her release. Anne's daughter, Sallie Reynolds Matthews, would recount part of this experience in her book *Interwoven* from stories she heard as a child. It would take another woman, however, to tease out the rest of the story.

Elizabeth also recounted the one benefit of captivity: the Kiowa had cured her epilepsy. During one of her fits that winter, they "rolled her in the snow until life was nearly extinct, after which they forced her to swallow copious draughts of a most villainous concoction which the squaws and their medicine men had brewed from roots and herbs. She was next swathed in blankets and buffalo robes where, as she reported afterward, she thought she would 'sweat to death.'" She never knew the potion, but she also never needed it again.

In 1880, Isiah Clifton, eleven years Elizabeth's senior, died. Two years later, Mrs. Reynolds, widowed, moved to her daughter's place six miles away, and the frequent and nostalgic visits ended. Elizabeth died on June 18, 1882. Lottie had a little girl, and the two of them mourned Elizabeth at her burial next to Isiah in an unmarked grave near old Fort Griffin.

SEARCHING FOR WATER...
FOUND OIL, 1920s–'30s

From the earliest times of Texas records and sprawling ranch interests, such as Juana Pedrasa's grant out near Presidio, some ranchers have been rewarded with significant mineral deposits beneath the surface of their pastures. Juana knew a silver vein ran through her land and into Mexico. After all, she had purchased land on the "Silver Trail." For others, it came as a surprise. In some instances, the surprise was a result of desperation, such as in the case of "Mrs. Middleton" in Central Texas, while others, such as Dora Nunn Griffin Roberts or Christine DeVitt's family, found it while searching for something deemed more prosperous: water.

The Middletons moved to Texas in 1857 from Alabama cotton fields. In the fertile Brazos and Little River valleys of Milam County, they claimed their land. It was safer there; the "Indian Scourge" had moved farther west. They arrived to a community around Port Sullivan with dinners, dances and sermons that drew folks from up and down the rivers. Slavery was entrenched, just as it was back home. Plantation owners depended on slaves to the extent that one neighbor offered 1,500 acres of Brazos River bottomland for one male slave. It came as no surprise, then, when Milam County voted for secession.

Although Margaret Middleton's husband, at age forty-nine, could have been exempted, he enlisted as a private, as did their three sons. She took on the responsibility of bringing the plantation through the rough-and-tumble years of the war until her husband and sons returned. For the first

A bridge over the Little River in Central Texas, the banks of which offered hope of coal during the Civil War.

few years, before slaves took note of their freedom, she and her daughters supervised the fields. Later, they took to the rows, plowing, planting and picking cotton while waiting for the men to come home.

A surveyor offered hope. In 1863, he observed a fine seam of lignite coal, a fuel that would be prized after the war. A coal bed ran through her land, bounded by Little River and located a little west of Port Sullivan, a steamboat port on the Brazos River.

When the Middleton men came home, the slaves returned as freed men to work as sharecroppers. Little is known about the family after that. It is presumed that Margaret and her husband both died from one of two major diseases that swept the area: small pox and yellow fever. A courthouse fire consumed details of births, deaths and land records, leaving us to guess about what happened to Mrs. Middleton and the Middleton Plantation. The youngest son assumed the property and began selling off the land into smaller parcels. Coal on the Middleton Plantation was not developed, although it was at other places in the county, prolifically.

Other women, on West Texas ranches decades later, capitalized on riches flowing beneath their sections, but not before they had survived the ups and downs of dry land cattle ranching—droughts; bitter freezes, or "die-ups," as the cowboys called them; falling beef prices; taxes; and, of course, politics.

Many Southern men returning from war sought to start over farther west. Signs on homes and wagons in Arkansas, Georgia, Mississippi and Alabama often read "GTT," the "Gone to Texas" tag that began in the 1820s, when people went broke, gave up at home and ventured to the new country. For some, the stories about this vast country that sprawled west of the Sabine River and lay between the northern boundary of the Red River and the southern boundary of the Rio Grande were an elixir. If they could just get their hands on enough acreage, they, too, could become independent ranchers.

In the 1870s and '80s, the state rewarded railroad firms with public lands at the rate of sixteen sections (644 acres a section) for every mile of railroad bed built. One of the larger companies, Texas and Pacific, received over 5 million acres of land valued somewhere between fifty cents and one dollar an acre. Railroads then sold to aspiring ranchers, becoming startups of many large ranches in the Llano Escatado, the Staked Plains, and the High Sky Country of the Permian Basin.

Dora Nunn Griffin Roberts

Andrew (Andy) Griffin, a red-haired cowboy reared in Brownwood and who aimed for a spread of his own, earned his start that way. On a visit home to see his folks in 1884, this Confederate veteran met Dora Nunn, a young woman about twenty-one years old, tall, slender and red-haired. When just a toddler, she had moved from Alabama to Bowie and then Brownwood with her family right after the Civil War. Once there, her father started cattle ranching, and that's where Dora developed a love for horses, horseback riding, cattle and roping. Ranch skills came naturally to her throughout her school years.

After a month-long romance, fairly common in those days, she caught Andy's dream, and they married in Brownwood and then drove a wagon back to Signal Peak, the only promontory on the land, a sentinel at the southern tip of Sulphur Draw. The newlyweds started ranching fourteen miles south of the "Big Spring," a Comanche War Trail watering hole where a tent city sprang up, attracting the "three evils of advancing civilization": saloons, sin and smallpox. Andy purchased, at auction, four sections of railroad land for fifty cents an acre, the price of a night's lodging. Dora pitched in. They pried up rocks and stones, hollowed out a room in the ground that backed up to a small rise (a dugout) and scrabbled to raise cattle.

In this land, dry on the surface but with some seepage from ponds, they ranched. Dora might go six months or longer before seeing another woman unless a family of Indians ranged off the reservations. From the bustling burg of Brownwood, with its churches, stores and schools—a fine social life—Dora had moved to an area a day's ride to a place she would have found difficult to fit in: the tent city. It had to be lonely, but no one recalled a complaint from her. Starved for companionship, particularly from other women, Dora poured heart and soul into the struggling ranch. The sky was high; the land, rocky and dry.

Most Indians had gone before she arrived, but stories from the recent past could send shivers of fear up her spine, sufficiently so that she hid when she spotted one. The U.S. Army, now back in the state, operated to remove the Indians to the Indian Nation (Oklahoma) and onto reservations.

In Andrew and Dora's first couple years, drought, cold and falling beef prices hampered their cattle raising. Andrew gathered buffalo bones to sell for fertilizer at five to fifteen dollars a ton, and Dora raised chickens

Signal Peak near Dora Roberts's ranch, the only promontory for miles.

The "Big Spring" started out as a Comanche watering hole but later became a buffalo hunter's camp and, in time, the town by that name.

and took her eggs to sell in town, a routine that became a tradition. She coaxed a garden from the rocky soil to break up their steady beef diet and joined Andy in working cattle, "Herefords," she would claim. Someone who knew her once said, "She straddled a horse and was as skilled with a loop as any hand."

She and Andy enlarged their holdings at more public land sales and built a wooden house with lumber hauled from the railroad. Their family grew with the birth of two little girls, Docie and Eloise.

In the drought of 1887–88, Andrew trailed part of the herd north of the Red River for grass. Dora and their daughters stayed behind. She burned cactus to feed remaining livestock and, when a steer went down, skinned it, trading two hides for a sack of flour. The Griffins rolled between the punches of Mother Nature and the economy.

About 1897, during a roundup with neighbors, Andy's horse fell, spearing him with the saddle horn. Neighbor John Roberts came for Dora. She brought Andy home and nursed him, but he died a week and a day later. The mother of two was now a widow and manager of land and cattle. She hired Roberts as foreman, but it was her land, her cattle. She plopped her daughters into a two-wheel buggy and took off over pastures, checking on cattle and fences. A crack shot, she toted a .22 rifle to pepper jackrabbits and fill the cooking pot. Dora also invited her sister to come out from Brownwood to teach her children; the sister did, and then she met and married a neighbor.

The year ended with a two-week blizzard. But Dora had hung on, both to the land and the cattle, and paid off debts for her three hundred head of Herefords.

Dora and John's friendship grew. She started the new century by marrying him in 1900. They merged and bought three sections that sprawled between them, continuing to build what would become a twenty-seven- to twenty-nine-section ranch, 18,500-plus acres.

They bought a town house in Big Spring, which was now a town, so the girls could attend school and Dora could attend church. She lived there with her daughters, and John stayed on the ranch, coming in on weekends. Dora described her house as one with a large wraparound porch, a good place "to sit and fan" and visit with friends. And she entertained. After years in the solitude of the ranch, she embraced the fellowship of the Methodist Church, and her home became a hospitality center for young people when her daughters hit high school.

However, she still worked. One town visitor told of calling on Dora to find her behind the house strapped to a mule plowing her vegetable garden. She never gave up on fresh vegetables to enjoy and can for winter months. She invited the guests in and unhitched from the plow to offer iced tea on her porch, lined with rockers.

This respite from hard times screeched to an end in 1909, when another horse accident claimed John Roberts. Once again, Dora, in what townspeople called her "head up" way, took over, moving back to the ranch to run it and hiring John's nephew as foreman. Years later, a fellow in a canvas-winged airplane flew in, touting the riches of oil. Her neighbors bit, but she balked, saying, "I'd rather dig a water well." Herefords and the range were her business, and her disinterest—or shrewdness—paid off. At age sixty-four, she capitulated to oil speculators but hammered out a ⅗₀ percent royalty agreement, the largest in the region in 1927. The company, Magnolia Petroleum, struck oil in what is called the Forsan Field, and the Dora Roberts #1 still pumps today, along with nine hundred other wells.

The ranch was in her blood, and she loved to be there. When she found an architect who understood her love for the land and its big, yellow-white and iron-streaked stones, she built a sprawling rock ranch house. Mindful of droughts, she insisted on an ivy-leaf strand, painted green, that looped the eve. She wanted "something green to see in times of drought."

Dora Roberts lived alone on Roberts Ranch for thirty-five years. She donated her town home to the library, now the Heritage Museum of Big Spring. She bought a new car every year for thirty years—and never drove a single one of them.

For twenty-five years, Dora Roberts presided over banks in Big Spring (a first for a woman), built Methodist churches, owned several other ranches picked up when people gave up and entertained visiting preachers. Today, townspeople still say that she never lost touch with "plain people" or being "plain spoken"—if someone asked for her advice, she expected them to listen. Still, on Saturdays, she would don her long-billed sunbonnet and come to town to sell butter and eggs, just as she had when times were tough, before becoming a multi-millionaire via oil production and owning stock in Magnolia Petroleum, forerunner to Mobil Oil, today's ExxonMobil.

Enjoying the riches and reputation of being a "wealthy widow," having experienced the largesse of what pooled beneath her topsoil and serving

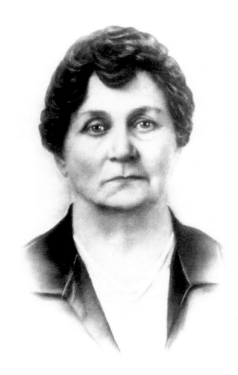

Above: The "Dora Roberts No.1," her first oil well—although, at first, water interested her more.

Left: Dora Roberts: rancher, banker and philanthropist. *Courtesy of the Heritage Museum of Big Spring.*

as gracious hostess for visiting Methodist ministers at Sunday lunch, it might be no surprise that Dora welcomed one man who claimed to be a minister. But he was not. He talked her into backing a gold operation, claiming that gold bricks had been found on her place. After all, her Roberts Ranch curled around the southern end of Sulphur Draw, and that had been a highway for those seeking gold in the 1849 gold rush. Perhaps it's no wonder that she shelved the skepticism she once expressed about oil and bought into the phony minister's scheme.

At this time, Dora, described by people throughout her life as "gentle," swallowed his pitches for several years, in company with her son-in-law and to the tune of over $300,000. She kept investing; the "minister" and his nephew kept producing phony gold bricks for her inspection. Not until her daughter's video of a scene where they buried what proved to be brass bricks was the scheme unmasked. Chagrined that she had been so deceived, she wanted little publicity at the trial for fear other con men would beat a path to her door.

Being duped, though, did not deter Dora Roberts from helping worthy causes. The sod hut bride, ranching and oil tycoon and banker devoted the last decades of her life to helping those less fortunate. In 1945, she embraced a new estate planning instrument and established a foundation. "One of the greatest contributions was her forethought to establish it," said a Big Spring citizen. A retired county judge whose mother had been a friend of Dora Roberts said of her foundation: "Not many were doing that then. She was strong, about medium height, slim—strong of body and quick of mind. Her hard work didn't stop because she got rich. She was very conservative. Very gentle." He elaborated on her work as bank board member and chairman, nothing that she had "good judgment [and] knew her business."

In her estate plans, Dora took care of her children and grandchildren for several generations. From the foundation created, she funneled funds to Big Spring hospitals, area churches, the Salvation Army, the library, the museum, parks and havens for those in need. The county's community college and three universities—Texas Wesleyan in Fort Worth, Southern Methodist in Dallas and Southwestern in Georgetown, home to a memorial for John Roberts—received her support. Millions pour into the county annually from Dora Roberts #1 and its hundreds of sisters.

Dora lived until her nineties, bankrolling people and worthy projects, the memory of the lean years brought home when she continued to sell her butter and eggs to grocers. Oil brought the wealth, but the land and

the cattle pleased her soul. The ranch, now bearing a grandson's name as the Garrett Ranch, is where her descendants gather today for holidays.

In 1953, ninety-year-old Dora, her last three years spent in a Fort Worth hospital (present-day Baylor-All Saints), died. A small chapel in the older section of the complex bears her name in memory of her gift, which was used to purchase the land where the hospital sits today.

Dora Nunn Griffin Roberts lived her adult life on the southern tip of Sulphur Draw, once a river and, in her time, a usually dry roadway used to freight goods from Brownwood west. Her southern end settled first.

From the buffalo hunters' watering hole, "Big Spring," the terminus of the railroad, Sulphur Draw stretched north. Its grass-covered depression flattened one hundred miles away on the *Llano Escatado*, the Staked Plains. Once a major Comanche highway, Sulphur Draw, wide enough for horse-drawn wagons, guided settlers crossing the sea of sand, limestone and bunch grass. After leaving Signal Peak near Dora Roberts's ranch, no promontories guided travelers.

Christine DeVitt

Although born south of Midland on a sheep ranch in 1885, Christine DeVitt, a gangly, curly-haired girl, would take root on the north end of Sulphur Draw eight years later, on her father's new ranch, the Mallet. A prairie fire had destroyed the sheep, which led David DeVitt to take advantage of public sales on the north end of Sulphur Draw, beginning the Texas Mallet Ranch about 1894 or 1895. Its rust-colored sand and never-ending blue sky, a natural canvas for sunsets, etched themselves in the heart of the girl, who many in the Lubbock area would come to call "Miss Christine" and the "wealthiest woman in Lubbock." At the time, though, without shelter or schooling on this frontier, DeVitt sent Christine, her siblings and her mother to Fort Worth. He visited periodically between buying land and cattle. The family returned to the Mallet in summers.

The public lands' policy had changed, and prices had increased to two dollars an acre for a maximum of four sections. To comply with state laws, DeVitt had to "prove up" his land, which meant erecting a

On a green patch of irrigated land, an oasis amid the sands of the Mallet Ranch, a ranch family makes their home.

Mallet Ranch chuck wagon, a favorite time for Christine DeVitt. *Courtesy of Wadkie Fowler's (former foreman) family.*

house and living there at least six months out of every year. Christine and her mother, brother and sister rode the train from Fort Worth to Big Spring. There, they piled into wagons loaded with strip lumber for the ride up Sulphur Draw to Mallet Ranch. Mallet hands helped build the two-room "box and strip" homestead house in this no-trees region between Lubbock and the New Mexico border. Indeed, the Mallet lay one hundred miles from the railroad and fifty miles from the four-year-old village of Lubbock, truly an isolated part of the country kept that way by severe droughts. For this new life, Christine left behind formal schooling, piano lessons and an insulated, brick home.

She loved it. She rode roundup and enjoyed the cowboys and the landscape, where nothing intruded but clumps of the prolific blue grama grass. After that, for the rest of Christine's youth, she and her siblings—two brothers and a sister—seesawed between summers of roundups and cowboying and education and music during the school term in Fort Worth. Ranch, education and music—three themes braided into her life in these early years—would continue for a lifetime.

Hungry for more land, Christine's father partnered with a more experienced rancher, John Scharbauer of Midland. In 1897, Scharbauer sold out to DeVitt for the land and six thousand head of cattle, a transaction estimated to be worth $55,000 dollars. The *Texas Live Stock Journal* regarded the livestock as "one of the best-bred herds in the Panhandle," a reputation that could explain Christine's drive to manage the ranch "like her Daddy" when she took over. Cattle in this area required lots of land: "40 acres per cow; 20 per steer"—a lot of land. The Mallet now covered fifty-two thousand acres.

While Mother Nature would still be a force to reckon with on this frontier, new battles ensued. For DeVitt, it was another rancher, C.C. Slaughter. Slaughter's cowboys disputed DeVitt's ownership and fencing of the Mallet, threatening with guns. Rather than up the ante with firepower, DeVitt took the battle to the courtroom by organizing the ranch, legally, in Missouri, outside Slaughter's political reach. This began a history of paper battles rather than bullets, a tactic Christine would pursue during her reign over the Mallet in decades to come. By January 1904, the maneuver saved the Mallet for DeVitt and his partner, a man named F.W. Flato Jr., son of a Flatonia, Texas rancher.

About 1910, Christine graduated from high school in Fort Worth, probably Fort Worth High School (forerunner to today's Paschal High School). She faced and accepted the reality that her younger brother, not

her, was destined to take over the Mallet. (Her other brother had been killed in a hunting accident.) So she packed her boots and jodhpurs and went east to boarding school, Hollins College in Virginia, for two years and then Forest Park College in St. Louis, where she graduated. Away from home, family and her beloved Mallet, she blossomed, especially around music and a revered music teacher in St. Louis. She recounted this time spent among other young women often and repeatedly to listeners in her later life. Here, besides the continuing influence of music, Christine also found an affinity for bookkeeping, a skill she would bring to bear in managing later on. Returning to Fort Worth, she taught for a while at Riverside High School and the elementary school she had attended, DeZavalla. She also taught private piano students for several years.

But not much is known about Christine during her twenties, thirties and forties. Vague but poignant references are made to strained relationships with both parents. Probably her father's philandering provoked her mother to pick up and move from Fort Worth to California. Christine's younger sister went with her. Later on, in 1921, Christine followed, believing she was needed there.

Terms like "strong willed, bull headed, a gentle friend, tall and gangly, deep voiced, a heart as big as Texas, if she liked you, a talker who expected others to listen, a high stakes poker player, a procrastinator" swirled around and about Christine. Both parents found her "criticism" and overbearing nature too much. Her mother fretted that Christine would be left out of the will, yet she did not adjust her own will to include her eldest. David DeVitt had clearly stated he would "disinherit her." Perhaps they were too much alike. It has been reported that he led two lives: that of an austere, tight-fisted penny pincher on the ranch and that of a wealthy, ranching playboy in Kansas City and New York. Later, Christine followed his path—she was tight-fisted on the ranch but wanted recognition as a wealthy and powerful Texas rancher on larger stages. However, she did open her pocketbook to friends, ranch hands and their families, exposing a deep generous streak beneath her crusty exterior.

She joined her mother and sister in California while her father wheeled, dealt and flirted from California to Kansas City. When the Depression of 1929 hit, he sold interests in the Mallet to save it, and those tentacles of ownership, stretching across the country and the decades, would come back to haunt Christine. At that time, her youngest sibling, David, a respected "cowboy" on the Mallet, was being groomed to take over.

But in 1932, he died in a high-speed collision with a tractor-trailer. An amiable sort, David was liked and enjoyed by many, the popular butt of cowhands' jokes while growing up. His death devastated the family and community. That left Christine, the eldest, but who was still on the outs with her father. Before he took action to disinherit her, perhaps ambivalent after the loss of his son and displaying procrastination—another trait he and Christine shared—the senior DeVitt died.

In 1934, two years after her brother's funeral, Christine arrived in Lubbock with a chip on her shoulder for lawyers and brothers-in-law and determined to protect the Mallet and her family's majority interest. Other shareholders wanted to break up the ranch and sell it off in small farming lots. Christine took on the job of keeping the Mallet intact and in the cattle business. A spinster at age forty-nine, she moved into the Hilton Hotel and began pulling the strings of Mallet land and cattle operations. The headquarters of the ranch house, where her family had lived while she was growing up, had been her father's, and it was supposed to be her brother's when he married. She did not want to live there. Occasionally, she would overnight there, leaving the barn and the house the way they were, a memorial or, perhaps, a hankering for more pleasant memories.

Christine's hands were full. The Depression struck drought-plagued Staked Plains ranchers and farmers hard. Her father had brought in partners to keep the place afloat, and those partners finagled to keep Christine from making decisions, despite her title as manager. She fired back, doing what she could to impede decisions of the manager the partners had chosen.

One decision Christine brought about, though, rescued the Mallet. She negotiated a handsome lease for the first oil well on the land in 1937. After eleven years of lawsuits and countersuits, she won. Christine DeVitt was manager of the Mallet by 1948. With the help of cowhands and foremen, she rebuilt the Mallet Hereford herd, profitably, the way "Daddy did it."

One pasture, however, remained a pure, grazing pasture, "the way it was when Daddy had it." No wells could be drilled on what the cowboys nicknamed "Purity Pasture." Some 1,100 wells now dot other pastures of Mallet Ranch.

A warm sense of trust and joy accompanied Christine's visits with the foremen and their families, especially those who had worked for her father. Ola Mae Fowler, later remembered by Christine in her will, wrote: "Miss

Mallet Ranch headquarters house. *Courtesy of former foreman Wadkie Fowler's family.*

Christine had a new Buick and would come and spend time with us and never wore out her welcome." The Coke-swilling Christine would arrive with a couple cases of her favorite beverage, and the kitchen table in Mrs. Fowler's home became the "campfire" for long nights of laughter and storytelling. Mrs. Fowler's husband, Wadkie, had been a favored foreman on the Mallet, let go by the partners to put in their own man after David DeVitt died.

Easygoing in this atmosphere, Christine seemed to relax out at Sundown, Texas, enjoying these friends and their children and grandchildren. September became a special month, as Christine's birthday was now shared with Ola Mae and Wadkie's grandchildren, Kathy and C.D. They celebrated birthdays together on the Mallet for numbers of years. Christmas was a family affair with Christine and the Fowlers as well.

Today, a granddaughter, a local teacher, recounted times Christine would arrive with a case of Cokes and a monologue of stories. Later, this young woman, Kathy Palmer, encouraged to teach by "Miss Christine," sought the rancher's approval of her fiancé. "I was so nervous," Kathy said of the time. She loved her young man and

Above: Christine DeVitt riding the paint horse on the Mallet Ranch with a friend. *Courtesy of former foreman Wadkie Fowler's family.*

Left: Christine DeVitt sharing a birthday party with Wadkie Fowler's family. *Courtesy of former foreman Wadkie Fowler's family.*

wanted the blessing of the woman who had encouraged her dream of becoming a teacher.

The Mallet "boss" fit in fine with the Fowlers. They had experienced her gentleness and kindness not only to themselves but also to many others. They offered no judgment; she offered no criticism. Not so in town.

In town, Christine reveled in being a "rich and powerful Texan" and kept charities cooling their heels until midnight on New Year's Eve for her annual tax-deductible contributions. In those environs, she neither trusted the people about her nor respected them, as her lawyer once complained. She played high-stakes poker in her apartment at the Hilton and griped bitterly about income taxes. She drank Cokes until the cleaning crews rebelled over the cleanup. The Hilton evicted her.

She bought a house in Lubbock, then another and another—largely to shelter a menagerie of stray cats she collected. Neighbors disapproved. People in town and ranchers one hundred miles away described her as "nuts." Those who sought donations called her "eccentric."

When Christine's sister Helen returned to Lubbock after years away, her company and gentleness might have polished off some of Christine's rough edges, helped a little, perhaps, by aging. Helen brought Christine into the world of women's study clubs and Lubbock's art and music community. She introduced Christine to ideas and projects that needed help through their collective wealth.

Christine agreed and eventually founded her CH Foundation. Her first gifts went to the Methodist Hospital and the School of Nursing. Her funds allowed upgrades in facility and technology. The foundation has continued to support efforts as varied as the YWCA and YMCA, prevention-of-blindness projects, education, music and the arts.

Without a doubt, Christine's favorite was the building of the Ranching Heritage Museum at Texas Technological University. Her foundation sent millions that way, asking only that it memorialize her parents. And so today, a plaque announces the David and Florence DeVitt Wing of the museum. Though Christine shunned publicity about her gifts, the university's museum named a wing after her.

From the 1,100 wells pumping on the Mallet, a steady stream of dollars flows into Lubbock and other South Plains communities. She wanted to help locally, and she did not want to fund churches.

Christine DeVitt, having lived at the Methodist Hospital for her last four years following a stroke, died on October 12, 1983, shortly after celebrating her ninety-eighth birthday.

Dr. and Mrs. Holden of Texas Tech flank Christine DeVitt, an enthusiastic booster of the Ranching Heritage Museum. *Courtesy of former foreman Wadkie Fowler's family.*

Dora Roberts and Christine DeVitt lived on separate ends of Sulphur Draw, their influence in different quarters of the twentieth century. One struggled to create a ranch. The other litigated to maintain one. Both negotiated prime mineral leases. Both lived through nine decades. Both spent their final years in hospitals. Both had the foresight to set

up foundations that continue to pump wealth into the communities of Big Spring and Lubbock—Christine's around the Caprock, and Dora's around the state.

Dora Roberts bequeathed funds to church-sponsored enterprises. Christine's foundation, in keeping with her wishes, continues to shun religious requests. Dora Roberts's town home has become the Howard County Museum. Christine and her sister helped fund the Ranching Heritage Center at Texas Tech, a project in memory of their parents, and Dora Roberts's foundation also has given it a boost, as have numbers of area ranchers, such as Ninia Ritchie of the JA.

These two women guided their ranches through droughts, disasters and a major depression into successful Hereford operations and oil kingdoms as surely as Sulphur Draw channeled early settlers.

CHAPTER 8

STAKING CLAIM ON THE "STAKED PLAINS," 1870s–1900s

In a land that would grow anything with water, new settlers arrived. Out where the sky rises high and the horizon seeks infinity, the South Plains of Texas would mesmerize some with its wide-open spaces and defeat others. This space between Fort Worth and the New Mexican border, territory characterized by the table-flat Caprock in one area and deep, wending canyons in the other, spreads out across the southern sector of the Panhandle. People brought with them dreams of land and ranching; the early ones, owning or partnering to own grand spreads. Later, when some of the giants sold land section by section, public lands came available. Developers recruited settlers. Small rancher-farmers, called "shortgrass" people, answered the call. It was their turn to make a go of ranching and farming, or not.

Large ranchers who remained and their cowboys clashed with "the nesters," as these smaller folks were called. They clashed over grazing, boundaries and a way of life during a period termed the "Nester Wars." When the small ones moved in, the population increased. Towns and counties formed. Schools opened. When the nesters failed, driven out by loneliness, wind and drought (and perhaps not enough land to run cattle profitably), they moved out, causing schools to close and towns to dwindle until the next influx.

Lizzie Bundie Campbell

Lizzie Bundie married a cowboy with more than a dream in his bedroll—it would be no small ranch for him. From study and experience, he had knowledge of cattle and what they required. Confederate veteran Henry (not Hank) Campbell, a plantation youth, had grown up far more interested in what he could accomplish from horseback than from a school desk. He studied cattle and what it took to raise them. He hired out to drive large herds to California (and smaller ones north) for wages ranging from forty-five to seventy-five dollars a month.

In 1871, on a trip back to his Ellis County (Ennis) home base and with a sizeable stake, he won the hand of Lizzie Bundie, a twenty-year-old Navarro County woman who was well educated and had a mind and ideas of her own. Henry continued to drive cattle. One season, he gathered a herd of his own, the dream of just about every cowpuncher in Texas; trailed them to Chicago; and sold for a profit of fourteen dollars a head (they cost him nine dollars; he sold for twenty-three dollars). Henry's success attracted investors to back his vision of a large ranch, the dream that culminated in founding the famed Matador Ranch with the "Flying V" brand.

Meanwhile, Lizzie stayed put in Ennis. There, she gave birth to their first child, daughter Erin, who was born in 1878 but lived only a few days. The following year, Henry found the land he sought, vast stretches with "good grass, ample water from running streams and seep springs and protection from the severe plains winters in the broken terrain of the Caprock Escarpment." A variety of grasses such as "buffalo, curly mesquite, blue-stem and blue gramma" carpeted the area's rolling hills. He bought out a buffalo hunter's camp at Ballard Springs in 1879 and moved into one of the two dugouts. The first cattle arrived next. Not Lizzie, though.

It's been said she told him, "I will not have dirt over my head until I die." While stocking up his land with cattle, acquiring more when folks called it quits, he formed the Matador Cattle Company. Now he could build a house for Lizzie, who had moved a little closer, to Fort Worth.

Miles of sagebrush and mesquite, grass and sky, "with little else but glimmering, dancing mirages" greeted her when, in 1880, she rode out to join Henry on a wagon loaded with windows. It had been a three-hundred-mile trip from Fort Worth, the nearest railroad. Arriving at Ballard Springs, she saw mounds of sun-bleached buffalo

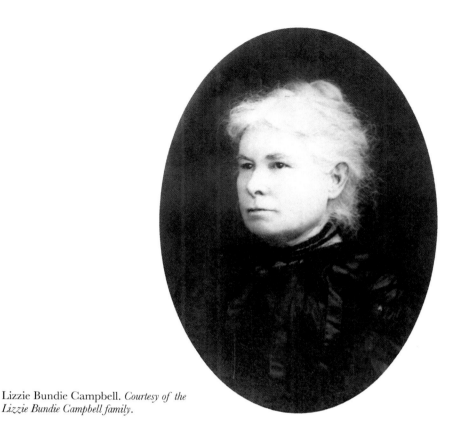

Lizzie Bundie Campbell. *Courtesy of the Lizzie Bundie Campbell family.*

bones piled up not far from the dugouts, remnants from days when the U.S. Army hired hunters to reduce the Indians' livelihood, making it easier to remove them to reservations.

While Lizzie rode with the windows, lumber for her home had been shipped from Fort Griffin. However, it was not quite enough; in building the two-room box, cowboys placed the planks so far apart that snow and dust whistled through the cracks, which she stuffed during winter. But she called it home. She had lived in a tent alongside the dugout and supervised the work, which was completed on March 25, 1880. In her excitement, Lizzie planned a Christmas party and ordered decorations. These did not arrive until the following March on an oxen-pulled wagon. The beginnings of her rangeland hospitality waited a year. She made do that first year with "mostly native products" for the Christmas tree. They strung a "native cedar tree with popcorn and odd bits of colored

ornaments." In later years, Lizzie's son, Harry, provided the following description of that first Christmas in his mother's words:

> *For the Christmas dinner, I prepared two wild turkeys, which as usual at that time of year, are very lean and dark but larded liberally with strips of bacon—the bacon coming from wild hogs killed on the range—and with excellent dressing they were voted a great success. I also prepared antelope stew with sinkers (cowboy name for dumplings), venison steak, boiled hams, wild rice and canned corn (the only cereal and vegetable on the ranch), apple pies made from dried apples and a washtub full of doughnuts. I had put up a liberal amount of wild plum jelly in the summer, and this served as a substitute for cranberries. I had brought out with me from the East (Ennis and Fort Worth) some popcorn, which I popped and made into popcorn balls.*

The cowboys favored these treats. When they left, headed back to their line camps, Lizzie packed them a lunch from the Christmas foods. The following year, 1881, brought more joy with the birth of Harry, the first white child born in territory that would become Motley County. A doctor rode out from Fort Worth and stayed on the Matador with Lizzie until the birth.

Similar to other women moving onto sparse ranges, Lizzie battled loneliness. Neighbors lived twenty to thirty miles away, and the only other woman, Mollie Goodnight, lived on the JA Ranch in Palo Duro Canyon, sixty miles distant. When they visited, they stayed for weeks, travel being long, rugged and dangerous. An avid reader with subscriptions of magazines and newspapers and a good collection of books, Lizzie also spent time sewing and might have joined other plains women in the crafting of "crazy jugs." Her great-granddaughter recalled, "So lonesome, they would get a jug like a whiskey jug and find knickknacks—seashells, broken colored glass, etc.—and stick them onto the jug," a manner of entertainment in a solitary land.

Years later, Lizzie's son, Harry, told a story about another way in which his mother coped. One day, when a tinker passed through, she traded all the flour and sugar on the ranch for a dog to keep her company, not realizing how long it would take to replace the staples. She and the ranch went without until a trip could be made to Fort Worth.

Adding to her sense of unease, left alone many nights and days, cowboys carried stories of Indians traipsing through. Although moved

out of the canyons and onto a reservation in Oklahoma a few years before, small bands would slip away and return to their hunting grounds, even though buffalo herds had been decimated. Recently, Henry had told of a boy being snatched by wandering Indians but eventually let loose in the neighboring county.

No wonder Lizzie's imagination could fill in fearsome details when they got stuck in a water-filled creek on the way to Colorado City. When the team bolted and yanked out the wagon tongue, Henry went for help. Left alone with her child, Lizzie entertained these trepidations—bears, panthers, coyotes, Indians and any manner of two-legged threats—as darkness settled. When her husband returned, she laid down the law. No more crossing of water. Not by horse, not by wagon, not by buggy. "Never again," she said. And from that day forward, wherever they drove, they skirted water crossings.

But those fears did not stop Lizzie. While she did not work cattle, she relished ranch life and explored the Matador, a ranch that would grow to become a 1.5 million-acre home to ninety thousand head of cattle. She rode horseback, alone. Her son said, "She liked to ride over the hills just to see what was on the other side." That's how she found the petrified forest, a patch of petrified wood that would come to be known on early maps as "Mrs. Campbell's Petrified Hill." Along the way, Lizzie took water samples from various creeks and streams that crawled through the land and analyzed them.

Curious, intelligent, adventuresome and elegant but not snobby. Those traits have been used to describe Lizzie by cowboys, family, neighbors and writers. It's no surprise, then, that she saw to her son's education. At first, far from any school, she hired a governess and then enrolled him in public schools that ebbed and flowed with the population. In the coming years, Harry Campbell would complete his formal schooling at Ennis, the Campbell hometown, and attend AddRan Male and Female College in Thorp Springs.

Lizzie's fondness for ranch life extended, in spades, to Matador cowboys. She cared for them, respected them and took care of them in so many ways. Matador hands named her the "Angel of the Matador."

She doctored. Although not trained in medicine, she set broken collarbones when a horse fell on a cowboy. She removed bullets. She administered medicines for illnesses such as "measles, mumps and fevers." She made poultices from prickly pears to bind on boils and acquired a reputation as a fine diagnostician. She sewed up cuts, even reattaching a

finger severed by a rope. She told the men, "Go find it," and when they did, she stitched it on. Although bent, the finger she saved worked. Night or day, Lizzie Campbell delivered the medicine, bandages and braces her "boys" needed.

A lineup of hands that numbered up to 125 during branding and roundup kept her busy. She cared not just for their medicinal needs but also their spiritual needs, arranging for a minister to hold monthly services at the ranch. The need for all of them to socialize prompted the first of a continuing tradition of annual holiday parties. After that first cowboy and family Christmas of 1880, as she says, "I wasn't on the ranch the next couple of years." But after that, beginning in 1883, she gave what became her famous Christmas parties, what she is most remembered for in the lore of the Panhandle.

Cowboys from the Matador, including all of its twenty-five line camps, as well as neighboring Spur Ranch hands, arrived to eat and dance. Lizzie prepared a "wagon load of food" to serve "from fifty to a hundred people" at the first fling. Families from within one hundred miles arrived; everyone was invited. Lizzie also invited some women, five the first year, which was a small number when compared to the fifty men, but they danced all night. Taking a break from the three-day affair, women slept on the floor of her home, while the cowboys "tended for themselves." But Lizzie had rules. No whiskey; no quarreling. "Her wishes were generally respected," one said.

Winter in the Panhandle could be, and often was, blustering and cold. The men described stamping through a blanket of white, knocking snow off their boots before heading into the mess hall. Recent arrivals would warm themselves by one of the fireplaces and eat. Built in 1883 and lit by lanterns, the hall would later host parties. The first night of the social, Lizzie served a seated dinner, probably family style on all available perches. After that, it was buffet style, food for the taking whenever anyone wished. Then the fiddlers tuned up and spun out melodies for quadrilles, waltzes and schottisches. In her white house, called the "White House," often dressed in white and with a yard surrounded by a white fence, Lizzie hosted and presided over the original "Cowboy Christmas Ball" through 1890.

Her role took on more responsibilities as early as 1887. The "Angel of the Matador" handled mail for cowhands and arriving settlers. The Matador Ranch served as post office and Lizzie the postmistress. Later on, she would return to those duties in the town that grew up and took

its name from the ranch when Henry organized Motley County and appointed himself judge. Some say he appointed her postmistress; others credit President Grover Cleveland. She served off and on until Judge Henry Campbell died in 1911. Before and after, she maintained her interest in politics, both local and national, and was well read from the abundance of newspapers and magazines she and Henry had received since living on the Matador.

Henry quit the Matador at the end of 1890, leaving it in the hands of his Scottish backers, with whom he disagreed about the future of ranching. In early 1891, Lizzie and Henry moved off the Matador to set up a town and move onto their own spread—a newer, smaller ranch, as he had advocated. This is the Campbell Ranch that continues in family hands today.

People called Henry a prophet. He had advocated breaking up the Matador, bringing more people into the country. At the last Christmas party that Lizzie gave, in 1890, he stood to read a farewell speech but handed his notes to her when his voice broke. Reading for him, she passed on the foresight he offered for his men to think to the future, prepare themselves and learn the cattle business. Subsequent Matador superintendents and their wives continued the annual Christmas party tradition that Lizzie started.

And Lizzie kept the Campbell Ranch in family hands, passing it on to her son and his heirs at her death on October 8, 1931, at age eighty, having lived over fifty years in the lower Panhandle, the last twenty as a widow. The Campbell Ranch passed from Lizzie to her son, to his three sons and to their children. One, Cheryle Campbell Stark, said, "Now our sons are taking it over." Their family ranch sports the seal of a "Heritage Ranch," awarded by the state of Texas to ranches that have remained in the same family for over one hundred years.

Mary Alma Perritt Blankenship

Moving into the fringes of large ranches, between the likes of the Matador and the Mallet, came what locals called the "shortgrass" people, small farming ranchers who were not welcome. And in 1902, that numbered Alma (Allie) Blankenship and her husband, Andrew. They arrived to

homestead on the Staked Plains, the Llano Escatado. His father and six brothers ranched out of Stephenville, and Allie and Andy set out to do the same out here. Arriving among these never-ending reaches of tall grass, she said of her life in those early days, "We had plenty of time to be still and know God. He was our nearest neighbor."

Their homestead lay about twenty miles, or a day's ride, southwest of Lubbock. A lawyer, a friend of Allie's, passed through Stephenville the year before telling of land that would be opened for homesteading soon. Ready to move out and away from the sharecropping plots they had farmed since their marriage in 1895, the Blankenships loaded a wagon of goods, grabbed their baby boy and headed west to their 2,500 acres that straddled Hockley and Terry Counties.

Eight families filed on new homestead land in this region. Homestead laws required them to move some possessions onto the land and file in Lubbock, where, as Allie described, there was a "courthouse, several stores, a hotel, and a wagon yard." The only woman in this caravan of the goods of eight families, Allie borrowed an eight-year-old boy from another family to keep her company. Other women had chosen to wait until the three-month time commitment had been met before leaving for this frontier.

A teen bride, a girl orphaned as a four-year-old, Allie, with her husband, Andy, forged a new life on these plains. They brought cattle with them and ranched, but on smaller lots of land—four sections or 2,560 acres versus the thousands of acres under Slaughter and Mallet brands nearby. They grubbed out fields. Not welcomed, they were called "little men" by ranchers because of their small spreads. They drew water from existing windmills, despite warnings. Their developer, the lawyer who had promoted the opening of these public lands to homesteaders, was found murdered at the base of a windmill. His murder, instead of scaring off the newcomers, incited them to stay.

Allie described some early nights when she was left alone with a shotgun, a baby and an eight-year-old boy. In the evening, cowboys from a large ranch rode out to the windmill and circled the house, seemingly to threaten her. They came back the next night. Allie looked for someplace to run but on the flat terrain and through the high grass could not see a trail to anyplace other than the lone windmill, where the cowboys circled but did not advance.

Her husband returned with their filings, and they pressed on, growing their herd and establishing themselves in the settlement of this

land between Lubbock and the New Mexico border. In later life, Allie chronicled this settlement, providing a glimpse of the countryside at the time and the way of life. She described the flat land as being populated with "thick winter grass, scattered mesquite, bear grass and cat claw bushes." Springtime growth she described as "green prairie grass," with white and yellow buttercups dotting the prairie along with red-orange Indian blankets and "highlighted by the 'candlesticks of God,' or bear grass."

In moving west, it was a lonely time with few encounters with other women. As Allie said, "We felt the absence of life on the Great Plains and were always starved for company and thirsty for conversation." She lived in their wagon until the men of this homesteading group helped her husband build their first home, a dugout. Left alone with her baby and the neighbor's boy when Andy and the other fellows rode to Lubbock to finalize receipt of their claims, Allie described her fear: "Too scared to sleep…the three of us and the shot gun occupied the same feather bed." This granddaughter of a traveling revival preacher described these times, in which an altar of both Bible and shotgun occupied their home and, when visitors called, "seven or eight hogsheads" would lay side by side on the table, ready to address any threat or mischief.

They cooked over dried mesquite limbs, and when those ran out, they dug out the deep roots for fires for cooking and warmth and then augmented these with "prairie wood," cow chips. They put up fences in previously open grasslands that could hide a rider on horseback. In warmer months, they planted and harvested, making ready for severe winters. She described a particularly harsh winter in 1905: "We ran short of coal, grubs and chips and had to burn corn for heat, which we gathered from the tops of the stalks left sticking out of the deep snow." The snow covered their feed stacks, and cattle could walk over fences because of the snow's depth. "The horses wore icicles," she wrote, as did the men, who had them dripping from their hair, beards and mustaches.

Summertime tempered the weather, but this was dry country, and a drought could plunge them into another disaster—not enough water and wind-deprived windmills. However, the Blankenships moved their cattle off to New Mexico for more watered grass only one time, she said.

The prairie windmill served many functions other than pumping water. When Andy would leave for freighting trips to Big Spring, 110 miles away down Sulphur Draw, Allie created a plains lighthouse, hanging a lantern in the windmill so he could find his way home. When cattle died in these blizzards, Allie and Andy skinned them for the "hideman" and sold their

horns to be polished for hat racks, not wasting any portion. They spotted down cattle from the windmill tower, and they also used it as a signal tower for lunch for the hands by hanging a cup towel high up.

With the arrival of other homesteaders and occasions for getting together, Allie described her role and that of other women: "The pioneer woman of the prairie soon sacrificed her femininity as she laid away her frills for the plain living, and took upon herself the yoke beside her husband as team mate and companion." This meant side by side in the saddle riding across the land, tending fences, cattle, hunting, stacking feed or pitching bundles.

Rainy winter days brought respite not only from droughts or dry spells but also from work. On these days, they might ride to a neighboring farm or ranch, play dominoes, toast their boots to the open fire, parch peanuts or pop corn. They told "tall tales," a Texas heritage, and they chewed, smoked and dipped snuff. Allie admitted in later years that she "laid down my snuff box and picked up cigarettes."

Although they started as small ranchers, the countryside showed them that they didn't own enough land to prosper in cattle ranching. Helped along by the Great Depression, they turned their ranch first into part-farm/part-ranch and then into a cotton farm. Andy mourned the loss of ranching. Allie recognized "that this would ultimately be our stronghold." And it was. Her memoir, *The West Is for Us*, gathered from scraps of paper that she had held onto and compiled for a 1955 exhibition titled "The Saga of the South Plains," was published by the West Texas Museum Association in Lubbock in 1958. Allie died a few days before the exhibition as a wealthy woman, a far cry from her "orphan's portion," as she termed her childhood with grandparents. Andy's death had preceded hers by a few years.

Allie and Andy Blankenship pioneered this section of countryside in the early twentieth century. By the mid-twentieth century, irrigation provided a boom, and the region contended for the reputation of cotton belt of the nation.

CHAPTER 9

MOUNTAIN AND DESERT RANCHES TAKE IN "GUESTS"

O ut in the far reaches of Texas, where the Rio Grande bends large and the Chihuahua Desert flattens between the Chisos Mountains of Mexico and the Davis Mountains, ranchers struggled. When droughts hit, long and severe, and their herds were decimated, women turned to their land to support them in a different way: hospitality. One such woman, Mrs. Hallie Crawford Stillwell, said, "There's something about ranch life that you don't give up. Everything I ever did was for the ranch. I can't imagine life without it." Certainly this was a sentiment she shared not only with Mrs. Ora Pruett Prude in the Davis Mountains nearby but also with ranchers all across Texas.

In Fort Davis, Mrs. Prude turned her working cattle ranch into a dude ranch and education center, enhanced by her renowned cooking talents. Mountain breezes and the dry air of the West offered cool respite for city dwellers in years before air conditioning. A little east and south of her, Hallie Stillwell found more greenbacks in tourism than cattle, but like Mrs. Prude, she kept running cattle. Hallie's daughter opened a general store, and then "Miss Hallie" opened an RV park near Big Bend National Park. Mrs. Stillwell told stories, regaling customers and becoming a tourist stop herself in later years.

Both women, widows, held on to ranches handed down by their husbands and reared their children to help out and then take over. And so they did.

Ora Pruett Prude

In the rugged Davis Mountains, originally known as Limpia Mountains, Ora Jane Pruett grew up on a ranch, having moved there at age three, shortly after the army's last battle in 1880 with Victorio, a Mescalero Apache chief. He led a band fleeing their New Mexico reservation into the Davis Mountains, raiding and killing. Chased into Mexico by the U.S. Army stationed at Fort Davis, Mexican soldiers killed Victorio and many of his raiders. With the end of terror, the countryside opened up for settlement in the mountains around the fort. Ora Jane's family arrived on August 1, 1880, moving from her birthplace in Santa Fe, New Mexico, via Tom Green County near San Angelo, Texas. An army troop the Pruetts met on the way told her parents that no more Indian skirmishes had occurred in Limpia Canyon.

The U.S. Army had constructed and occupied the fort in 1854, naming it for Jefferson Davis. The name soon applied to the town that grew up, as well as the encircling mountains. During the Civil War, the Confederate army moved in for a year. It abandoned the fort, which then stood vacant for four or five years. Not until after the war did U.S. troops return with "Buffalo Soldiers," the name Indians gave to black troopers. Except for one lieutenant, Henry Ossian Flipper, the first African American graduate of the U.S. Military Academy, officers were white. Although dismissed from the service at Fort Davis on June 30, 1882, for "conduct unbecoming," Lieutenant Flipper was exonerated of false embezzlement claims by the army a century later.

The Pruett family arrived in a Conestoga wagon. On the summer journey, Ora Jane's mother kept milk cool for her young children by wrapping it in towels and hanging it on the shady side of the wagon. They herded fifty milk cows onto some open range and then contracted with the fort to provide butter and milk. For the price of a pound of butter—and the Pruetts sold one hundred pounds a week—they could buy an acre of land at twenty-five to thirty cents an acre. They could also buy an acre for the price of two glasses of buttermilk, seventeen cents each. The older children, Ora Jane's four brothers, milked every day, and her mother churned.

By October 1881, her mother counted the family treasure—$1,800 saved to buy land—and the Pruetts settled in Musquiz Canyon, where they built a one-room adobe house, set out cottonwood trees on the

This sign welcomes visitors to Prude Guest Ranch in Fort Davis.

creek bank and then built a one-room school for their children and those of canyon neighbors. Two years later, however, they sold and moved, buying two sections at $1 an acre. This parcel had water. Each child homesteaded land, as allowed, and the Pruetts moved their herd, now 450 cattle, onto the property and dammed the creek. Now that they had irrigated fields, Ora Jane's mother grew a vegetable garden, selling the produce to the fort.

By this time, Ora Jane had reached school age, and her family hired another governess to teach her and her siblings before they moved into Fort Davis in 1884–85 to attend public school. Three years later, they moved back to the country and another governess. Ora Jane and her brothers grew up riding with her father on the Pruett Ranch, a sizeable stake of 253,000 acres. The spread remained in family hands until 1926, when her father sold to the Kokernots, the land becoming part of the 06 Ranch.

Later, managing the distance and tough terrain, Ora Jane's mother took the children into Alpine for school, where they would graduate. Ora Jane and her sister then attended Baylor University from 1893 to 1895.

Well before that, though, Ora Jane had danced all night with a young man with whom she would usher in a new era. For her generation and that

of her children, dancing became the most popular entertainment—first at other ranches, then the Bloys' camp meeting and finally the second floor of the county courthouse. In her youth, distances between dance floors were long and rugged and the mountains high. Ora Jane and her brothers would pile into a wagon for a full-day ride to a ranch or camp meeting hosting a dance. They danced all night and then returned to the wagons for another daylong ride home.

The Davis Mountains topped out at 8,378 feet at Baldy Peak atop Mount Livermore. The town site that grew up in the valley around the army post sat a mile high. The terrain discouraged a lot of socializing, as most young people usually received their education in a ranch school or by a governess without contact with other young people. But a Presbyterian minister moved in, riding between the ranches, providing worship and beginning a long-lasting tradition: camp meetings. After one woman suggested the idea to include women and children, the Reverend William Benjamin Bloys started the camp meeting in 1890, and it continues, each August, sponsored by Presbyterians (as he was), Methodists, Baptists and Disciples of Christ. At one such camp meeting, Ora Jane Pruett met and danced with young rancher Andrew G. Prude, or "A.G.," as he was called, son of another Davis Mountain rancher. A spark flared. His family had arrived six years after Ora Jane's. At the time they met, he worked for a brother but wanted a place of his own. She selected a site that would become the Prude Ranch because of its big oak trees. In 1893, he took her to the courthouse to claim a brand and suggested the "3-Bar." She registered it under her name. The teenage coed, about to be off to college, now possessed a brand.

A couple years after she returned from Baylor, she and Andrew married at the Pruett Ranch in 1897 and then danced all night on the second floor of the courthouse in Fort Davis before "retiring to their home," the site Ora Jane had selected a few years before. That became the thirty-section Prude Ranch, on which she rode and worked roundups and other tasks for the four hundred red, white-faced Herefords, each one sporting her 3-Bar brand on its left hip. Soon, however, the first of her five children arrived, needing her hand.

As these young Prudes grew up, they rode the five miles into town for school on horseback or in a buggy to carry several at one time. "Before we had an old pickup, we would tie the horses to a fence and then ride back to the ranch," said John G. Prude, one of Ora Jane's sons. They lived in the main ranch house, where the trees that guided Ora Jane to

select the site continued to grow. One still grows—through the roof of the present dining hall.

"Grandmother left instructions to never cut those big oak trees," John Robert Prude said. And they have not.

In biographical notes compiled and housed in the Archives of the Big Bend and signed off on by Ora Jane Pruett Prude, it is said, "During Mrs. Prude's girlhood, she rode with her father almost as much as her brothers…and enjoyed it." After she married Andrew, "she went with her husband on most of the round-ups…Mrs. Prude is now 55 years old…She still enjoys riding…preferring to ride her old sidesaddle."

After the turn of the century, Fort Davis began to grow, especially in summers. Residents called them "summer swallows"—rich people from "the East" (San Antonio, Houston, Dallas and the Gulf Coast) looking to escape the heat of their regions. They found respite from sweltering, humid summers in the dry mountain air of Fort Davis with its cool evenings and mornings. Ora Jane's son offered them horseback rides into the mountains on Prude Ranch horses. What had been riding to work cattle or for transportation became a tourist attraction.

Down cattle prices in the depression following World War I and the Spanish flu epidemic of the same era found their way into these mountains, imperiling townsfolk and ranchers alike. But as one neighbor said, "The Prude Ranch would have gone under if not for Ora Jane."

In 1921, she began taking in boarders, opening bedrooms to guests, who were entertained by her son's singing of cowboy ballads and his knack for horses, particularly his ability to match riders to mounts for a pleasant excursion. Most agree that Ora Jane's reputation as a swell cook, once for hands and family and now for guests, came to be a big draw, not to mention her big oaks for shade. In later years, she handed off the kitchen range to daughters-in-law and granddaughter-in-law Betty Prude. The last of the Prude Ranch kitchen matriarchs has kept her hand on the reins of the menu today, especially for the kids' summer camp, which she and her husband, John Robert Prude, started nearly sixty years ago, adding to the draw and sustainability of Prude Guest Ranch.

In the early days, though, Andrew Prude ran the cattle operation; Ora Jane, the guests and kitchen; and John G., also known as "Big Spur," the remuda. The 1930s arrived with another major drought and the Great Depression, a rough time all around, and Ora Jane's children helped out. John G. taught to help support the ranch, not completing his degree that he began in 1922 until 1934. When Andrew died, in 1940, Ora Jane ran

Mrs. Ora Prude opened her ranch to guests, the "Summer Swallows," fleeing summer's heat in 1921.

Prude Guest Ranch and its cattle operations with help from her children, especially Big Spur, who helped out during his summer vacation from teaching. A career begun to support the ranch drew to a close forty-six years later when he retired from Sul Ross State University as education professor. He loved teaching—so did his son, John Robert, known as "Little Spur," and his wife, Betty.

Post–World War II years brought on a double-whammy of financial difficulties: a postwar recession and air conditioning hit "the East," winnowing the flock of summer swallows, who could now stay home in the cool. With help from her children, Ora Jane pulled through this period, continuing the working cattle and horse ranch alongside her guest ranch.

Instead of inheritances and trusts deeding the ranch generation to generation, the Prudes passed on the land and the brand by purchasing it, first from Ora Jane, in 1945, and then from John G., in 1959. John Robert and Betty, teachers in Odessa, bought the ranch at a time when, if they had not, "we would have had to let it go," according to John Robert. But, as he said, "Grandmother started it…we try to do all we can to give them [the guests] an experience." Being teachers, they instituted

summer camp and education programs for children and adults. They expanded available rooms to rent for adults and built dormitories for kiddoes. Today, their granddaughter directs the summer camp program with help from family members, who arrive for the occasion to make sure it's done right, the Prude way.

One day, Ora Jane called Betty. "I think it's time to take me to the hospital."

"Are you hurting?" her granddaughter-in-law asked.

"No, it's just time to go."

Two weeks later, in 1977, at 101, Ora Jane Pruett Prude died. Her grandson said, "We got to live on the ranch a long time with her. She taught us how to live, and she taught us how to die." The Prude Ranch, whose location she chose and which she helped to build and, when needed, change, a ranch amid the desert mountain seesaw of prosperity and struggle, continues today with fifth-generation family involvement, but with an outside investor in charge. The 3-Bar brand, Ora Jane's brand selected for her by a young man in love, rode the left hips of Prude Ranch cattle—first the Highland Herefords in 1893 and then the crossbreds in the 1960s and '70s—until the last beeves left the range about a decade ago.

She left a legacy for family and community at Prude Guest Ranch that she began in 1921. Continuing events include summer camps for kids, reunion and retreat gathering places and holiday events. Also, the ranch became the site for the annual star-watching party in this area that boasts the blackest sky, the reason the McDonald Observatory and its massive telescopes sit atop a mountain up the road from Prude Guest Ranch and on earlier family land.

About the time Ora Jane Pruett Prude married, Hallie Crawford took her first breath. Both women lived long and contributed much to their families and this far West Texas community.

Hallie Crawford Stillwell

Hallie Crawford Stillwell's personality and spunk, spanning nearly a century, took her from a "pistol-packing" teenage teacher on the Rio Grande to the "Matriarch of the Big Bend," visited by governors and

Hallie Stillwell being congratulated by former first lady Lady Bird Johnson. *Photo courtesy of Marfa Public Library, Marfa, Texas.*

first ladies and, at the end, eulogized in the *New York Times*. She garnered such a following not by luck but by scrabbling to do the next thing to feed her family and keep the Stillwell Ranch operating.

Hallie liked people, and she dressed to receive them in long-sleeved print dresses, a bit of a contradiction from her beginnings. She arrived in Alpine in 1910, driving a Conestoga wagon and its team. At age twelve, alternating days with her sister, Hallie took the reins of a family wagon, in which they moved from New Mexico back to Texas. Her responsibilities included not only driving but also feeding and watering the horses, checking their hooves and hobbling them when they stopped. In later years, she reflected on this experience, saying that it was the first of many experiences in which "you've got to do what you've got to do." And that meant shouldering responsibility, one she exercised throughout the twenty-four-day trip from New Mexico.

When Hallie started sixth grade in Alpine, and throughout the rest of her years there, her mother clucked over her tomboy ways. Hallie confirmed this but noted that being independent and responsible, as well as being able to ride and shoot on par with the boys, paid off in

Hallie
Stillwell
(right)
sharing a few
laughs with
former Texas
governor Ann
Richards.
*Photo courtesy
of Marfa
Public Library,
Marfa, Texas.*

spades when she married Roy Stillwell, a man more than twice her age, in 1918. They moved to his twenty-two-thousand-acre ranch with his one-room, "about 12 x 16 foot" headquarters house, fourteen or fifteen miles from the Mexican border in the Chihuahua Desert and forty-six miles south of Marathon, Texas. There, she would see no other women for long stretches of time. There, she would experience soul-wrenching loneliness, communing with nature from atop a boulder out from the house beneath a star-studded sky, her gaze on the blue mountains, the Chisos. There, she would "dress like a man, work like a man and act like a man until I thought I was a man," as she wrote years later. Yet when she headed out with Roy "and the boys" to check on cattle in

Above: Sighting through to Mexico from Texas's Big Bend, "The Window."

Left: Like most ranch women, Hallie Stillwell was as at home on a horse as anywhere else. *Photo courtesy of Hallie Stillwell Hall of Fame Museum, Alpine, Texas.*

days before fencing, saving newborns and young ones from the dreaded screwworm, or when rounding up and branding, she wore face powder and lipstick—every day. Of these daylight-to-dusk rides, she would say, "I've been so hot I could have died. I've been so cold I thought I'd freeze. I've been so tired I thought I'd drop. But you just go on."

And Hallie did go on. As did female ranchers before her, whether it be Henrietta King or Lizzie Williams, Hallie adapted her clothing. Khaki riding skirts (which had a flap across the front, hiding the split britches), fine for in town, would not work. They spooked the ranch horses. Her mother made a pair of riding pants that ballooned in the stride in such a way Hallie could neither mount nor dismount. Chagrined, she took a pair of pants from one of the cowboys. "I wore men's pants with a high-neck shirt, long sleeves, gloves and a jacket," she said. "I wore chaps, boots and spurs, a handkerchief around my neck and a man's hat." The sunbonnet women had worn to cross the plains of the last century and that shielded them from the drying ravages of sun in the 1920s would block her vision while riding, according to her husband.

For years described as hardheaded, stubborn and independent by family, especially her parents, and later herself, Hallie credited her parents for providing a loving family that let her exercise her independence and know she was loved and safe. Hallie took her first breath on October 20, 1897, in Waco. The Crawford family spent the next ten years on a peripatetic path: to Ozona, to Tom Green County near San Angelo and to the Estancia Valley of New Mexico before the move to Alpine. Once in this crook of Texas, her father, who alternated between being a rancher and a grocer, settled down. Hallie and her siblings graduated from Alpine High. Simultaneously, she earned a teaching certificate at the Normal School for Teachers in Alpine and hired out to teach in Presidio, Texas, Juana Pedrasa's country, where Hallie earned hazardous duty pay, an extra ten dollars a month in 1916.

During these years, Mexican bandit Pancho Villa ranged back and forth across the Rio Grande, raiding and murdering, seeking revenge against Americans because President Woodrow Wilson had recognized Villa's enemy as the head of the Mexican government. "We didn't know where they were going to hit next," Hallie said.

Not surprisingly, her parents objected to her move to Marfa. Too dangerous, they feared. Her father called it a "wild goose chase." She responded, "Then I'll gather my geese." And she did, years later titling her memoir with that comeback.

Above: A teenage teacher in Presidio during Pancho Villa's raiding years, Hallie Stillwell wore the riding skirts of the time, a flap across the front to hide the britches. *Photo courtesy of Hallie Stillwell Hall of Fame Museum, Alpine, Texas.*

Opposite: A crack shot, Hallie Stillwell rode her ranch to protect her livestock. On this day, a puma threatened. *Photo courtesy of Hallie Stillwell Hall of Fame Museum, Alpine, Texas.*

But since Hallie persisted, her father wanted her to go well armed. Guy Crawford gave his daughter his .38 officer's pistol, which she stuffed in her waistband every day on the mile walk to school. In class, she rested the pistol on top of her desk, within easy reach, in case of raiders. They struck all around, but not at Hallie or her school. When the army believed that Pancho Villa was most dangerous, she forted up in the garrison, where drunken soldiers proved to be more bothersome. Of these times, Hallie said she never fired the gun at anyone, "but they knew I could."

After a year in Presidio, she moved to Marathon, a safer place farther from the border. A blind date with Roy, an older widower, led to her marriage in 1918. Once again, her parents disapproved of her decision, not just because of his age but also because of his fondness for liquor, cards and horse races. Called taciturn and gruff, a cowboy of the old ways, Roy knew how to win Hallie's heart: he hired a Mexican band to serenade her. He drove a racy Hudson Six. They honeymooned in San Antonio.

And then they returned to Stillwell Ranch, booting his three cowboys from the one-room house. The "boys" didn't approve either, saying the "teacher" wouldn't last six months. They resented having to bunk in the

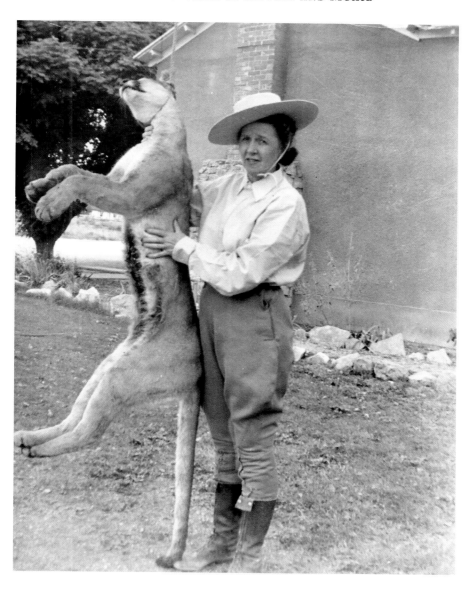

barn. The newlyweds spread their sleeping bag on the floor and made it home. In the mornings, Roy showed his tenderness by bringing Hallie a cup of coffee and frying up the bacon. That memory of scents and tenderness, stitched in the routine of their marriage, would be one she would wake up with and treasure after Roy died from an accident thirty years later.

After a period of what today might be called "hazing," while she learned the ropes from Roy, a tough taskmaster, Hallie became his most steadfast partner. He would rather ride with her than anyone as they covered the land, took care of cattle, built fences when those reached the Big Bend and then repaired them. Besides, because of Pancho Villa's marauding, neither Roy nor the cowboys would leave Hallie alone at the house, even though she could shoot quite well. So, when children started arriving, in 1919, 1921 and 1922, Hallie moved into their Marathon house to be near the doctor until after the births. She hired a young Indian girl to care for them afterward, and she returned to riding with Roy. That arrangement lasted until Son (the eldest), Dadie (the middle child) and Guy (the youngest) reached school age. In those school years, Hallie and the kids lived in Marathon during the week and on the ranch on non-school days.

With her first pregnancy, Hallie recognized her life had turned a corner. Now, she was responsible for a new life—gone was the partying that had beckoned them to town. After the first year on the ranch, however, and despite a town home she enjoyed, for Hallie, Stillwell Ranch was home. "It seemed to be the place where I belonged, the place of contentment and utter tranquility," she recalled. There, she would sit on a rock and "listen to the various creatures of the land as they gathered their families…what a luxury." It would be on that rock that she would stare at the blue mountains, the Chisos; take sight of a soaring golden eagle; and gather her inner strength after Roy died.

But long before, other crises would hit. World War I siphoned off cowboys, leaving them shorthanded, and Hallie's brother died in an army camp from the Spanish flu that decimated large swaths of the local population. Shortly after her first child's birth, Hallie, Roy and their housekeeper all came down with the flu. They survived, and the ranch picked up until the Depression hit, accompanied by tanking beef prices and a severe drought. Like ranchers across the country, the Stillwells accepted the government's offer to kill the cattle and sell for twelve dollars a head. With heavy hearts, Roy, Hallie and their children herded their weakened cattle into the canyon, and the government men provided what Hallie always called "a mercy killing" because of the little water and no food available. That didn't mean that all five Stillwells did not cry at the scene, one "I hope never to see again," she said.

During this desperate time, in 1930, Hallie had signed on as a correspondent for the *Alpine Avalanche* to help ends meet, writing as the

"ranch editor," her first step into a world of newspapering and writing that would broadcast her name. Three or four years later, rains came at last to this Big Bend country. She and Roy restocked their herd. Ranching, however, in this bend of Texas continued to seesaw between drought and plenty. During the hard times, Hallie worked extra jobs, including as a hairdresser, in a flower shop and as a cashier at a café. She did whatever it took to save the ranch.

The 1940s brought different challenges. Pearl Harbor's bombing called her elder son, Son, off to war. A few years later, her youngest child, Guy, donned the army khaki for four days, a speedy homecoming brought about by victory. The workforce on the Stillwell Ranch had grown lean and Roy older. After the war, after selling off a third of the land, their Dove Mountain Ranch, to help with expenses, Roy drove to town to buy hay for the cattle and a couple loaves of bread for Hallie. On the return trip, loaded with hay, he overturned and died the next day. The year was 1948.

When Hallie had married Roy and made the Stillwell Ranch her home, it was long before electricity or piped-in water, not to mention refrigeration or phone service. She had tugged her husband into some improvements, such as electricity and room additions when the children came, but not many. A tough yet tender man, he had taught her to be strong and knowledgeable about ranching.

Now Hallie had to take over, and that she did after a long bout of soul searching on that boulder underneath the starlit sky. The leading edge of the worst drought in Texas history already had struck the Stillwell Ranch. Hallie was a grandmother now, and as she said, she "squared her shoulders" to keep going. She could not wilt. The young—not only her children but also the young livestock—needed her. She rode nearly every day looking for calves and shooting at predators such as coyotes, eagles and panthers. Running out of feed, she shipped some of her herd to Colorado to summer on the green grass, as many Texas ranchers have done through the years. The railroad lost some of her shipment, a common occurrence; she challenged and, despite the odds, received a fair settlement. Her son followed the herd to Colorado to tend them, and Hallie hired a Mexican man to help her.

In the midst of this, a woman who had visited a few years earlier asked Hallie to come to New York City and help write a book about place names of the Big Bend country. Leaving her foreman in charge of the homeplace, which was beginning to see some July showers, and Guy with

the cattle in Colorado, Hallie took off on a train for her first trip across the country. Using her formidable charm and reasoning prowess, she convinced the stationmaster to wrangle her a ticket aboard the booked-up train. He did. At a layover in New Orleans, a railroad official gave her a tour of the city, mistaking her for someone high ranking. And she spent a couple weeks in New York City seeing the sights and making plans for the book, *How Come It's Called That?*, co-written by Virginia Madison and completed and published in 1958, a year after the drought broke and the cycle swung to floods. When the drought ended, more than 100,000 farmers and ranchers in Texas had moved to town. But not Hallie Stillwell—at least not permanently.

Early in the drought, her older son had moved to Oregon and suggested they buy a place there for their cattle. On the heels of her New York trip, Hallie boarded a train and met him. They made plans, and she called her banker back home. He tried to dissuade her, but she persisted, telling him she knew what she was doing and asking, "Do I get the money or not?" He agreed. She arranged to ship her cattle from Colorado to the ten-thousand-acre Oregon spread that would endure one of the harshest winters that part of the country had ever seen. They lost some cattle, but her son saved most, and they fattened up well. A season later, they sold the Oregon ranch and cattle, pocketing a much-needed profit for the Stillwell Ranch, and Son came home.

On the home ranch, Hallie's other son had been hauling water for the cattle every day. He and Hallie had burned prickly pear so the herd could eat without stickers, a common practice in West Texas during the 1950s. Meanwhile, her family had grown, but life had not proved easier. She often repeated what a banker told her, that he would finance feed for her livestock but not the family. She went to work at a talent that came naturally to her, storytelling, but it was a talent not yet harnessed. However, through visitors she met in town at one or more of her sundry jobs, she went on a speaking tour of college campuses and other venues in Kentucky, particularly. Amazed at pocketing $130 for a two-hour stint on her first appearance and having held students captivated for the full time, "Hallie Stillwell, ranch woman from Texas," as she was introduced, launched a forty-year career as a lecturer. She returned home from this first trip with a nest egg to buy feed for the cattle. Although her formal lecture tours came to an end in the late '80s, she never stopped telling the stories of the Big Bend, her exploits of learning to ranch and of the people and ranch life that shared her neighborhood. She just did so from

The Rio Grande, once known as Rio Bravo, divides Texas from Mexico.

the front porch of the convenience store and RV park that she and her daughter started and ran in the late '60s.

Before that, though, Big Bend National Park, authorized in 1944, brightened prospects for the area to emerge as a tourist draw, a venture Hallie supported, although she mourned the loss of friends from across the decades whose homes were displaced. The park, about five miles from Hallie's ranch, would contribute to easier living in years to come. But not yet. She still needed to slog through the '50s. Her family—both sons, her daughter and a granddaughter—suffered numerous illnesses. Desperate, she called a family council and decided to sell the ranch. Her younger son, Guy, couldn't work the ranch because of back problems. She had a buyer but then could not go through with it. She held another family council. To sell would mean breaking a promise to Roy, as she saw it. However, what Hallie did sell, with regret, was the house she and Roy owned in Marathon. Those proceeds went for cattle feed. After nailing down three jobs at one time, Hallie breathed easier. She could make ends meet for a while.

One day, while having coffee at the Holland Hotel in Alpine, a fellow asked Hallie to string for the *El Paso Times*, which she did. She later did

Above: Hallie Stillwell worked a lot of tasks to feed her cattle during drought years. *Photo courtesy of Hallie Stillwell Hall of Fame Museum, Alpine, Texas.*

Opposite: A water witcher like this found water for Hallie when the well on the site of her ranch's wax factory gave out. *Photo courtesy of Hallie Stillwell Hall of Fame Museum, Alpine, Texas.*

the same for the *Fort Worth Star Telegram*. After her co-authored book came out, in 1958, the *San Angelo Standard-Times* and the *San Antonio Express* hired her as a stringer, as did wire services Associated Press and United Press International.

Needing help on her ranch, she employed what she called "wet" Mexicans. Arriving "half-starved," she would feed them for a few days and let them sleep in her barn before they could work. She relied on these workers, as she said, if not for the ranch then for another venture—wax. Fueled by demand during the Korean War for candelilla wax—a hardening ingredient in food, cosmetics and varnish—she started a wax plant. She grew candelilla, which often looks like dead twigs, in abundance in out-of-the-way places on the ranch. Proceeds went to prop up the ranch: mortgages, taxes, feed and family.

After President Truman beefed up border control, Hallie had to get her guys legalized, a process that had her storming both sides of the International Bridge and furious with the men in her truck, who were so excited about their new papers they went for a drink in Mexico to see if the document worked. It did. She finally got them back to her place and the wax plant, which spewed out $1,000-a-month profit until the water

well required and used to boil the plants went dry. A few years before, the Stillwells had hired a water witcher. One of the sites he indicated as holding water was near the wax plant. She directed the men to dig. It took sixty-seven days to crack through the rock to the aquifer, but they did, and the new well put the wax factory back in business.

Hallie had her hands full between family needs, a ranch that teetered on collapse for seven or eight years, a slew of writing jobs and a wax factory venture that sustained the cattle's feed costs.

When the rains came and notes were paid, the Stillwell Ranch remained in Hallie's hands and that of her sons and daughter. The hard work could be left for others, finally. And Hallie got a job that lasted for fourteen years, from 1964 to 1978, as the first female justice of the peace in Brewster County. She presided over court, handing out fines to her best friend, Inda Benson, a known speedster; jailing her grandson and buddies for drinking underage; and fining the mayor for speeding—all with equal justice.

Before long, Hallie was called on to judge something else: the first Terlingua Chili Cookoff, in 1967. She continued that role annually, wearing the jalapeño crown as "Queen of the Terlingua Chili Cookoff." The chili duel started with a dare between two Texas chili cooks. They agreed to hold the contest at Terlingua (a mining ghost town at the time), where it still takes place. The forty-eighth annual Terlingua Chili Cookoff will bubble up on October 30–November 1, 2014.

During this time, with a financial gift from her brother, Hallie realized a vision for the Stillwell Ranch: turning a corner of it not far from Big Bend National Park into an RV park, the Stillwell RV Resort, alongside her daughter's grocery store. At her retirement as justice of the peace, at age eighty-two, residents gave her $1,000 to put down on a "ticket to anywhere." She went to England alone, a trip she relished for years to come. Then, after retiring to her Stillwell Ranch in 1979, Hallie spent time with her daughter at the store, regaling park visitors with stories by and about her life as a Texas ranch woman and the history of Big Bend.

But she did not just retire. She wrote her memoir of her years up to 1948, the year Roy died. In 1991, Texas A&M University Press published *I'll Gather My Geese*, named after her quip to her father when she left home in 1913. Numerous accolades came Hallie's way after this, including being inducted into the National Cowgirl Museum and Hall of Fame in 1991 and the Texas Woman's Hall of Fame three years later.

The Texas ranch woman holds a copy of her first book and memoir, *I'll Gather My Geese*, outside the Hallie Stillwell Hall of Fame Museum at her RV park and grocery store. *Photo courtesy of Hallie Stillwell Hall of Fame Museum.*

Hallie built an addition to the store and, on her ninety-fourth birthday, opened it as the Hallie Stillwell Hall of Fame Museum, which she furnished with elements of life from the Stillwell Ranch as well as other artifacts and memorabilia from around the Big Bend. She promised another book, as she told the late Evelyn Koger, a Lamesa-area ranch wife, saying, "And I'm going to call it *My Goose Is Cooked*." Hallie came through. The first ten chapters picked up after the death of her husband. In these, she described the drought as well as—if not better than—anyone. This drought had driven many to town; she, too, had gone to town, but to save the ranch. And then recreation kicked in, because of her foresight of an RV park, to provide a comfortable retirement. But the ranch continued, as she had promised Roy in one of those moments sitting on a boulder, staring at the blue mountains of the Chisos.

A stroke felled Hallie before she could finish her second book, as the "Matriarch of the Big Bend" died on August 18, 1997, two months and two days before her one-hundredth birthday. Author Betty Heath put the finishing touches on *My Goose Is Cooked* and included some of Hallie's unpublished notes, as well as published columns about the "ranch years." The Center for Big Bend Studies published the book in 2004.

Hallie Stillwell did what she had to do—waited tables, visited with state governors, chased cattle, told her stories in print and on the stage—with a flair as large as her personality and as large as other legends of Texas.

The Stillwell Ranch & RV Resort continues today, but in different hands. The recent drought forced the sale of the Stillwell cattle in 2011. Hallie's daughter and a granddaughter kept it going while they lived. Remaining heirs sold the ranch in August 2013 in the midst of another extreme drought. Today, a Schulenberg doctor holds the reins with plans to convert the cattle range into a wildlife area while continuing the Stillwell Ranch & RV Resort, Grocery Store and Hallie's Hall of Fame Museum.

WOMAN TO WOMAN: CONTINUING FAMILY TRADITIONS

W omen have stepped into saddles—sidesaddle, western or eastern—to manage ranches with family in mind. In the Panhandle of Texas, they had to make it on cattle and horse revenues rather than oil. Or they succumbed to the early twentieth-century trend of breaking up large spreads into smaller parcels. At least one of the large ranches depended on a woman, the JA, a Palo Duro Canyon spread owned and managed by Cornelia Wadsworth Adair. It dwarfed most. Another pair of women would sustain and thrive on a somewhat smaller, ten-thousand-acre ranch on the High Plains, a bit south and west of the Palo Duro. The Binfords, Kate and Nancy, ran the M-Bar throughout their lives. All four women established reputations as superb horsewomen, excellent and fearless riders and savvy ranchers.

Cornelia Adair

The famed JA Ranch, "first in the Palo Duro," beckoned the first two non-Indian women who followed the steep trail 1,500 feet down from the ridge to the canyon floor. In the summer of 1877, Cornelia Adair, with Molly Goodnight, gazed across red rock walls and down the slope to the "hard woods" that lent their name to the canyon that framed a stream,

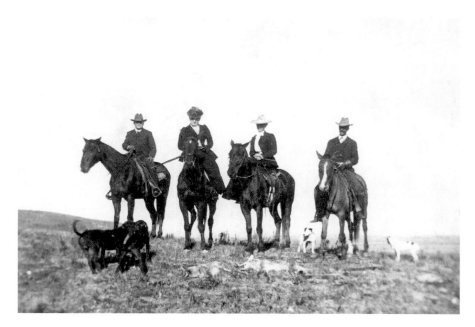

Cornelia Wadsworth Adair riding sidesaddle with her cowboys on the JA Ranch. *Photo Courtesy of Panhandle Plains Museum, Canyon, Texas.*

Prairie Dog Town Fork of the Red River. From the rim, Cornelia, her husband, the Goodnights and their hands admired waves of golden grass, cottonwood, willow, juniper, mesquite and salt cedars along the walls and lining the canyon floor.

Cornelia Wadsworth Adair had ridden four hundred miles from Colorado to the Panhandle, and she rode sidesaddle, as most women did in this post–Civil War era. This trip, brought about by her fascination with the West, followed a buffalo hunting expedition along the Platte River in western Nebraska. Born in Philadelphia 1837, Cornelia grew up in New York society and relished not just the society balls but also the chase of a hound during hunts.

Growing up riding, and loving it, she expressed bafflement at the U.S. Army wives she encountered who shunned riding. And they did not understand Cornelia when she visited, a relative of a ranking officer. Cavalry units protected the expedition that took place in Plains Indian country before General George Custer's Battle of the Little Big Horn. Sleeping under the stars, eschewing a military ambulance (a wagon)

made ready for her, this adventure, likened to safaris today, seemed to spring to life Cornelia's childhood dreams.

As a girl in Genesco, New York, she was lured by the tales of the West—Indians, buffalo, plains and mountains. No wonder, then, that she encouraged her husband to relocate his finance office from New York to Denver after this first expedition and, later, to back a rancher with huge dreams who had lost his bankroll in the Panic of 1873. The Adairs and Goodnights arrived in Palo Duro Canyon just three years after the Cheyenne, Comanche and Kiowa had been driven from the canyon and onto reservations.

John Adair was Cornelia's second husband. Her first husband, Montgomery Ritchie, whom she had married in 1857 and with whom she had two sons, died in 1864 from illnesses contracted as a Union officer in the Civil War. Three years later, she met John Adair, a member of the Irish gentry, at a New York ball, and they married in 1869, beginning a life of alternating between living in New York and living abroad on his Irish and English estates. In 1874, they left for the adventure that would change Cornelia. She would alternate between living in Europe and Texas rather than New York. She prodded her husband to invest in cattle ranching, befitting her fascination with the West.

Adair brought money to the ranching venture, while Goodnight brought experience as a cattleman. His reputation for knowing cattle and horses, as well as the countryside on which they needed to roam, attracted Adair, who backed Goodnight's vision of extremely large ranching, providing money for land and cattle. Goodnight proposed Adair's initials, J.A., for the name of the brand and the ranch. Adair joined a bevy of European financiers bankrolling Texas ranches.

Cornelia's female counterpart on that first trip from Colorado to Palo Duro was schoolteacher Mollie Goodnight of Weatherford, Charles's wife, who drove a team and a wagonload of supplies while Cornelia rode. They would be four hundred miles from the nearest train or supply depot. As soon as he could, Goodnight started buying land in what became a "crazy quilt pattern," snagging plots that provided shelter, grass and water.

After settling into the small house Adair had built the year before from native salt cedar trees, and on future trips to the ranch, Cornelia set out on long rides to find the right place for the ranch's headquarters. She explored a wide valley in the canyon backed by a high bank that brought shelter from winter winds yet remained accessible from the other sides. Her chosen site remains the headquarters of the JA Ranch.

Over the next few years, Mollie would become known as "the mother of the Palo Duro" for her care of the men, the cattle and the buffalo as she shouldered ranch-building tasks with her husband. When he found motherless buffalo calves, she tended them, helping to save buffalo from extinction. The Goodnights and Adairs formed a partnership that reaped over a $500,000 profit in the first five years from a ranch that had grown to 1.3 million acres with ninety thousand head of cattle.

John Adair died midway through their second five-year contract. As with so many women before and after her, Cornelia stepped in. Even in the early days, she had insisted that Goodnight pay the highest wages for men who were skilled and reliable, a requirement she continued. Unlike her husband, who viewed cowboys as "servants" unfit to share a table with, Cornelia welcomed the men who worked for her to her dinner table in the Big House, a nineteen-room rock mansion. And she joined them during roundup, sharing beef and beans at the chuck wagon.

Cornelia partnered with Goodnight for the duration of the contract and then bought him out. Known as Lady Adair, she proved to be an easier partner than her husband to get along with, even as she grew more involved in operations. But Goodnight was ill and faced what he termed the ever-increasing "nester" problem. He urged her to find someone to manage so that he and Mollie could move to a smaller place. When the Goodnights moved on, to ranch and form a town and a college that bore their name, they agreed he would take over Cornelia's "first" ranch, the Quitaque sector and its 140,000 acres. Adair had bought it for Cornelia so that she would have a ranch in her name. Now she had the JA Ranch in her name only. As sole owner, she became "one of the few women in the world to preside over such a huge business and financial empire…she loved every minute of it." Her reign began just after the railroad whistled by the canyon, eliminating the need for long trail drives and bringing eastern markets closer.

Cornelia continued running her ranch for the rest of her life. While she might manage from afar through managers she hired, a common practice of Europeans investing in the American cattle business, she remained ranch boss with buying, selling, hiring and firing responsibilities. She visited annually, usually in October for roundup. One foreman who might have doubted her hands-on management learned the hard way. One year, while riding the range during her annual visit, Cornelia found some speckled cows, San Simones. The foreman had ignored her directive to run only Herefords. She fired him on the spot. Equally particular about

horseflesh, Cornelia required the JA horses be bays, dark brown with a black mane and tail and "preferably stockings." An article in the October 17, 1901 *Canyon City Stayer* newspaper reflected the men's reception of her: "The cowboys are expecting a grand time when she arrives." The paper also dubbed her the "English cattle queen."

In addition to her ranch mansion, Cornelia built one in Clarendon, where she supported community needs and services, specifically funding a hospital, supporting the local Episcopal church, helping to build the first YMCA and getting the community to adopt the Boy Scouts of America, newly arrived in America in 1910. A friend of hers in England had started the Boy Scouts in 1908.

Cornelia had grown up on land near Genesco, New York, that her family had purchased from the Seneca Indians, and this legacy of keeping land in the family she sought to continue. She would hand over the reins at her death, in 1921, to a son too ill to manage, as a result of World War I. In 1931, her grandson, Montie Ritchie, a teenager at the time of Cornelia's death and who had been living and educated in England, would visit the JA for the first time. Even in those Dust Bowl years, the twenty-one-year-old embraced his grandmother's ranch and, in the next few years, bought out other heirs. In 1935, he assumed management. His first task was to win respect of the cowboys. The rookie proved himself in horsemanship and as a cattleman. Next, he needed to rescue the ranch from indebtedness after fourteen years of absent stewardship.

Montie would hand the JA's reins back to another woman, his daughter, another Cornelia. He noted, "A fourth generation who loves the ranch and knows most of its secret places and will likely carry on the family tradition, my daughter Cornelia." Today, Cornelia Wadsworth Adair's great-granddaughter, Cornelia Wadsworth Ritchie, lives on and runs the JA. Having been the ranch boss since 1993, she continues the tradition of the ranch in family hands now for over 130 years, 93 years after the first Cornelia died on September 22, 1921.

Cornelia "Ninia" Wadsworth Ritchie

This Cornelia, better known as Ninia, grew up on the JA. She followed the cowboys and her father, accompanying him and the crew on cattle

drives. Her mother died before she reached school age. An only child, she played with the other children of the ranch and, when she reached school age, joined them on the JA school bus for the trip to Claude. It was no surprise, then, when she would say that they were more than crew or friends; they were her extended family. She mentioned that "headquarters Paloduro" was a small community.

Like her great-grandmother Cornelia Adair, Ninia has exhibited respect and affection for JA hands and families that live in about fifty houses spread across the ranch. Her managing partner said of her, "It would be impossible to write about Ninia without addressing her compassion for people and love for the JA crew. [She is] one of the most caring and generous ranchers I know." He wrote this in nomination for her induction into the National Cowgirl Museum and Hall of Fame.

Ninia attended the Claude school with other ranch kids until she turned ten. She spent her middle school years in Colorado, living either nearby or on the Colorado ranch her father purchased in 1960. For high school, she selected Garrison Forest School, an all-girls boarding campus in Maryland noted for its riding program. There, she competed in jumping and hunting events, perhaps shades of her great-grandmother's thrill of the hunt but certainly in an English saddle, not a sidesaddle.

Art history became a passion, an interest shared with her dad, an avid collector. Yet her love for the ranch trumped most other pursuits. She returned to the mountains of Colorado for college, pursuing an art history degree, and in 1975 married a young Texas man with whom she had a son. After their divorce, she bore down on learning the ranching business by watching her father work and working alongside him and the cowboys. She continued her interests in art and in preservation of the Panhandle and cowboy way of life with museum contributions and the establishment of museums. In later years, she placed the Colorado ranch in a conservation easement to protect the "view corridor" from her land that sprawled between Denver and Colorado Springs. She also donated the JA's buffalo herd, the Charles Goodnight herd, to the state of Texas. Designated as the official Texas State Bison Herd, they now roam in Caprock Canyons State Park in Quitaque.

Ninia gathered cattle and branded, side by side with her crew, certainly a step her aristocratic great-grandmother did not do, but times were different back then. Of her cowboys, Ninia said, "They gave me a master's degree in ranching…taught me about the land, animals and living away from civilization." All agree, Ninia "knows every square inch of the JA."

When her eldest hand, indeed "Texas' oldest working cowboy," Tom Blassingame died, "it had been his wish to rest on the ranch. Ninia led an empty saddle procession to the cemetery, followed by the cowboys from the ranch. She took Tom's favorite gray horse, saddled it and turned his second-best pair of boots backwards in the stirrups," an act to honor a fallen comrade "by showing an empty spot that is hard to fill."

Ninia's father died in 1998, having already handed her the titles of owner of the JA Ranch and president of JA Cattle Co. Since 1993, the JA has been hers, and she became even more involved in the details of ranch management, such as prescribed burning of control brush to restore prairie and wildlife habitat, rebuilding fences and restoring the century-old original buildings of JA headquarters. In the sundrenched and arid rolling prairie around the canyon, she needed to develop new watering sources, not to mention the perennial fight to curtail juniper and mesquite. She has practiced "rotational grazing…rest every pasture periodically."

An effort this modern rancher has engaged in with U.S. Fish and Wildlife has been to restore the plains and protect playa lakes, providing habitat for the endangered lesser prairie chicken and rebuilding bobwhite quail numbers. Ringing playas with grass to slow erosion and fences to deter the two-legged kind helps. Playas are circular, shallow lakes, usually but not always under thirty acres in size and refueled by rain and irrigation runoff. The state's wildlife department calls them the "most significant ecological feature in the Texas High Plains." As country music legend Red Stegall said, "[Ninia] constantly works at making sure she leaves the ranch as healthy as possible when it comes time to pass the land to her son, Andrew Bivens."

For all these reasons, Cornelia "Ninia" Wadsworth Ritchie was inducted into the National Cowgirl Museum and Hall of Fame in 2009, her first year, rare considering a waiting list of nominees that stretches into the hundreds. "The nomination was more than enough," she said at the ceremony in October 2009. "I never, ever, dreamed I would be inducted. It's the most incredible honor of my life. My father and Cornelia would be so proud."

In her acceptance speech, she choked up but managed to allow that those two would also be pleased that the fifth and sixth generations of family are queuing up. Ninia's son, Andrew, joined her management team in 2005, paying particular attention to land management. He and his wife, Wendy, provided Ninia with a couple grandchildren to treasure.

Of her life on the ranch, struck by the beauty today as her-great grandmother had been in 1877 when she first peered down into the Palo Duro Canyon, Ninia said, "It's staggeringly beautiful…the light's always changing…the birth of a foal or a calf…it just touches you." She described greeting sunrise while riding out in the mornings to gather up. "It's a pretty good way to go to work," she chuckled, and qualified that to mornings above fifty degrees.

Cornelia "Ninia" Wadsworth Ritchie continues the family western traditions first dreamed of by a girl, the "first Cornelia," and with her management team has brought the JA into the twenty-first century, surviving the latest drought. No small feat.

Kathryn Binford

A twenty-year-old horsewoman rode the train from home in Prophetstown, Illinois, to its last stop in Wildorado, Texas, in 1908. Kathryn Cabot (better known as Kate), her parents and a sister took one of the first trains to this town of one hundred, the town only eight years old at the time. Kathryn's mother, a noted photographer, required a drier climate for her health. Some of the sprawling Panhandle ranches, however, were breaking up, and parcels for small ranchers and farmers came available. As produce farmers and horse breeders (of Percheron, large draft horses, and Standardbred trotters and pacers) in Illinois, the Cabots acquired a couple sections around Vega, Texas, west of Amarillo, most of it yet to be fenced. "The train tracks stopped at Wildorado, so from there we finished our trip to Vega by wagons," Kate said years later.

Fencing would come soon. But before that, Kate would meet an Iowan here to scout his family land prospects. Gene Binford, a lawyer who never professed to enjoy law practice, persuaded his parents to let him run the ranch out of Wildorado. They did. He and Kate married in 1910 and a year later moved onto the Binford Ranch, where she would make her home for the next three quarters of a century. Gene Binford had a sure and steady partner in Kate. She had been training the people-friendly Standardbreds since a girl of twelve. She would make a dummy out of stuffed clothes and put that on the horse first. After letting them get used to the dummy, she mounted up, displaying an early knack for

horse training and patience, traits she would hand down to her younger daughter, Nancy.

The Binfords' ten-thousand-acre ranch, northwest of Wildorado, sprawled south of the Canadian River and north and west of Palo Duro Canyon. The river and its deep gorges divided the Llano Escatado from the northern High Plains. In these Canadian Breaks, Kate and Gene moved into a two-room trapper's cabin, a log and sod shelter first designed by mountain men in the fur trade.

They registered their brand, the "M-Bar." About the time the newly married Binfords settled in, the U.S. Army stepped up its call for remount horses. The Binfords responded, breeding ("using Thoroughbreds as studs to improve the colts") and supplying the cavalry with mounts until the need passed after World War II.

Their stallion breeding program, however, was not all that Kate took part in. She joined Gene on a trip to Tulia to buy their first cattle. They made this first trip in a horse and "our democrat, a buggy," camping out for two nights each way. When they finished selecting the herd, the seller challenged Gene. "Let Mrs. Binford select the bulls," he said.

Kate did. "As she was through with her pick the man just sighed: 'She ruined me!' Mrs. Binford had chosen his best bulls." A chronicler of her life noted several years ago, "Her pick is the best." Binford cattle gained a reputation as "good, hardy, well built animals." Kate and Gene drove their new herd home, on horseback, of course. They loaded wagons with post and wire and "went around building fences in their spare time." Kate rode fences with Gene, participated in roundups and branding and helped with newborn calves and foals. She loved the ranch and animals; she even bottle-fed her pet antelope that romped through these plains, tucked him in their car and sent pictures to family in Illinois.

Often selected for jury duty in Tascosa, Gene met those obligations with Kate by his side. Usually, their stay would be a week, which afforded them time to visit with friends, while camped out on another rancher's place, and fish.

In 1912, a week before she delivered her first child, Kate and Gene moved to town. She drove the team; Gene rode. "Next fall," she said, "we will be in our Ford when we go. I have decided to have Gene and I get one together and I will learn to runn [*sic*] it first and then teach Gene afterwards."

Kate had given birth to two boys, in 1912 and 1914, but they died in infancy. Her first girl, Barbara Ferne, arrived in 1918, followed by Nancy in 1921. From the outset, the Binford Ranch was a family affair. Both

girls accompanied Kate and Gene on the feed wagon on cold winter days. Kate drove the wagon; Gene rode a horse. They built a larger house, a fine house. Kate's reputation as "a fine horsewoman" traversed these High Plains.

Beef prices fell during the Great Depression, and, as in most of Texas and the Southwest, winds, sand and dust blew, earning the decade the title of the "Dirty Thirties." One neighbor lamented: "Dirt piled clear over fences and buildings and grass was so scarce they even had to burn the stickers off the bear grass (a small Yucca) and grind the leaves and roots to feed the stock."

The struggles deepened in 1934. In that one year, Kate lost both parents and her husband. But the M-Bar was home, and that's where she stayed. Her daughters, now sixteen and thirteen, attended school. When they left for the day, Kate prepared the horses for Barbara and Nancy and asked them to join her after school to tend cattle, calves and fences on the ride back home, continuing the work of the ranch and its livelihood, entrenching their bond. She fed stock from wagons during snowstorms and farmed "with a team and rudimentary implements and later with tractors." Running the Binford Ranch alone, Kate, a horsewoman from preteen days, handled their remount stallions in the army's cavalry program.

In nominating Kate for the Western Heritage Award of the National Cowgirl Museum and Hall of Fame and Western Heritage Center, one who knew her wrote, "Mrs. Binford spent most of her life on horseback. She rode all day long checking and mending fences and watching the stock. She used to carry a rifle in the saddle for rattlers and coyotes, and she rode her traps daily, as her husband had done."

Along the way, the good-humored ranch woman often credited friends, neighbors and her daughters, as well as the hands, for the help they gave her in surviving the rough times after her husband's death. She wrote, "It took many people in those days to operate the ranch. Families who worked and lived on the Binford Ranch were loyal; one family lived and worked there for 41 years, another, 19. They're like family."

A nephew, home from World War II, said of Kate after working for her between the war and the start of college, "Had she been in the army, she would have made a great top sergeant and the troops would have been home sooner."

The ranch demanded hard work. "We raised our own cattle feed and it was usually late in November or December before all of the feed was put

into stacks," Kate said. "The feed was hauled from the farm on the plains into the fences, cattle, and etc. Today so many of those same chores can be done by automobile." Kate, too, switched to the automobile to check cattle. She spotted the sick cattle, and Nancy went to rope them.

Continuing to improve with breeding programs, water and pipe to carry it, Kathryn "Kate" Cabot Binford changed and advanced with the times and sent both daughters, Barbara and Nancy, through Texas Technological College in Lubbock. Whether leading the PTA, serving on the Oldham County Welfare Board or as director of the Producer Grain Corporation of Wildorado, Kate led and participated in her community and provided a family home. Her daughter Nancy would say, "We had a tennis court, golf course and polo ground here at the ranch. My sister, Barbara, and I both grew up with a love of sports and athletics."

Barbara graduated from Tech during Nancy's first year and went on to marry a soldier who became a doctor and lived in Colorado Springs. She returned to help on the ranch when her growing family permitted. Nancy returned to ranch alongside her mother.

Nancy Binford

Called "one of the premier horsewomen in the country and a celebrated female cutting horse trainer," Nancy graduated from Vega High School in 1939 and enrolled in Texas Tech in the fall. In between, she entered rodeos. Years later, her college magazine revealed a secret about her. Nancy "was an original member of the 'ghost riders' or Matadors, thought to be only men." They preceded today's masked riders. Echoing her mother's youthful start with horses, Nancy topped a horse at age two and never got off. In rodeos, she entered calf roping, horse cutting, bareback bronco riding and barrel racing contests, events that took her around the country between terms and after college, Kate coming along when possible. Other female contestants said Kate was "always helpful. If a girl got hurt, Nancy's mother would go in the ambulance with them to the hospital."

After graduating from Tech in 1943, Nancy taught at Lubbock High School for a year, but the ranch beckoned. "During the war, my mother needed help," Nancy said, as so many of the men were away in service.

After the war, she stayed. As Kate Binford said, "She remained here to assist me in the farm and ranch operations...we are partners."

Nancy continued competing in rodeo events, and in 1947, she and another female competitor took on a new challenge. They produced the first "All Girls Rodeo" at Amarillo. Recognizing the need and establishing standard rules for their competitions, she and Thena Mae Farr became charter members of the Girls Rodeo Association (GRA), forerunner to the Women's Professional Rodeo Association (WPRA). Nancy continued to produce all-girl shows in San Angelo, Seymour and Amarillo, and in 1950, she served as president of the GRA.

Before that, however, in 1947, with the rise in the quarter horse's popularity, she and her mother both purchased quarter horses, and Nancy got involved in the birth of both the American Quarter Horse Association (AQHA) and the National Cutting Horse Association (NCHA). In 1948, she was selected as the only woman to join a group of three to exhibit her cutting horse in the International Livestock Exhibition in Chicago, Illinois. The AQHA and the NCHA sponsored the three riders' appearances to promote the associations to an eastern audience. "That was the most rewarding and memorable event during my rodeo career," Nancy said.

Two years later, in 1950, Nancy's prowess as rider and trainer of cutting horses won her the top award, World Champion, in cutting horse competition and roping. Her roping skill, of course, born on the ranch and honed on working cattle, defined one of her jobs, according to Kate. Nancy roped cows that Kate pointed out while checking on them from a car rather than horseback. Nancy roped from horseback. "I'd rather rope off a wild horse than off a car with my mother driving," Nancy said. "She hits too many bumps too fast."

The constants of farming and ranching ran through her life day after day. Nancy's sporting interests, though, changed. In 1953, she retired from the rodeo circuit but continued showing horses. In 1960, she established a racing training stable on the M-Bar, including a barn and track. "Many of our horses ran in New Mexico, and the better Thoroughbreds we shipped to eastern tracks," Nancy said. Her silks were turquoise and white with a black chaparral, representing the name, Chaparral Racing Stables, taken from all the chaparrals around the ranch. The first horse to prance out onto the track under the turquoise and white colors was Silhoubar, first of some twenty racing steeds. But there came a time, ten years later, when that, too, changed.

"The stable was taking too much of my time away from the cattle and farming operation that my mother had been running," Nancy said. "In her [Kate's] eighties, she's slowing down some." When Kate turned ninety-one, Nancy said that she still helped in the decisions of the ranch, its people and its stock. She described the Binford Ranch as one with cross-fenced pastures and "piped water most everywhere." Mother cows made up half of the herd, yearlings the other half. The horses, the broodmares, she described as "a versatile type quarter horse which does well as a using horse, showing or running."

Both Binford women, Kate and Nancy, earned induction into the National Cowgirl Museum and Hall of Fame—Kate in 1976; Nancy in 1979. Nancy served on the National Cowgirl Museum board for several years, even nudging the selection of Fort Worth for the new site of the museum and hall of fame with encouragement from *Fort Worth Star-Telegram* sportswriter Frank Reeves. "He had always been a supporter of 'the girls' activities," Nancy wrote the director. The National Cowgirl Museum and Hall of Fame relocated from Hereford to Fort Worth in 1994, opening the present building in 2002.

In nominating Kate Binford for the Western Heritage Award of the National Cowgirl Hall of Fame as a pioneer, a biographer described Kate: "Her life and her many friends' respect are proof of the spirit of all real American pioneer women, of their sense of work and human values. They helped build our country, filling in spots men left empty."

Kate Binford left empty a large "spot" when she died on October 1, 1987, a month shy of her ninety-ninth birthday. Almost a decade after her mother's death, Nancy Jean Binford, seventy-six, died on July 27, 1998. Her words about ranching, though, spring to life every time a woman or a man rides out to check on grass and livestock, feeding some by hand, as Kate did. "You don't really own the land; it's just loaned to you," Nancy said. "I feel like if you don't take care of it, you can't keep it. It takes a little bit of work and a whole lot of love."

AFTERWORD

A little bit of work and a whole lot of love." That sums up the stories of these ranch women selected for *Texas Ranch Women: Three Centuries of Mettle and Moxie*.

In researching this and my earlier book, *Texas Dames: Sassy and Savvy Women Throughout Lone Star History*, I've been struck with a realization: the lives of these women glow and dim within the span of a decade or so unless nourished through long lines of family, family fortunes and foundations such as Henrietta King's or Dora Roberts' or through storytellers such as the Campbell ranching family. No matter how high the flame, the light dims. Let's not let it sputter and die.

My purpose in the last fifteen years of research is to re-ignite those flames, to remind some, and acquaint others, of the momentous contributions Texas women have made in Lone Star history. Along this way, I have confronted a serious limitation: so many stories of Texas ranch women; so few pages.

So, if you or your family know of any family "dames" or "ranchers" whose stories need to be shared, please contact me at www.carmengoldthwaite.com or carmengoldthwaite@sbcglobal.net. Soon I will launch a blog to include tales left out of these two books and, who knows, perhaps to be included in a future book. I would like to include your family women, if possible. In coming weeks, my website and newsletter, "Scribblers Sanctuary," will provide the blog address.

Thank you for joining me in the stories of *Texas Ranch Women: Three Centuries of Mettle and Moxie*.

BIBLIOGRAPHY

Chapter 1

Carrington, Evelyn M., ed. *Women in Early Texas.* Austin: Texas State Historical Association, 1994.

Castañeda, Carlos E., ed. *Our Catholic Heritage in Texas.* New York: Arno Press, 1976.

Graham, Jose S. *El Rancho in South Texas: Continuity and Change from 1750.* Denton: University of North Texas Press, 1993.

Horgan, Paul. *Great River: The Rio Grande.* Vol. 1. New York: Rinehart & Co. Inc., 1954.

John, Elizabeth A.H. *Storms Brewed in Other Men's Worlds.* 2nd ed. Norman: University of Oklahoma Press, 1996.

Malone, Ann Patton. *Women on the Texas Frontier.* El Paso: Texas Western Press, 1983.

Shipman, Alice Jack Dolan. *Taming the Big Bend: A History of Extreme Western Portion of Texas from Fort Clark to El Paso.* Austin, TX: Jones Von Boeckman, 1926.

Texas State Historical Association. "Pedrasa." In *Handbook of Texas*. Vol. 1–6. Austin, TX, 1996.

Tolbert, Frank X. *Legendary Ladies of Texas*. Nacogdoches: Texas Folklore Society, 1981.

Chapter 2

Adams, Katherine, and George B. Ward. "Images of the Past: Imprints from the Republic of Texas." *Southwestern Historical Quarterly* 90 (July 1986).

Ashbel Smith Papers. The Dolph Briscoe Center for American History, University of Texas–Austin.

Austin Colony Papers, 3 volumes. "List of Colonists." Eugene C. Barker Library, University of Texas–Austin.

The Austin Papers. The Dolph Briscoe Center for American History, University of Texas–Austin.

Bowden, J.J. *Spanish and Mexican Land Grants in the Chihuahuan Acquisition*. El Paso: Texas Western Press, 1971.

Brown, John Henry. *Indian Wars and Pioneers of Texas*. Austin, TX: L.E. Daniel, 1880.

Canales, J.T. "Juan N. Cortina: Bandit or Patriot?" Address before Lower Rio Grande Historical Society at San Benito, TX, October 25, 1951.

Carrington, Evelyn M., ed. *Women in Early Texas*. Austin: Texas State Historical Association, 1994.

Cartier, Robert R., and Frank Hole. *San Jacinto Battleground Archeological Studies: History of the McCormick League and Areas Adjoining the San Jacinto Battleground*. Austin: Antiquities Committee of the State of Texas, 1971–72.

Deed Registries, Republic of Texas, Red River County, Books A and B. Nacogdoches County.

Douglas, C.L. *Cattle Kings of Texas*. Austin, TX: State House Press, 1989.

Edward, David B. *The History of Texas; or, the Emigrant's, Farmer's, and Politician's Guide to the Character, Climate, Soil and Productions of That Country*. Austin: Texas State Historical Association, 1990. Originally published: Cincinnati: J.A. James, 1836.

Francaviglia, Richard V. *From Sail to Steam: Four Centuries of Texas Maritime History, 1500–1900*. Austin: University of Texas Press, 1998.

Goldfinch, Charles W., and Jose T. Canales. *Juan N. Cortina: Two Interpretations, 1824–1892*. New York: Arno Publications, 1974

Guthrie, Keith. *Texas Forgotten Ports*. Vol. 2. Austin, TX: Eakin Press, 1993.

The Handbook of Texas. Vols. 3–6. Austin: Texas State Historical Association, 1996.

Harris County Historical Society. *Houston: A Nation's Capital, 1837–1839*. Houston, TX: D. Armstrong Co., 1985.

Horgan, Paul. *Great River: The Rio Grande*. Vol. 1. New York: Rinehart & Co. Inc., 1954.

Hunter, Robert Hancock. *Narrative of Robert Hancock*. 2nd ed. Austin, TX: Encino Press, 1966.

John, Elizabeth A.H. *Storms Brewed in Other Men's Worlds*. 2nd ed. Norman: University of Oklahoma Press, 1996.

Lack, Paul D. *The Texas Revolutionary Experience*. College Station: Texas A&M University Press, 1996.

Land Records. Texas State Library and Archives, Austin.

Larralde, Carlos, and Jose Rodolfo Jacobo. *Juan N. Cortina and the Struggle for Justice in Texas*. Dubuque, IA: Kendall/Hunt Publishing Co., 2000.

Linn, John. *Fifty Years in Texas*. New York: D&J Sadlier & Co., 1886. Facsimile reproduction of original, Austin, TX: State House Press, 1986.

Looscan, Adele B. "Harris County, 1822–1845." Austin: Texas State Historical Association. Reprint from *Southwestern Historical Quarterly* 18 (October 1914).

MS McCormick File. LaPorte, TX: San Jacinto Museum of History.

Murray, Myrtle. "Home Life on Early Ranches of Southwest Texas." *The Cattleman* (June 1939).

"Republic Claims—McCormick, Margaret & McCormick, Mike (Pension Claims)," Nos. 7003, 32, Reels 66 and 228. Texas State Library and Archives Commission.

Republic of Texas. Deeds, Civil and Criminal Court Records. Houston Public Library, Regional History, 1836–1848.

Rippy, J. Fred. "Border Troubles Along the Rio Grande, 1848–1860." *Southwestern Historical Quarterly* 23 (October 1919).

Sowell, A.J. *Rangers and Pioneers of Texas*. Austin, TX: State House Press, 1991.

Strickland, Rex. "Anglo-American Activities in Northeast Texas, 1803–1845." Dissertation, East Texas State University.

Tolbert, Frank X. *The Day of San Jacinto*. New York: McGraw-Hill, 1959.

Vance, Mike, and Stephen L. Hardin. *Houston: A Nation's Capital*. Houston, TX: Houston Arts & Media, 2010.

Webb, Walter Prescott. *The Great Plains*. Lincoln: University of Nebraska Press, 1931.

———. *The Texas Rangers*. Austin: University of Texas Press, 1935.

Wilbarger, J.W. *Indian Depredations in Texas*. Austin, TX: Hutchings Printing House, 1889.

Wooster, Ralph A. "Wealthy Texans, 1860." *Southwest Historical Quarterly* 65 (July 1961).

Zuber, William P. *My Eighty Years in Texas*. Austin: University of Texas Press, 1971.

Chapter 3

Bache, A.D. "U.S. Coast Survey, Preliminary Sketch of Galveston Bay, 1852." University of Texas–Arlington Libraries, Special Collections Division.

"Battle of San Jacinto/April 20–21, 1836." Albert and Ethel Merstein Library, San Jacinto Museum of History, Laporte, TX.

Bowden, J.J. *Spanish and Mexican Land Grants in the Chihuahuan Acquisition*. El Paso: Texas Western Press, 1971.

Burr, David H. "Texas." New York: J.H. Colton & Co., 1833. University of Texas–Arlington Libraries, Special Collections Division.

Clayton, Lawrence. and J.U. Salvant. *Historic Ranches of Texas*. Austin: University of Texas Press, 1993.

de León, Doña Patricia de la Garza. Vertical Files. Texas Women's Collection, Texas Women's University, Denton.

Edward, David B. *The History of Texas; or, the Emigrant's, Farmer's, and Politician's Guide to the Character, Climate, Soil and Productions of That Country*. Austin: Texas State Historical Association, 1990. Originally published: Cincinnati: J.A. James, 1836.

Hardin, Stephen. *Texan Iliad: A Military History of the Texas Revolution*. Austin: University of Texas Press, 1994.

Kendall, W.T., and Ronna Hurd. "Map of the Battle of San Jacinto." San Jacinto Museum of History, Laporte, TX.

Lott, Virgil N., and Virginia M. Fenwick. *People and Plots on the Rio Grande*. San Antonio, TX: Naylor Co., 1957.

Malone, Ann Patton. *Women of the Texas Frontier*. El Paso: Texas Western Press, 1983.

"Mapa Topografico de la Provincia de Texas, 1822." University of Texas–Arlington Libraries, Special Collections Division.

Montejano, David. *Anglos and Mexicans in the Making of Texas, 1836–1986*. Austin: University of Texas Press, 1987.

Murray, Myrtle. "Home Life on Early Ranches of Southwest Texas." *The Cattleman* (June 1939).

Pool, William C., Edward Triggs and Lance Wren. *A Historical Atlas of Texas*: Austin, TX: Encino Press, 1975.

"The Republic of Texas, 1836." Reproduced from the Fletcher-Boeselt Collection, a Historical Series of Restored Early American Cartography, Carto-Graphic Galleries, San Antonio, TX, and St. Louis, MO, 1986.

"Texas and the Contiguous States, 1845." University of Texas–Arlington Libraries, Special Collections Division.

Young, J.H. "New Map of Texas with the Contiguous American and Mexican States." University of Texas–Arlington Libraries, Special Collections Divisions.

Chapter 4

Day, James M. *Texas Almanac, 1857–1873*. Waco, TX: Texian Press, 1967.

DeShields, James T. *Border Wars of Texas*. Austin, TX: State House Press, 1912.

Ford, John Salmon. *Rip Ford's Texas*. Austin: University of Texas Press, 1963.

Handbook of Texas. Vols. 2–6. Austin: Texas State Historical Association, 1996.

Holden, Frances Mayhugh. *Lambshead Before Interwoven: A Texas Range Chronicle, 1848–1878.* College Station: Texas A&M University Press, 1982.

Holland, Gustavus Adolphus. *History of Parker County and the Double Log Cabin.* Weatherford, TX: Herald, 1931.

John, Elizabeth A.H. *Storms Brewed in Other Men's Worlds: The Confrontation of Indians, Spanish and French in the Southwest, 1540–1795.* Norman: University of Oklahoma Press, 1996.

Knight, Oliver. *Fort Worth: Outpost on the Trinity.* Fort Worth: Texas Christian University Press, 1990.

Malone, Ann Patton. *Women of the Texas Frontier.* El Paso: Texas Western Press, 1983.

Matthews, Sallie Reynolds. *Interwoven: A Pioneer Chronicle.* College Station: Texas A&M University Press, 1936.

Newcomb, W.W., Jr. *The Indians of Texas from Prehistoric to Modern Times.* Austin: University of Texas Press, 1993.

Sibley, Marilyn McAdams. *Lone Stars and State Gazettes.* College Station: Texas A&M University Press, 1983.

Sowell, Andrew Jackson. *Rangers and Pioneers of Texas.* Austin, TX: State House Press, 1991.

Stearns, Rhonda Sedgwick. "Mary Nan West: Rancher and Business Woman." National Cowgirl Museum and Hall of Fame nominating paper. Fort Worth, TX, 1998.

Voorhees, Deborah. "Mary Nan West." *Dallas Morning News,* May 16 1999.

———. "Mary Nan West: The Boss Lady Runs Rafter S." *Dallas Morning News,* June 13, 2009.

Webb, Walter Prescott. *The Texas Rangers: A Century of Frontier Defense*. Austin: University of Texas Press, 1935.

Wilbarger, J.W. *Indian Depredations in Texas*. Austin, TX: Hutchings Printing House, 1889.

Chapter 5

Anderson, H. Allen. "Winchester Quarantine." Handbook of Texas Online. http://www.tshaonline.org/handbook/online/articles/azw01.

Crawford, Ann Fears, and Crystal Sasse Richards. *Women in Texas*. Austin, TX: State House Press, 1992.

"Elizabeth (Lizzie) Johnson Williams/ Mrs. Hezekiah George Williams." In *Texas Women on the Cattle Trails*. Edited by Sara Massey. College Station: Texas A&M University Press, 2006.

Frank Leslie's Illustrated Newspaper Archives, 1855–1891. http://www.accessible-archives.com/collections/frank-leslies-weekly/#ixzz32UA1cbwd.

Haygood, Tamara Miner. "Texas Fever." Handbook of Texas Online. http://www.tshaonline.org/handbook/online/articles/awt01.

Mooney, Booth. *75 Years in Victoria*. Victoria, TX: Victoria Bank & Trust, 1950.

Ramos, Mary G. "Cattle Drives Started in Earnest After the Civil War." Texas Almanac. http://www.texasalmanac.com/topics/agriculture/cattle-drives-started-earnest-after-civil-war.

Rose, Victor. *History of Victoria*. Edited by J.W. Petty Jr. Victoria, TX: Book Mark, 1961.

Shelton, Emily Jones. "Lizzie E. Johnson: A Cattle Queen of Texas." *Southwestern Historical Quarterly* (January 1947): 351–66.

Shelton, Mrs. John E. (Willie Idella Greer). Statement Concerning Elizabeth E. Johnson Williams. (Typescript). Dolph Brisco Center for American History, The libraries at the University of Texas at Austin.

Chapter 6

"Early Settlers and their Domestic, Social and Other Activities." *West Texas Frontier* 1 (1933).

Pickrell, Annie Doom, ed. "Mrs. Hezekiah Johnson." In *Pioneer Women in Texas*. Austin, TX: E.L. Stech Company, 1929.

Chapter 7

Atherton, Lewis. *The Cattle Kings*. Lincoln: University of Nebraska Press, 1972.

Campbell, Harry. "History of Matador Ranch." Motley County, TX, 2011.

Campbell, Harry H., and Marisue Potts. *The Early History of Motley County*. Wichita Falls, TX: Nortex Offset Publications, 1971.

Campbell, Ruby G., PhD. "Judge Henry Harrison Campbell and the Matador Ranch." *Journal of the Clan Campbell Society* 32, no. 3 (Summer 2005).

Connor, Semour V., ed. *The West Is for Us: The Reminiscences of Mary A. Blankenship*. Lubbock: West Texas Museum Association, 1958.

Cullen, Jim, and Bryan Wildenthal. "Teepee City Once Pleasure Island in Sea of Prairie." *Matador Tribune*, August 23, 1985.

Douglas, C.L. *Cattle Kings of Texas*. Austin, TX: State House Press, 1989.

Exley, Jo Ella Powell. *Texas Tears and Texas Sunshine: Voice of Frontier Women.* College Station: Texas A&M University Press, 1985.

Goldthwaite, Carmen. Telephone interview and e-mail correspondence with Cheryle Campbell Stark, great-granddaughter of Lizzie Bundie Campbell. June 1 and June 20, 2014.

Harper, Minnie Timms, and George D. Harper. *Old Ranches.* Dallas, TX: Dealey and Lowe, 1936.

Ledbetter, Barbara A. Neal. *Fort Belknap Frontier Saga: Indians Negroes and Anglo-Americans on the Texas Frontier.* Austin, TX. Eakin Press, 1982.

Lincoln, John. *Rich Grass and Sweet Water.* College Station: Texas A&M University Press, 1989.

Pearce, William M. "The Establishment and Early Development of the Matador Ranch, 1882–1890." *Bulletin of West Texas Historical Association* 27 (October 1951).

Potts, Marisue. *Motley County Roundup: Over One Hundred Years of Gathering.* Floydada, TX: self-published, 1991.

Taylor, Joe D., and Marisue Potts. *The Motley County Library Mural History Book.* Crosbyton, TX: Mount Blanco Publishing Co., 1988.

Traweek, Eleanor Mitchell. *A History of Motley County.* Quanah, TX: Nortex Publications, 1973.

Chapter 8

Baker, D.W.C. *A Texas Scrapbook.* Austin: Texas State Historical Association, 1991.

Duke, Cheryl. "DeVitt's and Mallet Ranch Make Their Mark in West Texas History." *Ranch Record* (Spring 1984).

Goldthwaite, Carmen. Interview with Carter Williams, superintendent, Mallet Ranch. Sundown and Lubbock, TX, July 2002.

———. Interview with Joe Pickle, retired editor, *Big Spring Daily Herald*. Austin, TX, 2002.

———. Interview with Kathy Palmer, granddaughter of Wadkie Fowler, early Mallet foreman. Sundown, TX, August 2002.

———. Interview with Nelda Thompson, executive director, CH Foundation. Lubbock, TX, July 2002.

———. Interview with Ralph Choate, chairman of the Howard County Museum and distant relative of Dora Roberts. Big Spring, TX, July 2005.

———. Interview with R.H. Weaver, retired Howard County Judge and trustee of the Dora Roberts Foundation. Big Spring, TX, July 2005.

Hutto, John R. *Howard County in the Making*. Big Spring, TX: self-published, 1938.

Jones, Helen DeVitt. Diary Notes. Southwest Collection, Texas Tech University, Lubbock.

Kelley, Leslie. "Dora Roberts: Howard County Pioneer." Research paper for Howard County Junior College, Big Spring, TX.

"Marriages and Will and Probate Proceedings, 1882–1930, Howard County, TX." Land and Court Records, Southwest Collection, Texas Tech University, Lubbock.

Murrah, David J. *Oil, Taxes, and Cats: A History of the DeVitt Family and the Mallet Ranch*. Lubbock: Texas Tech University Press, 1994.

Pickle, Joe. "Big Spring–Howard County Centennial." *Big Spring Daily Herald*, May 1981.

———. "Getting Started: Howard County's First 25 Years." *Big Spring Daily Herald*, n.d.

Ranch memorabilia. Ranching Heritage Center, Texas Tech University, Lubbock.

Watkins, Orville R. "History of Hockley County." Thesis for Texas Technological College, June 1941.

Chapter 9

Casey, Clifford B. "Mrs. A.G. Prude." In *Pioneer Women of Texas*. Alpine TX: Archives of the Big Bend, 1952.

Dillard, Betty. "The Storyteller: An Interview with Big Bend Pioneer Hallie Crawford Stillwell." *Journal of Big Bend Studies* (June 1994): 37–47.

Fisher, Mary M. "Elderly Author Recalls Seven Decades of Life on the Ranch." *North San Antonio Times*, n.d.

Goldthwaite, Carmen. Interview with John G. Prude and John Robert Prude of Prude Ranch. Fort Davis, TX, October 17, 1999.

———. Telephone conversation with John Miller, manager, Stillwell Ranch & RV Resort. April 10, 2014.

———. Telephone conversation with Kelly Prude Boultinghouse, July 1, 2014.

Jacobson, Lucy Miller, and Mildred Bloys Nored. *Jeff Davis County, Texas*. Fort Davis, TX: Fort Davis Historical Society, 1993.

Kohout, Martin Donell. "Fort Davis, TX." Handbook of Texas Online. http://www.tshaonline.org/handbook/online/articles/hlf24.

Madigan, Tim. "Survival on the Frontier." *Fort Worth Star Telegram*, June 25, 1987.

Rust, Carol. "The Life and Times of Hallie Stillwell; The Legendary Matriarch of Big Bend Ranching Turns 98." *Houston Chronicle*, October 29, 1995.

Scobee, Barry. *Fort Davis, Texas, 1583–1960*. Fort Davis, TX: Hill Printing Company, 1963.

Stearns, Rhonda Sedgwick. "Hallie Crawford Stillwell." National Cowgirl Hall of Fame Western Heritage Center, 1992.

Stillwell, Hallie Crawford. *I'll Gather My Geese*. College Station: Texas A&M University Press, 1991.

———. *My Goose Is Cooked: The Continuation of a West Texas Ranch Woman's Story*. Compiled by Betty Heath. Alpine, TX: Center for Big Bend Studies, 2004.

Thomas, Robert McG, Jr. "Hallie C. Stillwell, a Rancher and Texas Legend, Dies at 99." *New York Times*, August 24, 1997.

Thorpe, Helen. "Hallie and Farewell." *Texas Monthly* (October 1997): 133–234.

Chapter 10

Amarillo Globe. "Area Ranchwoman Has Capable Hand on Reins." November 20, 1962.

Anderson, H. Allen. "JA Ranch." Handbook of Texas Online. http://www.tshaonline.org/handbook/online/articles/apj01.

Binford, Kathryn. "Kathryn Binford: A Pioneer Woman." Biographical notes/nominating papers. Hereford, TX: National Cowgirl Museum and Hall of Fame, 1976.

Binford, Kathryn Cabot. Script in Kathryn Cabot Binford's scrapbook. Wildorado, TX.

Binford, Nancy. "1979 Cowgirl Honoree, 1921–1998." Hall of Fame nominating biography. Hereford, TX: National Cowgirl Museum and Hall of Fame, 1979.

————. Nominating notes and autobiography. Hereford, TX: National Cowgirl Museum and Hall of Fame, 1979.

Conroy, William. "Palo Duro Canyon." Handbook of Texas Online. http://www.tshaonline.org/handbook/online/articles/rkp04.

Harper, Minnie Timms, and George D. Harper. *Old Ranches*. Dallas, TX: Dealey and Lowe, 1936.

Huson, Hobart. "Canadian River." Handbook of Texas Online. https://www.tshaonline.org/handbook/online/articles/rnc02.

LeCompte, Mary Lou. *Cowgirls of the Rodeo*. Chicago: University of Illinois Press, 1999.

"Ninia Ritchie of the Legendary JA Ranch." *Accent West* (November 2009).

Ritchie, Ninia. Acceptance speech and JA history. Edited by Diane Tribitt. Fort Worth, TX: National Cowgirl Hall of Fame and Museum, 2009.

————. Nominating papers/notes/correspondence. Fort Worth, TX: National Cowgirl Hall of Fame and Museum Archives, 2009.

Robertson, Pauline Durrett, and R.L. Durrett. *Panhandle Pilgrimage: Illustrated Tales Tracing History in the Texas Panhandle*. Amarillo, TX: Paramount Publishing Co., 1978.

Rogers, Mary Beth, Sherry Smith and Janelle D. Scott. "The Women of the JA Ranch: Cornelia Adair and Molly Goodnight." In *We Can Fly*. Austin, TX: Ellen C. Temple, Publisher, 1983.

Vick, Frances. "Cornelia Adair." In *Texas Women on the Cattle Trails*. Edited by Sara R. Massey. College Station: Texas A&M University Press, 2006.

Walker, Charlene. "Not for Men Only." *Texas Techsan* (July/August 1992).

Wikipedia. "Standardbred." http://en.wikipedia.org/wiki/Standardbred.

INDEX

ABOUT THE AUTHOR

A seventh-generation Texan, Carmen Goldthwaite found a yen for Texas history as a child in Alice, Texas, while helping her mother dig flowerbeds, unearthing Texas Revolutionary War arms and shackles. Her mother, Kathryn Fitch Goldthwaite, was a storyteller rich with tales of long-ago family members from Goliad and other treks across Texas. Telling the stories in print became Carmen's path, her skills honed while working on newspapers from Texas to New York. In recent years, she's brought together the love of Texas lore into western heritage magazine articles and newspaper columns. A good many stories appeared in her first book, *Texas Dames: Sassy and Savvy Women Throughout Lone Star History* (The History Press, 2012). Research for *Texas Ranch Women: Three Centuries of Mettle and Moxie* started her on this path years ago. A couple of her family stories found voice in essays for *Chicken Soup for the Soul: The Magic of Mothers and Daughters* (2012) and *Chicken Soup for the Soul: Miracles* (2014).

A Fort Worth resident, Carmen teaches creative writing, narrative nonfiction, memoir and essay at Southern Methodist University (SMU), where she has been appointed to the advisory board of the DeGolyer Library's Archives of Women of the Southwest. She also is a member and Spur Award judge for Western Writers of America, as well as a member of Westerners International, the Texas State Historical Association, the Society of Professional Journalists and former director of the Friends of the Fort Worth Public Library.

She loves to learn of more stories, so contact her at www.carmengoldthwaite.com, where you also can subscribe to her free newsletter, "Scribblers' Newsletter," which focuses on writing and Texas history.